"We'll Never Be Young Again"

"We'll Never Be Young Again"

Remembering
The Last Days of John F. Kennedy

Chuck Fries and Irv Wilson
with Spencer Green

Tallfellow®Press
Los Angeles

Published by
Tallfellow® Press, Inc.
1180 S. Beverly Drive
Los Angeles, CA 90035
www.Tallfellow.com

ISBN: 1-931290-51-2

Printed in USA

10 9 8 7 6 5 4 3 2 1

From Chuck Fries
This book is dedicated to my wife, Ava, who has always been an inspiration and to all my children and grandchildren whose legacy I hope I've enhanced.

From Irv Wilson
In memory of Stanley R. Greenberg 9/3/27–8/25/02.

I first met President John F. Kennedy on November 21st, 1963. It was the last night he lived. It was a twist of erratic fate that set me on a collision course less than eighteen hours later with the most nightmarish day in American's twentieth century history (other than Pearl Harbor).

I was the chairman of a huge public event in Houston on November 21, honoring Congressman Albert Thomas. President Kennedy and Vice President Lyndon Johnson were the special guests and the main speakers. That evening, following the gala dinner, I was to fly with the Vice President to Ft. Worth. On the next morning after a breakfast meeting, we would fly on to Dallas for a noon speech by the President, thence to Austin for a climaxing fund raising dinner. We were never to make it to Austin.

We landed at Love Field from Ft. Worth on the 22nd under a fine Texas sky. I got into the motorcade, six cars back of the President. The rest of the story is an awful re-telling of a senseless act of mindless malice, wherein the 35th President was slain in the streets of Dallas. When my car learned that the President had been shot as well as Governor John Connally, I raced to Parkland Hospital. There in the basement were clusters of somber dignitaries, bewildered, stunned.

A hand was on my shoulder. I turned. The hand belonged to Cliff Carter, an aide to the Vice President, who told me the Vice President wanted to see me, now. I was to accompany Carter to a room in the hospital where LBJ had been sequestered. As we moved briskly down the hallway, Carter slowed down and hesitantly said, "the President is dead, you know." I broke down sobbing. But he urged me to compose myself. When we got to the room, it was empty except for a lone Secret Service agent named Lem Johns who, with some agitation, reported to me that the Vice President had ordered him to transport me to Air Force One.

In a police car, siren keening, we made a speedy trip to Love Field where Air Force One had been removed to a remote corner of the airport, now guarded by a cordon of menacing, heavily armed men. We got aboard the Boeing 707, and ran to the mid-ship presidential office, now thickly crowded.

Suddenly from the rear of the plane strode the six-foot-four figure of the new president. He beckoned to me and said in matter-of-fact tone: "I want you on my staff. You'll fly back to Washington with me."

So it was that with a bleak intrusion of terrible tragedy, the life of the nation (and my own) changed in a cataclysmic way.

I had long been an acolyte of Senator Johnson. I was part of his campaign team (though on the lowest rung of the ladder, more of a spear carrier than an intimate adviser) that urged his selection as the Democratic nominee in 1960. When he lost to JFK, and became Vice President, I was still on his team, though a mite higher in his inner council.

I never really knew John Kennedy personally, but I was increasingly drawn to his enticing presence. My first glimpse of what later became a wildly affectionate personal embrace of him as a political leader of the first rank came during the Democratic convention in Los Angeles. JFK came as an invited guest (actually it was a misdirected invitation that was never intended to go to JFK) to speak to the Texas delegation in the Biltmore Hotel. That day I realized that this dashing, good-looking fellow was made of stern, wily and witty stuff. He came into the room, relaxed, unburdened by doubt. He smiled charmingly at LBJ, and with a casual elegance said to the highly partisan LBJ audience: "I think that Lyndon Johnson is the greatest Majority Leader ever in the history of the Senate, and it is in the best interests of the nation that he remain in that most important post where he can continue to serve his country and his party." We Texans were a bit confused as to how to handle this

display of humor and respect, but we all applauded. What the hell else could we do? I must confess I appreciated mightily the neat trap that Kennedy had sprung.

In the 1960 campaign, my advertising agency, Weekley & Valenti, was in charge of radio and TV ads for the Kennedy/Johnson ticket. During the campaign in Texas, I arranged a confrontation between the nominee and Protestant ministers who yearned to clamp their biblical teeth in what they judged to be a Papal emissary. I must confess the ministers were carefully chosen. No moderates, no soft-voiced clerics, but only those steel-driven in their honest discomfort with a Catholic in the White House. In Texas the supreme issue was religion. No Catholic had ever won a state-wide race in Texas. LBJ knew, with certainty, we had to tackle this issue with no waffling, no jerky charades, but hit it head-on. Kennedy was keen to do it as well.

So, the issue was joined. The Rice Hotel in downtown Houston was my chosen venue where we would fill the Crystal Ballroom with hundreds of Houstonians. And we would film it.

I had a small foot-high platform set up against draped windows in the middle of the ballroom, so everyone had a clear view of the candidate. Atop the platform, I put a small table and one chair. In front of the platform, we set up folding chairs for the some thirty ministers, close enough for them, if they chose, to storm the platform.

I had discussed these provisions with Larry O'Brien, one of JFK's top aides. He agreed. To the side of the platform, I stood as unobtrusively as I could. O'Brien opened a door in the rear of the ballroom, and peeked out. I nodded to him. He nodded back. All was ready. Let the candidate come forward. All of a sudden, the door opened wide and through it strode the Democratic nominee, all alone. I had thought there would be some kind of entourage with

him, but there was none, not even a Secret Service agent, though I daresay they were everywhere in the ballroom.

Kennedy moved forward briskly, confidently. He approached the small platform, mounted it, turned to the ministers flinging them a hospitable smile, and sat down with languorous ease. It was as if he was saying, "I'm here, so do your damndest."

I was brimming over with admiration. My God, the sheer act of striding out unattended, alone, unafraid, absolutely poised, so deflated the ministers that they never really recovered from their surprise. Kennedy made brief but heart-catching opening remarks, which in essence said that he was surely Catholic, but as President his deeply-committed vow would be to do all that he could to benefit the people he had by solemn oath sworn to serve. His religion would not be exiled, but it would not be his priority. That priority was to be the needs of the American people, and preserve, protect and defend the Constitution of the United States.

In truth, the battle was over before it began. The ministers' questions were at worst feeble, and at best slenderized. JFK never lost his cool. His answers were deferential but firm without ambiguity. It was a triumph by any standard one chose to employ. Indeed, the Kennedy campaign staff put that debate on countless TV stations throughout the South, wherever the religious issue raised its unhandsome head. JFK, in that one encounter, demolished the Catholic bogey-man, and did it with verve and courage.

I became a Kennedy disciple. As a clinical observer of political presentations, I was engaged by his style of speaking, the rise and fall of the clauses, the rhythmic cadences of that superior voice. Its prime defect was it infected too many young college student debaters to ape the Kennedy speaking design. He was the first television president who, not since the radio supremacy of Franklin Roosevelt, had the natural talent to win the affection and the confidence of voters, using humor and wit as weapons.

Thus it was on that November 21st, his last night on earth, just before the large political dinner-gala in Houston, Vice President Johnson summoned me back stage to a curtained-off private area to meet President Kennedy and his wife. I came through the curtain with a nervous hesitancy.

LBJ took me by the arm, and brought me to the President, saying: "I want you to meet Jack Valenti who had the most to do with your great welcome here today."

Well, hell, what right did I have to contradict the Vice President? By my modest smile I sort of allowed as how I personally herded the half-million or so who thronged the streets of Houston to greet the President. The President gave me a big grin, saying, "Well, let me say 'thank you,' Jack. I am really grateful." Then both LBJ and Mrs. Johnson introduced me to Mrs. Kennedy, glowingly beautiful, serene, elegant. I held her hand a mite longer than I should have, but she didn't seem to mind.

A small digression: Some thirty years later I wrote a political novel, PROTECT AND DEFEND. It was bought by Jacqueline Kennedy Onassis, then a senior editor at Doubleday. She became the editor of my book. We worked closely together for several months. I counted her a thorough-going professional , with a sublime gift for nourishing insecure first-time novelists. She was a wonder and I fell deeply in love with her. I suffered mightily when she died, much too young.

Over the long years I have thought about that night of the 21st of November. My total time with John Kennedy was a scant few minutes. But at least I was in his presence. For that I am eternally grateful.

JACK VALENTI *is the president and CEO of the Motion Picture Association of America. He was the head of a Houston advertising and public relations firm before becoming an advisor to Lyndon B. Johnson.*

The authors, Chuck Fries and Irv Wilson, and editor, Spencer Green, would like to acknowledge the commitment of those who have contributed to this book in so many ways...Diane Morgan, Alexei Cowett, Esq., Mamie Mitchel, Jeff Swanson and Rob Pawloski...and thank their families for their patience and fortitude...Ava Fries, Anne Carlucci and Tom and Carol Green.

The title of this book comes from a quote by the late Senator Daniel Patrick Moynihan. After President Kennedy was assassinated, Moynihan—then the assistant secretary of labor—was speaking with Washington *Star* writer Mary McGrory, who sadly commented, "We'll never laugh again." Moynihan replied, "Heavens, Mary, we'll laugh again. It's just that we'll never be young again."

Table of Contents

Introduction

Chuck Fries

Several years ago, I organized a lunch group which I called the "Let's Get Together Gang" and a number of us have been having lunch ever since. Our group consists of producers, directors and writers and our favorite topics are movies and books. One of our luncheon colleagues has been a longtime friend and the producer of series like "Get Smart" and "McMillan and Wife" and has been involved in the publishing business, operating under the name of Tallfellow Press. As you can imagine, Leonard Stern stands well over six feet tall.

One luncheon, he was expounding on a new book that was being written for his company by Frank Pierson and Stanley K. Sheinbaum. It was at that time entitled *1936* and subsequently released as *A Nation Lost and Found*. They were going to contact a number of friends and other individuals to write to them about their remembrances of the depths of the Great Depression.

This ticked off in my mind an idea that my friend, Irv Wilson, and I had been involved with for many years. What do people remember about John F. Kennedy; about him and his family; about his political career and, most importantly, about the day he was assassinated and the impact of the man and that day on their lives. So I

xx "We'll Never Be Young Again"

recommended to Leonard that we join forces and contact a select list of people to get their remembrances of the fateful day John F. Kennedy was assassinated. And we'd incorporate them in a book that chronicled the 72 hours from the assassination in Dallas until he was entombed in Arlington Cemetery.

We initially contacted close friends, especially those in the entertainment industry. But as the book developed, we realized that our celebrity concept could be expanded to include, for example, sports figures and individuals who were associated with President Kennedy in some way, like Robert McNamara and Letitia Baldrige, who gave great interviews.

Jack Valenti wrote a fabulous letter which we have used as our foreword to the book. Alphonzo Bell, Jr., whose father developed Bel Air in Los Angeles, and Liz Smith sent their memories of the day Kennedy was assassinated as excerpts from their memoirs.

As we received these very personal stories, we were often struck by the deep emotion of their memories. We'd just express a "wow" when we read, for example, Roger Enrico's (former CEO of PepsiCo) letter to his local newspaper about attending the JFK funeral; or Jim McGinn's "Never Another Sunrise"; or George Stevens, Jr.'s Embassy lunch which unfolded with politicos all around the room visibly shaken by the news; and Jerry Lewis' clandestine relationship with JFK. And we learned that November 22, 1963 was Allen Bernstein's (chairman of Arnie Morton's) 18th birthday and Dominick Dunne's "sense of loss was overpowering."

It's interesting that a book about the Depression helped initiate this book for as I grew up, my heart and my mind were always impacted by the influence of the Depression on my family. Most

everyone in the Fries family voted for Franklin Delano Roosevelt in 1932 as a backlash against the Republican party under whose regime the Crash of '29 had taken place. So my Mom, Dad and my mother's parents, who lived just across the yard from our house, were staunch Democrats and I grew up thinking I was a Democrat until I went to college and began a business career.

In 1963, I was 35 years of age and the vice president of production at Screen Gems-Columbia Pictures working with a group of men who were all Democrats, including my colleague, Jackie Cooper, while I was probably the only executive who voted as a Republican. We were the premier comedy producers with "Father Knows Best," "Bewitched" and "The Donna Reed Show," among others on the networks.

After Jackie came to Screen Gems-Columbia Pictures, things improved. Jackie had a strong interest in the welfare of the people who worked with him. Accordingly, the scrungy office that I had occupied for three years was remodeled to create a much more attractive environment in which to work.

As a part of this new decor, my good friend, Ross Bella, who did the art direction on all of our series at the studio, designed a pecky cypress backdrop to my desk instead of paneling the walls. To the right of me the screen curved out until it was about three feet from the wall and there he carved a niche for a television set.

I was in the television business, I was in television production, but unfortunately I had very little time to look at that television set. In those days, we didn't have VHS videocassette players and there was really nothing to see during the day on television but sports and daytime soaps. So from time to time, I would turn it

on to the World Series (they played in the daytime then) or a
daytime program like "Days of Our Lives," which was a soap that
I had been instrumental in launching for Screen Gems.

When the word that JFK had been shot crackled through our
Screen Gems offices (someone must have picked this up by radio
or the news was called in by telephone), I immediately turned
on my television set.

What a horribly unbelievable experience it was to see and to
hear reports from Dallas about this terrible event. The fact that
John F. Kennedy had been assassinated was astounding. The last
time something like this had happened was when William
McKinley was assassinated and Theodore Roosevelt became
President. Roosevelt rode on a train for hours to reach McKinley
and return his body to Washington. In this case, the Vice
President, Lyndon B. Johnson, was sworn in as President of the
United States at Love Field in Dallas on Air Force One within a
few hours of Kennedy's death, and they were all back in
Washington, D.C. that evening.

This event began a series of involvements with the JFK assassina-
tion and the Kennedy family that coursed its way through my
work over the next 40 years. Immediately after the assassination, a
group of Hollywood people chartered a plane to go to the funer-
al. On their return, Jackie and I met with Gene Wyman, an enter-
tainment lawyer and a major figure in the California Democratic
party, about doing a film on *The First Thousand Days*. However,
everyone felt it was too soon, not realizing that over the ensuing
years many films would be produced on the Kennedys.

Then in 1976 my colleague, Malcolm Stuart, brought me an
idea. "What if" Lee Harvey Oswald had lived and had been

tried. It was entitled *The Trial of Lee Harvey Oswald*. I turned the project over to Larry Schiller, who had been a *Life* magazine photographer and reporter, and who loved to research this type of project, and asked him to develop this into a four-hour mini-series for ABC.

Lorne Greene and Ben Gazzara played the opposing attorneys and a young writer whom we discovered, John Pleshette, played Lee Harvey Oswald. As a part of Schiller's research, he brought Marina Oswald to my home in Laguna Beach. We spent a full day talking about Lee and her own very serious problems after he committed this heinous crime and about her life as a young woman in Russia.

I traveled to Dallas with David Greene, the director, and Larry to visit the locations where we would be shooting the film. The first and most remarkable experience was to go to the Texas Book Depository, take an elevator to the sixth floor and stand at the window from which Lee Harvey Oswald shot JFK. From that window, I could view Dealey Plaza, where the motorcade had streamed down as Oswald took aim, and the grassy knoll. We also went to Parkland Hospital, Love Field and all the other land-marks in the Dallas area that are all so well known and which were definitively chronicled in the mini-series.

My interest in the Kennedys has also been motivated by the fact that I also have a large family. In my first marriage, I had eight chil-dren, five boys and three girls, and with my wife Ava's two daughters we have a family of ten. The Kennedy clan had nine children, four boys and five girls. We were a Catholic family, as were the Kennedys, and I've spent many hours reading about their family and from time to time recording the history of my own family.

In thinking of the horrendous deaths that occurred in the Kennedy family, I reflect on the loss of my second son, Tom, at the age of 47. Losing a child is a shattering experience. But losing four children is an unbelievable tragedy.

Later in 1978, we came across several books on the life of Rose Kennedy and set the project up as a six-hour mini-series with ABC. Bob Lee and Jerry Lawrence, of *Inherit the Wind* fame, were the writers. As a part of the research on the project, I visited Katharine Hepburn, who we wanted to play Rose Kennedy. I traveled to Boston, where Kate was in a play, and then had an opportunity to visit the JFK Library, the old Kennedy home on Brookline Drive (where Rose does the commentary on little speakers in every room) and then subsequently met with Ted Kennedy and Jean Smith in New York to get their approval to go forward.

We later moved the project to NBC and they ordered a four-hour mini-series. But after several changes in management, the project was not produced and eventually Katharine Hepburn lost interest. I still have the scripts and I still want to do a film or a Broadway show on Rose Kennedy. I have that on my development schedule and it will stay there until it gets produced.

It's truly amazing how the memory of John F. Kennedy has been ingrained in our hearts and our minds. Only one thousand days in the Oval Office—not even a complete four-year term—and his words, his profile and his career as our President have taken a remarkable place in the history of our country.

I want to thank my colleague, friend and neighbor, Leonard Stern (the Tallfellow) and his partner, Larry Sloan, and their staff, Larry's daughter, Claudia, and Leonard's daughter-in-law, Laura, without whom nothing would have reached the printed page.

I am proud to co-author this book with my colleague, Irv Wilson. He's a longtime friend and has always been deeply attracted to John F. Kennedy. Irv and I had dabbled from time to time in attempting to do a project revolving around the day JFK died. And so Irv and I joined together to produce this book, "*We'll Never Be Young Again.*" We've worked on innumerable projects together over the years and I think this is the jewel in the crown of creative ideas we have fostered. We were fortunate to have Spencer Green join us in completing this book. His unrelenting drive and creative writing represent an enormous contribution.

Irv Wilson

I was a young (32) hotshot television executive in New York working for the American Broadcasting Company.

It was 12:30, a beautiful late-fall day in N.Y., and I was to meet a dear friend for lunch at the old Reuben's restaurant on W. 58th Street (famous for the Reuben sandwich). The country was getting ready for the Thanksgiving holiday weekend. My friend and I had a couple of drinks and before lunch was to start, I excused myself and headed for the men's room.

As I left our table, I noticed about three or four of the waiters were all standing around in the corner, with one of them holding what looked like a baseball. As I got closer, I realized it was a portable radio they were listening to. One of the waiters told me the President had been shot; they didn't know if he was dead or alive or what was happening.

I was dumbstruck—it's unthinkable. I quickly ran to a phone and called my office at ABC to find out what was going on. The lines were all busy. I kept slamming the phone down in frustration and decided to find a place to either watch the news on TV or listen

to it on radio. My friend had already left to return to his office.

I ran down the street to a men's clothing store owned by a friend of mine. When I got there, he was listening to the radio. I heard a young reporter, Dan Rather, reporting from Parkland Hospital in Dallas that the President had been shot while riding in a motorcade to attend a fund-raising event. Before Rather could finish his sentence, the report switched to N.Y. where Walter Cronkite announced in a broken voice: "The President is dead, shot by an assassin's bullet in Dallas, Texas."

Bewildered, stunned and almost faint, I stumbled out of the shop trying to get back to my office. All the phone lines were jammed. I tried to get a cab but that was impossible. The city was immobilized. I kept walking the long walk back to my office, numb from the event, unable somehow to cry, just thinking "why would someone do this?" JFK was my hero. His youth, his intelligence, his courage, his commitment to making a better world inspired us all.

Slowly walking and thinking, my mind started wandering to my early childhood.

It was April 12, 1945. I was living with my parents and sister in a two-bedroom apartment in the South Bronx. It was late afternoon on a beautiful spring day. The baseball season had started and, to a 12-year-old boy who loved the Giants, all was well in the world. I was sitting at the kitchen table doing my homework, when I looked up at the kitchen clock and saw that it was time to meet my father, who was coming home from work.

I would meet him every day at the subway station entrance and watch him as he climbed out of the bowels of the subway. My

father would always have the evening paper under his arm and he always bought me a little packet of Chiclets chewing gum. I would kiss him, grab the paper and check the latest baseball scores, which for me was the great and only feature in the evening paper. This was my daily ritual.

As I left my apartment that day, I sensed a buzz that seemed to surround the neighborhood. People were standing around in little groups. I approached an old woman with tears in her eyes, who informed me that Franklin Delano Roosevelt had just died in Warm Springs, Georgia.

I was shocked, I couldn't believe it. I didn't really understand it all but I did somehow feel a terrible loss. I started running furiously to meet my father. He doesn't even know, I thought. America had been at war for almost four years. FDR was our President. The only President I had ever known.

He came into office when I was just two years old. My parents worshipped him. My father, mother, sister and I would all listen to his Fireside chats on the radio together. My father told me he helped us get through the Great Depression and now he was leading us through the frightening days of World War II. The news of his death affected me like a member of my family had just died.

As I ran to the station, I saw my father coming up the stairs. He had his paper under his arm and the little packet of Chiclets in his hand. I ran to him, hugged him and blurted out that the President had died. I will never forget the look on my father's face. He turned ashen, the paper slipped out from under his arm and he fell to the ground. He never gave me the gum. Seeing my father cry upset me so much that I started to cry as well. We walked home hand in hand, wept and mourned the passing of

this great man together.

That day turned me into a political news junkie who has spent his entire life hoping America would once again find another FDR to lead us through frightening times.

A leader whose intelligence, courage and vision would lead us to a more kind, just and caring society.

A leader who could articulate what all its citizens hoped for and make us all proud to be Americans once again.

America found that leader in JFK and now he was gone...

FDR. JFK. They were so much alike. Men born of wealth and privilege, blessed with incredible charm and good looks. Men of great intelligence and courage. FDR, who got us through the hard times of the Depression and the crisis of WWII and put America back on its feet. JFK, whose wisdom and intelligence during the frightening 13 days of the Cuban Missile Crisis averted an almost catastrophic nuclear war with the Soviet Union. JFK, whose potential as a world leader was never realized and America has been the worse for it.

Both great men were driven to make America and the world a better place; they inspired me personally as a television producer and executive to try to make a difference in what we presented to the world. They drove me to do two television dramas I am most proud of: in 1974, *The Missiles of October*, which document- ed how two great powers tried to avoid a nuclear war, starring William Devane as JFK, Martin Sheen as RFK and Howard Da Silva as Nikita Khrushchev. Then in 1980, *FDR: The Last Year*, the story of FDR and the conclusion of WWII, and the reper-

cussions it created, which led to the the Cold War and our dealings with the Soviet Union.

How tied together for me these men truly were. I also thought how blessed I was to have experienced both great men during my lifetime.

When I finally got home, my wife and kids, like most Americans that day, sat glued to the TV set. Glued to what became the MOST unforgettable weekend in America's history.

The world stopped for us.

No laughing.

No going to grandma's for Thanksgiving dinner.

No movies on the weekend.

Just the endless television reports, the grief, the confusion, the lack of answers.

By Sunday, I was crazed and restless. I was determined to get out of the house and away from the TV. For some reason, the NFL decided they would play their entire football schedule that Sunday. I was a Giants season ticket holder and I decided to go even if my heart wasn't in it.

As I was leaving the apartment, I heard the TV announce that Lee Harvey Oswald was being escorted to the federal prison from the local Dallas jail. There he was on TV. Suddenly, out of nowhere, a man in a black suit and fedora shot Oswald to death.

This took place on national television in front of millions and millions of viewers. What was going on? How were we to deal with this?

For America, I think it was the start of Reality TV. The events of that week were truly the most tragic and numbing this country has ever experienced. It changed America forever.

The subsequent killing of Martin Luther King, Jr.; Robert Kennedy; Medgar Evers and the Vietnam War...all of it traumatized us and I believe we have never recovered. I believe the nation has been on a downward slide ever since. The quality of our leadership has declined from year to year. We have become a nation that seems to kill its heroes and ignore its citizens.

November 22, 1963 is the day it all began.

Will we ever find men of vision, with leadership qualities we so desperately need? Will we ever find another JFK or FDR? I don't know. But we must continue to look and, most importantly, speak out, particularly at this time.

"With Humphrey (if only Stevenson had his fighting energy!) defeated, Kennedy seems clearly the best of those available. Amid such empty figures as the moronic Symington and sophomoric Jackson, and even beside so able a man as Lyndon Johnson, Kennedy shines. His grace, his tact and his intelligence are unmistakable...In the gamble that is the inescapable nature of every presidential choice, Kennedy is promising. He might turn out to be a big man. This cannot be said of his close rivals in the last lap at the convention, nor can it be said of Nixon. Never did our country and the world need a big man in the White House more."

(I.F. Stone, "At Least There Is the Promise of Bigness
in Kennedy," *I.F. Stone's Weekly*, July 18, 1960)

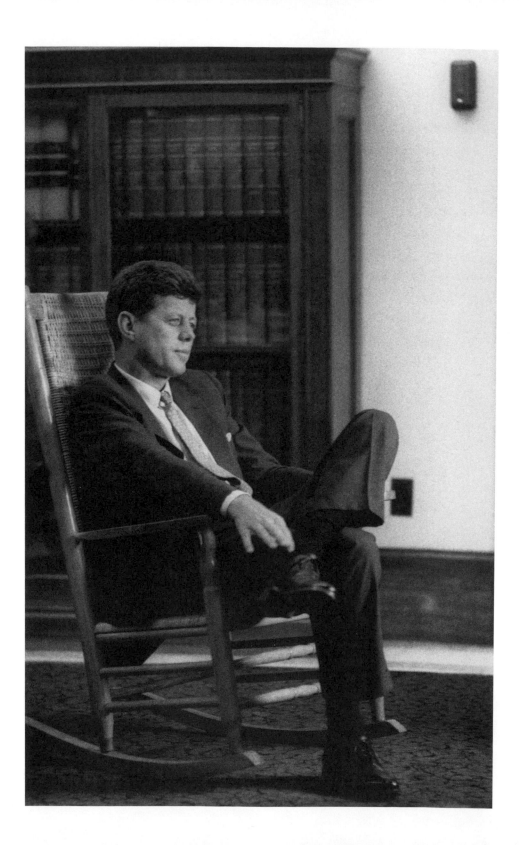

1
Road to Dallas

Some of the people around President John F. Kennedy were
worried about his November 21, 1963 trip to Texas. The
November 2nd *New Republic* described the situation thusly: "The
Democratic Party in Texas has been riven for some years by a
feud over whether it should be a Southern-style party represent-
ing respectability and money, or a Northern-style party repre-
senting the Negroes, the Mexicans and the labor unions (or at
least representing their leaders)."[1] Political infighting between
Texas Democrats had reached a boiling point; liberal Senator
Ralph Yarborough and conservative Governor John Connally
were barely on speaking terms. Yarborough was also not terribly
fond of Kennedy's Vice President, Texas-born Lyndon B. Johnson,
who was perceived as too conservative by liberals and too liberal
by conservatives and was, as Ben Bradlee recalled, "a less viable
mediator than he had once been."[2]

Texas was known as a conservative stronghold, but the city of
Dallas, in particular, had a reputation that far exceeded this
image. William Manchester observed, "Dallas was the one
American metropolis in which incitement to violence had
become respectable."[3] On October 24, 1963, United Nations
Ambassador Adlai Stevenson had visited to make a speech and
was booed, spat upon and actually hit by a woman with a plac-
ard. He later told Arthur Schlesinger of his doubts about the

President's visit to Dallas. Byron Skelton, the Texas Democratic national committeeman, had written warnings to Attorney General Robert Kennedy and also Lyndon Johnson aide Walter Jenkins about the city and its possible hostile reception towards Kennedy. Dallas businessmen hired public relations firms to calm citizens and urge them to welcome the President. Yet, the worries continued. Pierre Salinger, the White House press secretary, remembered receiving a letter on November 19 from a woman in Dallas who wrote, "Don't let the President come down here. I'm worried about him. I think something terrible will happen to him."[4] The plans had been made, however, and the official "unofficial" reelection campaign for 1964 was already gathering steam. On November 13, Kennedy and several key members of his staff—brother Robert Kennedy, the attorney general; Special Counsel to the President Theodore Sorensen; Special Assistants Larry O'Brien and Kenneth O'Donnell—had gathered with Democratic National Committee Chairman John Bailey to discuss the campaign and convention for the following year. The President and his team discussed ways to make the convention more entertaining, a possible film about the Democratic Party and organizing states for the campaign. Mostly, Kennedy discussed statistics with the director of the Bureau of the Census, Richard Scammon, and was riveted by information regarding the 1960 census and projected numbers for 1964's election.

November 17, 1963 · Kennedy far ahead of Goldwater and Rockefeller in the latest poll

November 22, 1963. I remember it well. I was at the time the vice president of a television film company called Four Star. In its day, and that was its day, Four Star was hot stuff with a great many series on the air. Steve McQueen, Clint Eastwood, Mary Tyler Moore and Aaron Spelling all became famous there. On the day under discussion, we were having problems with a show called "The Smothers Brothers." I can't remember what the problem was about, but somehow I recall Tommy Smothers being very unhappy about something to do with the series. We were in the conference room in the executive suite at Four Star, which had once been the old Republic Studio. We were six men, maybe eight, wearing suits and ties, except for the Smothers brothers, who were less formally attired. We were talking seriously, as if it really mattered, which I suppose it did at the time, about what had to be done to the show to fix the problem. A wonderful woman named Gladys Benito, who was the executive secretary to the president of the company, Tom McDermott, walked into the serious session without knocking first and said, "The President has just been shot." It was a surreal moment. For a very long instant, we all stared at Gladys and did not speak, trying to absorb what she had just said. What had been so terribly important a moment before wasn't important anymore. It being a television studio, there was a battery of television sets at the far end of the conference room. There weren't as many stations back then as there are now, and we had the three networks on, as we crowded around a foot away from the screens. I so well remember Walter Cronkite, when he nearly cried making the announcement that our president was dead. We all went home to be near people we loved.

The death of President Kennedy was like a deep wound. My grief was as great as if he were a family member, although I hadn't even voted for him. Democrat or Republican had nothing to do with it. He was our President, and we were proud of him and his beautiful wife. They were bigger than life characters on the world stage, and the magic they exuded was like nothing we had ever known before. The sense of loss was overpowering.

In my personal life, plans had been made that had to be unmade. The next day my wife and I were giving a very large party for a visiting English lord, who was arriving that day to stay with us. We hadn't known him before, he was a friend of friends, but the sharing of that dreadful historic experience made us lifelong friends. That night, we sat in front of the television set at home, as we were to sit for the next several days until after the funeral, with a list of the invited guests and their telephone numbers, calling one after the other to cancel the party. No one asked why. Everybody knew. Everyone wanted to be home, anyway.

Dominick Dunne

DOMINICK DUNNE *is a best-selling author and columnist whose work has examined the intricacies of the court system and our fascination with wealth and fame. His weekly series, "Dominick Dunne's Power, Privilege and Justice," appears on Court TV.*

November 17, 1963 · Mr. and Mrs. Robert Kennedy, Mrs. Joseph Kennedy and Mr. and Mrs. Sargent Shriver attend premiere of *It's a Mad Mad Mad Mad World*

Northeastern
U N I V E R S I T Y

Jack Kennedy was, as you can imagine, a huge influence on the lives of those of us who were just coming of age politically as he ran for the Presidency in 1960. I had just graduated from law school and was at the 1960 convention in Los Angeles the night he came over to the convention hall to thank the delegates for the nomination. I was a young first term Massachusetts legislator when he was assassinated. I was on the way back from lunch to my law firm on the day he was shot, and that weekend was one of the worst Kitty and I ever experienced, particularly since our young son had never seen his parents both weeping uncontrollably as we sat in front of the television set hour after hour.

On the other hand, I can't exaggerate the impact he and his life had on aspiring young politicians like me. He was a living example of how a young, highly intelligent, and committed political leader could make a difference in the world and in our lives. He inspired thousands of us, including myself, to follow in his footsteps. I only regret that I was/not able to follow him into the White House with another impressive Texan as my running mate.

Sincerely,

Michael S. Dukakis

MICHAEL S. DUKAKIS *is a former Democratic member of Massachusetts' House of Representatives and twice-elected Governor of Massachusetts. He was the Democratic Presidential nominee in 1988.*

JFK: A Dean's Perspective

By Joseph S. Nye, Jr.

Like many young people in the early 1960s, my life was affected by John Kennedy. 1960 was the first election in which I could vote. I had grown up in a Republican home, and my parents voted for Nixon. But after watching the debates, I voted for Kennedy. He was able to articulate a vision of a broader and better future for Americans and others that seemed to rise above the details of the Cold War world in which we lived. As a graduate student at Harvard, I remember the excitement of watching many of our professors set off to join his administration in Washington to make the world a better place. And like others, I will always remember where I was when I learned of his death. I was doing research on my thesis in East Africa, and saw the headline as I stepped off the Mombasa train in Nairobi. I still remember the sense of shock and grief.

As a young academic, I devoured the Schlesinger and Sorensen books that recounted his thousand days. I was pleased when Harvard renamed the Littauer School of Public Administration as a memorial to the slain president. But subsequently, as the inevitable backlash set in, and details of his reckless and self-indulgent personal behavior in high office became more broadly known, like many, I suffered a sense of disillusion.

I regained my respect for Kennedy in the late 1980s in the course of doing research. In 1987, on the 25th anniversary of the Cuban Missile Crisis, the Kennedy School held a meeting of the surviving principals (including McGeorge Bundy, Robert McNamara, Theodore Sorensen, Douglas Dillon and others) in what we called an exercise in "critical oral history." Later, we held another such meeting in Moscow which included Russian participants such as Andrei Gromyko and Anatoly Dobrynin. Working with Graham Allison, James Blight, David Welch and others, we published books and articles that tried to understand that fateful episode. And in that research, I developed an enormous respect for the wisdom and judgment that Kennedy used in averting nuclear war while standing up to the Soviet Union. I learned about

his personal courage, his skills in managing a fractious group of advisors, and how prudence can be essential to morality in a nuclear age. I was reinforced in my faith in the outcome of the 1960 election, but this time because of facts rather than rhetoric.

But now, as dean of the school that bears his name, I have come again to appreciate Kennedy's rhetoric as well. The 1960s and '70s were difficult times for the United States. Confidence in government and other institutions declined dramatically from two thirds of poll respondents replying that they had a great deal of confidence in 1964 to about a quarter in the 1970s. The all-time low was after the election of 1994, and concern about what this meant for the future of democratic governance and public service was a major reason that I agreed to leave government and become a dean. I was concerned that three quarters of the young American graduates of the school had gone into government in 1980, and that this had slipped to one third. Over the years, as I addressed hundreds of young people and tried to explain why government and public service still mattered despite bureaucracy and low pay, I found that the man for whom our school was named had already put it eloquently: "Ask not what your country can do for you, but what you can do for your country." And equally important for a globalizing world, and for a school with nearly half its students from overseas: "My fellow citizens of the world: ask not what America will do for you, but what together we can do for the freedom of man."

For this dean, those words still ring true. And I have to hope that the students to whom I quote them share at least some of the feeling they engendered in me four decades ago.

JOSEPH S. NYE, JR. *is dean of The John F. Kennedy School of Government at Harvard University. He has served with distinction in three government agencies and has written numerous articles and books, including* The Paradox of Power: Why the World's Only Superpower Can't Go It Alone.

November 18, 1963 • Debates held in New York over Mayor Wagner's proposal to fluoridate city water

Two major Southern states that Kennedy needed to win were Florida and Texas, and so the push began. After an appearance before the AFL-CIO in New York, Kennedy went to Cape Canaveral to watch a Polaris missile being fired. Then, he relaxed in Palm Beach with his longtime friend, Florida Senator George Smathers, before giving his first speech in Tampa on November 18th at the Florida Chamber of Commerce, and then inspecting MacDill Air Force Base and appearing at a Steelworkers' Union meeting. *Newsweek* observed that his schedule was "the itinerary of a candidate for reelection" and further noted that of the seven speeches he delivered in four states, five were in Florida, "the only one of the four states that he didn't carry in 1960."[5]

But Texas was key to winning in 1964 and the President knew it: He had won the state in 1960 by only 46,233 votes. The feud between Yarborough and Connally was minor to Kennedy, something to be smoothed out; much more important were Texas' 25 electoral votes and the need to raise Lone Star State–size money. For months, Kennedy had been pushing Texas Democrats to arrange a big fund-raiser. On a trip to El Paso in June, he had sat with Johnson and Connally and asked, "Do you think we're ever going to have that fund-raising affair in Texas?"[6] His trip in November coincided with a tribute dinner for Representative Albert Thomas, a beloved Texas figure who had been instrumental in getting the future Johnson Space Center built in Houston. A further indication of how important this trip was: Kennedy's wife, Jacqueline, had decided to accompany her husband. Mrs. Kennedy was a force to be reckoned with, as popular in many ways as her husband. She was notoriously wary of public political appearances and had remained in virtual seclusion since the death of their baby, Patrick, who had been born prematurely in August and lived only two days. Mrs. Kennedy made an appearance to view Britain's Black Watch regiment on the White

House lawn and *Newsweek*, reporting her decision to go to Texas, commented that it was obvious "she would spare no effort to keep her husband in his present line of work."[7]

November 18, 1963 • Yale professor returns from Moscow after being held for 16 days on espionage charges

Like most people I know, I remember the moment vividly. I was at Universal Studios with Walter Seltzer and Franklin Schaffner preparing *The War Lord*. One of the assistants rushed into the office and excitedly said, "Turn on the radio–there is terrible news–Kennedy has been shot." In that instant I was certain the doctors could somehow save him which was, of course, not to be. Our country changed in that moment.

As ever,

Chuck

CHARLTON HESTON's *indelible acting career includes such films as* The Greatest Show on Earth, The Ten Commandments, Ben-Hur *(for which he won the Best Actor Oscar),* El Cid, Planet of the Apes *and* True Lies. *He has served as president of the Screen Actors Guild, the American Film Institute and the National Rifle Association.*

November 18, 1963 · Coca-Cola reports third-quarter net income increased from $16,271,313 to $18,247,187

LIZ SMITH

Out of a job again in February 1963. Second banana slips on another peel. Fired again "through no fault of my own." My resumé was beginning to sound awfully suspicious. But a Texas pal, Bill Anderson, with whom I had worked at NBC, now wanted me to join him at Allen Funt Productions.

Funt was a legend, a demanding, irascible boss. Anderson bombarded him, singing my praises and maybe it was Bill's lanky Texas style, his twinkling eyes, his great sense of humor that disarmed his fearsome boss.

One Friday, I was lunching at Fontana di Trevi with my friend of Lena and Cholly days Saint Clair Pugh. We were sitting near the front of the restaurant when we heard something. It was like an ocean wave that was gathering momentum as it beat toward shore. A murmur, then a rising wail, a cry—I still can't describe it, but I get chills remembering it.

Disbelief changed into credibility. "The president has been shot! The president has been shot in Dallas!" Saint and I dropped our napkins and flew out onto West 57th Street without bothering to pay our check. We began rushing toward Fifth Avenue, which was ever the center of the universe. We paused in front of one of those giant Magnavox showrooms, solid plate glass for two stories, hundreds of TV sets all tuned to one Walter Cronkite. This was an unbelievable and surreal American moment, like something out of a Fellini movie. Walter would tell us the little he knew. We would then move on to another TV set, where he would tell us something else. I recall thinking, "Why did it have to happen in Texas?"

Saint and I plowed on to Fifth Avenue and 57th. At Tiffany's the corner was clotted with people weeping and hugging one another. Total strangers comforted total strangers. Nobody seemed to be going anywhere. The world hung in limbo. I returned to the Funt office, which was near Fifth Avenue. Inside, almost everyone had left their cubicles

to watch the many TV sets in the main room. People were crying softly. Cronkite then announced that the president had been pronounced dead. A wave of anguish rose in the room.

People sat on the edges of desks, stunned. Many went to the coatracks and began preparing to leave. Allen had, throughout, been totally out of sight. No one was even thinking of him.

Suddenly he burst out upon us screaming, "Okay! Okay! He's dead. They say he's dead. So all of you get back to work now. Instantly—back to work!" We all looked at him. One or two Funt sycophants, the people we all knew were informers and "secret police," scurried back to their holes. But ninety-nine percent of the workforce ignored the red-faced Mr. Funt. We put on our coats and silently began leaving, while he continued to yell and berate us. Bill and I left with the rest. We never really looked at or acknowledged him.

I went to my apartment in Murray Hill and promptly went to bed. For three days I watched TV, drank vodka and ate out of cans. I remember rising groggily out of a sick sleep early Sunday morning to watch Lee Harvey Oswald being brought down in the Dallas jail. I wanted to get a look at this creature. But Jack Ruby lunged out from the side of the screen, fired and erased Oswald. It was all "too much for TV" as they say!

When I went back to work after the funeral of the thirty-fifth president, I was numb like the rest of the nation. I wrote my letter of resignation and put it in my top drawer. Some weeks later I presented it, having put a P.S. at the end: "Just add me to the long list of those who have worked for you who can't take it any longer."

LIZ SMITH *has worked as a proofreader, editor, typist and radio and TV producer. Her syndicated gossip column runs in more than 70 newspapers, earning her the title "Grande Dame of Dish."*

November 19, 1963 - Former Yankee coach Hank Bauer replaces Billy Hitchcock as manager of Baltimore Orioles

Chalmers M. Roberts

During the campaign of '60, I was up in Minnesota. Kennedy was in a grocery store and he was looking to shake hands and he came up to a woman who had a bunch of bananas which she had just picked up. He came up and stuck out his hand and said, "I'm Jack Kennedy, I'm running for President." And she looked at him and she looked at the bananas and it was just too much. I mean, she had to choose between how many of these bananas she wanted and here was some guy saying he was running for President. And he just took it in and decided the thing to do was to get out of there.

The first television debate—as you know, television wasn't as widespread then as it is today—people who heard it on the radio, most of them seemed to think that Nixon had won. But, the people who saw it thought that Kennedy had won, based on his appearance and not his appearance so much as Nixon's bad appearance. I watched it on television and I thought that Kennedy had come off better, because Nixon looked so terrible.

He was a charmer. And he used his charm to subvert anybody he could. This, of course, did not originate with Kennedy. It originated as far as I was concerned with FDR. People who have that incredible political charm, you always find as you go on with them, you begin to see what's put on and you begin to try to differentiate and you learn to de-escalate your view.

I think, though, that my respect for him historically has gone up as I read the transcript of the taped conversations of the Cuban Missile Crisis. He really handled it amazingly well, better than I thought at the time. He had a whole lot of people, beginning with McNamara, who wanted to bomb the hell out of the Russians in Cuba. And we didn't know that they had armed missiles at the time, we thought they were further behind. And it's quite possible in retrospect to think that one of them might have been fired at us, if we had done that.

The inaugural speech—"Ask not what your country can do for you"—was a bombshell. I mean, we had eight years of Eisenhower, the great General...and Kennedy was this ball of dynamism, publicly. Ted (Sorensen) gave me the inaugural address the day before the inauguration. He was soliciting opinion about how it sounded. I guess he had asked a number of people, you know, out of the press. I told him I thought it was terrific. That one set the mood of his administration.

CHALMERS M. ROBERTS *was chief diplomatic correspondent for the* Washington Post *from 1953 until his retirement in 1971. He is the author of the book* How Did I Get Here So Fast?

"In the long history of the world, only a few generations have been granted the role of defending freedom in its hour of maximum danger. I do not shrink from this responsibility—I welcome it. I do not believe that any of us would exchange places with any other people or any other generation. The energy, the faith, the devotion which we bring to this endeavor will light our country and all who serve it—and the glow from that fire can truly light the world. And so, my fellow Americans: ask not what your country can do for you—ask what you can do for your country. My fellow citizens of the world: ask not what America will do for you, but what together we can do for the freedom of man."

(John F. Kennedy, Inaugural Address, January 20, 1961)

At this time, there was still no crystal-clear Republican front-runner for President. In a November 17th *New York Times* article, Arthur Krock judged that, based on "the early spurt of pre-convention activity," the leading contenders were New York Governor Nelson Rockefeller, Arizona Senator Barry Goldwater, former Vice President Richard Nixon and...General Eisenhower.[8] Other possibilities: Pennsylvania Governor William W. Scranton, Kentucky Senator Thruston J. Morton and Michigan Governor George Romney. The *Times* reported a survey of 48 editors which predicted Nixon would be a compromise candidate, with Barry Goldwater as a runner-up. *Time* magazine speculated that, "In the months to come, Goldwater's fortunes will surely ebb and flow, Rocky's (Rockefeller's) prospects will probably improve, favorite-son candidates will emerge, dark-horse possibilities will have their day—and there will be much more speculation about Dick Nixon."[9]

November 19, 1963 - Pro-Communist terrorists in Caracas engage in gunfights with police in effort to disrupt elections

As I remember it, November 22, 1963 was a pleasant, warmish California day and I left my house with a happy wave to my wife, on my way to a network meeting. Earlier that month, Herb Solow, Wilbur Stark and I had dreamed up and packaged a game show titled "The Object Is..." The basic premise of the show was to have a guest panel of celebrities give clues to civilian teammates tying inanimate objects to famous people...a bamboo cane and a derby hat, for instance, led to Charlie Chaplin, etc. In any case, we pitched it to the networks, found interest at NBC and ABC and wound up being signed for the season by Army Grant, head of daytime programming at ABC.

The reason for my happy mood will be apparent to anybody who has ever sold a television show to a network with a full season commitment. At that point in time all sane reason is supplanted by insane, unfounded cockiness...the show will be a huge hit, it will run for ten years, it will win Emmies, and you will wind up richer than Croesus. As it turned out "The Object Is..." ran just the one season and while moderately successful, not successful enough to be picked up for renewal. But on November 22, 1963 the world, as they say, was my oyster.

The meeting I was going to was with Chuck Barris, then the head of ABC daytime programming, West Coast. This was, of course, long before his brilliant career as the host of "The Gong Show," as author, as international celebrity, etc. But Chuck was always delightful and fun to be with and I looked forward to meetings with him. Today we were going to nail down the various production requirements, the sets, the personnel and tour start date which was to be soon after the beginning of the year. We were in a particularly triumphant mood because we had just nailed down signing Dick Clark as our show's host. Dick, in addi-

tion to being a marquee name with a popular following, had the intelligence and good humor for handling the celebrities and guiding the non-pros through the game. With Dick as MC, how could we miss? Oh, happy day!

It was while we were discussing Dick's role in the show that a young assistant stuck his head in the door and shouted, "Chuck! The president's been shot!" After a stunned second, Chuck turned on both television sets in his office, one tuned to ABC and one tuned to CBS. Then came the jumble of reports and the repeated replay of the cars speeding away toward the hospital. We hoped Kennedy wasn't wounded too badly. I don't think any of us dared admit the possibility of the worst. And then came Walter Cronkite, swallowing hard to contain his emotion, announcing the death, with the exact time of Kennedy's passing.

I don't remember what was said in the room, but each of us had other pressing agendas which took precedence over what had been the focus of attention less than an hour ago. I rushed out to my car and remember little of my drive home except stunned and sad faces at every red light stop along the way.

Our handsome, dashing leader was gone. The hopeful, positive force, which made one proud of the American who was leading the free world, was lost. The beautiful day that had begun in hope and happy dreams had turned to dirt and I was surprised to discover tears had wet my face as I drove west on Sunset Boulevard.

Hal

HAL COOPER *began as a child actor in radio and went on to direct hundreds of TV shows, from "The Dick Van Dyke Show" and "Maude" to "Empty Nest" and "Bob."*

November 19, 1963 · Air disaster kills 118 people in Montreal

Peter Bela Fodor, M.D., F.A.C.S.

Diplomate American Board of Plastic Surgery

My parents and three younger sisters immigrated to the United States as political refugees in February of 1963. Words cannot do justice in describing the euphoria, enthusiasm, ambition, tenacity, and most of all the naiveté that permeated our initial existence in this wonderful, free, and democratic new country of ours. The contrast was enormous between it and our previous lives as Hungarians living in Rumania, a country known for its mistreatment of national minorities and for being one of the darkest, and most suppressed communist regimes ever in existence.

These circumstances to a significant degree fueled the extraordinary ambition and determination characteristic of our new lives.

As the eldest child and only son, at twenty-one years of age, I felt I was in the keystone position as to whether our family would succeed or fail. Since failure was not a choice, success by necessity, became the only option.

Not speaking any English, my spring and summer of 1963 was spent with learning the language and working in house cleaning, painting, and a variety of other jobs ranging from bellhop, to parking cars, tending bar, and bussing and waiting tables in a Catskill's Resort of New York State.

Through perseverance and a significant dose of good fortune, by September of 1963, after seven months in the U.S., I was enrolled in medical school at the University of Wisconsin in Madison. In my overtly optimistic judgment, by then, I possessed a "working knowledge" of the English language. This hardly proved to be the case, because in effect, I could not understand my classmates, professors, and the textbooks.

Some two months later, on the morning of November 22, 1963, at the time of the tragic shooting of President John Fitzgerald Kennedy, I was attending a preventive medicine talk delivered by a very popular teacher, who possessed a great sense of humor. Even though his wit was unfortunately wasted on me, his lectures represented the highlight of the week for the rest of the class.

Once the announcement of what just happened in Dallas was made through the loud speakers, even though I did not first fully comprehend it, it was obvious that a great tragedy occurred. The class, of course, was suspended and we were dismissed. Needless to say this event contributed in no small measure and in more than one way to my "upbringing" as an American citizen.

Life goes on, and the struggle to get through, soon again became the only focus of my life, for the rest of that scholastic year. As it happened, I almost did not make it that year even though eventually I graduated in 1966, in the top of my class.

Retrospectively, by November 1963, having lived in this country for less than a year, perhaps, I was not able to fully comprehend the magnitude of this event. Not so, as time passed.

For that matter, the decisions I made later on, such as volunteering for a Vietnam assignment while I served as a captain in the Air Force (this was not granted because of my origin from a communist country) and interning in 1966/67 at Parkland Memorial Hospital in Dallas (the hospital where John Fitzgerald Kennedy died), were at least in part influenced by what happened on that sad and memorable day; November 22, 1963.

Peter B. Fodor, M.D.

PETER BELA FODOR, M.D. *is an international leader in the field of Aesthetic Plastic Surgery and has taught endoscopic surgery procedures and techniques here and abroad. He is president-elect of the American Society for Aesthetic Plastic Surgery and the chief of Plastic Surgery at Century City Hospital.*

November 19, 1963 • President spares life of 55-pound California turkey

LETITIA BALDRIGE

The Kennedy style was the latest and the handsomest way of entertaining, also the most informal and warmest way of entertaining. That meant receiving people in an informal, nice way that wasn't intimidating, like one's grandmother's white damask tablecloths with the tall sterling silver candelabra and the great urns of flowers marching down the center of the table. The Kennedys loosened up the style of entertaining and yet made it warm and personal and attractive. That was the Kennedy style.

It's very true that his being in the White House suddenly woke up the world — not just our country — to what the Presidency was. It woke up the country to what this man does and how he lives and how his family lives and also, what the inside of the White House was like. Not too many people saw the inside and when they saw it, they didn't understand what any of the history was. And the Kennedys changed all that, getting donors to return all this furniture and decorative objects that had actually been in the house at the time of the early presidents in the 19th century. The bad copies of presidential portraits suddenly changed to the originals on the walls. The people who had acquired them from the presidential families or by auction felt inspired to return them to the White House for patriotic reasons. All those details, such as rescuing from storage in the basement the incredible collection of 18th- and 19th-century vermeil (silver-gilt) that Margaret Thompson Biddle had donated to the White House six years before, and which would now be used forever throughout the house for entertaining. So, all these things suddenly started to be used and the guides would explain the history and the CBS televised tour explained the history of all of this. And Americans suddenly found out that the House was theirs. That it was their history, their President who lived there. Before, the perception of the White House was just a white box, closed to the world.

We had come through an era of grey — darkness and no real warmth. We had survived the terrible Depression and World War II years. We had the White House, with the ceiling falling down and in such bad repair, it had to be totally refixed in the Truman administration. Then, we had General Eisenhower, who was a military man

and his life, his entertaining, had been military, so he carried on that way. All of a sudden, into the White House comes a very social young couple, with great pedigrees, looking beautiful, having wonderful taste in clothes, well-read, witty — all of this was a renaissance as far as the public was concerned.

Kennedy went through some very tough times in the White House; the Bay of Pigs was devastatingly humiliating to him. And then comes the Cuban Missile Crisis — really, we were ready to go to war and he performed so magnificently, going down into the cellar and taking the top people in the administration and they never came up until they had it solved. He used social occasions to forget and to have a good time and he would turn off the terrible woes that he was having with the world back at the White House. He was able to do that and that's a great skill — to be able to relax when you want to relax and you need to relax and get out of the business, the whole business frame of mind and have a good time.

He was warm. He cared about people. He would remember that your brother was in the hospital for something a month ago and he'd say, "How's your brother? How's he doing? Is he out of the hospital?" That's the kind of warmth people appreciate, the way he would question people about their jobs and what they did, he was always interested in everybody else, which flattered the heck out of them.

We were in awe of his job and the fact that he stepped into it with such ease. It was inspiring. We all felt, well —he's young and if he can do that, well we can press a bit more ourselves. We can have a little more courage out there. We had such an affection for him, those of us who worked for him. We really did idolize him and he left his mark on all of us. And that is definitely leadership.

LETITIA BALDRIGE *worked in foreign service as an assistant to the American ambassadors in Paris and Rome. She was Tiffany Co.'s first woman executive until she became social secretary to the White House and chief of staff for Jacqueline Kennedy. She is a well-known author of 19 books, lecturer and business consultant.*

November 19, 1963 · Celtics defeat Knicks 126-98

"The Kennedy style was an eclectic blend of amusing and grace-
ful activities that ranged from taking fifty-mile hikes to inviting cellist
Pablo Casals to perform at the White House to playing touch football on
the lawn. As the Kennedy mystique grew, the first family's activities were
widely imitated: Before long, millions of Americans were taking Pablo
Casals on fifty-mile hikes. When he begged for a chance to rest, they
laughed and threw footballs at him. Such was the vigor of the times."

(Dave Barry, *Dave Barry Slept Here—A Sort of History of the*
United States, Ballantine Books, 1989)

Kennedy, according to O'Donnell and Special Assistant Dave
Powers, originally thought the Republicans would choose the
more moderate George Romney and that, "If he did run against
Goldwater, all of us would get to bed much earlier on election
night than we did in 1960."[10] But Goldwater's popularity had
increased and Kennedy realized that he was the likely choice to
win the Republican nomination. (Despite their obvious ideologi-
cal differences, Kennedy and Goldwater had great respect for
each other; in his memoirs, *With No Apologies: The Personal and*
Political Memoirs of United States Senator Barry M. Goldwater,
Goldwater remembered his and Kennedy's idea of campaigning
together for the 1964 election.) Though national polls showed
Kennedy far ahead of Goldwater, in Texas the Senator was ahead
and the President's approval rating had fallen from 76 percent in
1962 to 50 percent. A November 21st *Houston Chronicle* survey
predicted that Goldwater would defeat Kennedy by 1.3 million
votes to 1.2 million if the election were held that day. The paper
also reported that "General 'disenchantment' with the Kennedy
administration and an adverse reaction to his civil rights program
are the two most frequently mentioned reasons for the
President's decline in popularity in Texas."[11]

November 20, 1963 - General Assembly adopts declaration on ending
racial discrimination

JIM MORPHESIS

Remembering November 22nd, 1963

Late in the afternoon of November 22nd, 1963, I was pretending to be doing what everyone else around me seemed to be so conscientiously engaged in, reading the assignment in Mrs. Diaco's English class at Paxon Hollow Junior High School, located just outside of the city of Philadelphia. My face was buried in a book but my mind was already out on the football field. Our junior high football season was over; however, a few of us, who would be playing for the high school team the next year, were invited to participate in the varsity squad's final practices before the big Thanksgiving Day homecoming game. I think that Mrs. Diaco could hear my brain counting off the seconds and took pity on the two of us by asking me to take some papers to the school's main office.

When I arrived at the office, I stepped up to the counter where I expected someone to take the material from me. No one came. I could hear that a radio was on so I went up on my toes to look over the counter and back into the office. I was able to see that a group of people, including the school's principal, were huddled around the radio set. Their faces seemed so sullen. Then I heard a voice from the radio say: "This is to confirm that the President has been shot, in Dallas, and we believe his condition is grave." The words knocked me back on my heels and I stood motionless for what seemed to be minutes. Finally, one of the secretaries noticed me and asked what I wanted. I looked at her and slowly handed over the folder. I wanted to ask if what I had heard was true but I wasn't able to speak. She told me to return to my room before quickly rejoining the group listening to the broadcast. I

left the office and began a much longer walk back to my class. As I slowly headed down the hallway, I tried to tell myself that what I had heard wasn't true. President Kennedy had become a hero to me. My family may have been Republicans but I had my own political views. This was my President and he was the one who was taking us to the stars. He could not have been shot. He could not be dying.

By the time I reached my classroom, I was feeling exhausted from the sickening weight that I was carrying and it was, obviously, showing. My teacher took one look at me and quickly asked if I was all right. I wanted to tell her what had happened but no words came out of me. I shook my head and took my seat. Moments later, there was a pounding at the door. Mrs. Diaco rushed out into the hallway to talk to someone that none of us was able to see. She stepped back into the room with a strange, disbelieving smile on her face and yelled out: "The President has been shot!" I was the only one in the room who did not gasp. I was the first student in the school to hear the news and now I knew, absolutely, that it was true.

As soon as my fellow students began breathing again, the bell rang, classes were over. Within minutes, the entire school population poured out of the front doors and assembled before the buses that were waiting to take them home or to the high school for extra activities. By now, everyone was buzzing with speculations. "It was only a minor wound!" "The person shot was not the President at all!" "The President has been assassinated!" "The whole thing is a hoax!" I heard the words as they flew by me but remained silent. After a while, a depression seemed to fall on all of us and things started to get quiet. Long faces began filing into the buses and there was nothing for me to do but join my teammates and head to the high school. As the bus pulled away from the junior high, I finally opened my mouth and asked if anyone had

heard how the President was doing. I don't remember seeing who said the words, but when someone quietly said: "He's dead," I knew that it was true. The bus driver had been listening to his transistor radio. He heard what was said and did not respond. It was true.

When we arrived at Marple-Newtown Senior High School, my shoulders and legs felt heavy and there was a strange queasy feeling in the pit of my stomach. As we stepped off of the bus, we were all slumped over. The locker room was filled with football players not ready to play the game but in need of something to do. Some kids leaned against lockers. Some slowly mingled and talked. Some big tough guys stared at the floor so that no one would see them crying. Tears would come to me later that night, as I tried to sleep, after the coaches made their speeches about how football was the President's game and that we needed to find the strength to carry on, and after my father tenderly assured me that the human spirit always finds a way to deal with even the greatest tragedies. Time would prove my father to be correct; however, as I sat in that locker room, as the day grew dark, and even as I looked at my friends and teammates and understood that we were all wounded and bleeding, I felt alone. I felt that one of the most important people in my life had been taken from me but I felt no anger. My aching sadness was so consuming that there was no room for anger. I worried about what might happen to our country and I worried that I would never have fun again. The afternoon passed into evening and as I boarded another bus, the one that would finally take me home, I thought that nothing would ever be the same again. The world was a little meaner and I felt a little older.

JIM MORPHESIS' *powerful, Biblically and mythologically inspired paintings have been seen in many one-man exhibitions and are in the collections of such museums as the Metropolitan Museum of Art and the Los Angeles County Museum of Art.*

HENDERSON PROD. CO., INC.
Garry K. Marshall

Where I Was the Day President Kennedy Was Killed

When my wife and I married in early 1963, I was a comedy writer and she was a nurse. I told her the cardinal rule of being married to a comedy writer was that we often worked late nights and didn't like to wake up before noon. She respected this edict until the morning of November 22, 1963. When she woke me up out of a very sound sleep I knew immediately something was terribly wrong because she was crying. In between tears she told me that President Kennedy had been shot in Dallas. We then sat huddled together in our living room and watched the news reports. At first it appeared as if Kennedy was going to live, but soon it was announced that he didn't make it. Barbara began to cry even harder, and I told her that she had to calm down and pull herself together or she was going to hurt our baby. You see, at the time, Barbara was pregnant with our first child, who was due in mid-December 1963, and I worried her hysterical crying might induce labor. I also had to pull myself together because I had to go to work on the set of "The Joey Bishop Show" where I worked as a comedy writer. The guest star that week was Zsa Zsa Gabor and the last thing I wanted to do that day was write jokes for Zsa Zsa or anybody else. But I had to do it because we had a show to shoot. I remember I told Zsa Zsa that her character should say some-

thing like Mickey Rooney once said, "I always get married in the morning because if it doesn't work out it won't ruin the whole day." She laughed. I laughed. We needed to laugh. It was one of the darkest days that I can remember, but there was still room for laughter. Since Kennedy's death, my wife has had to wake me up early only two other times: Once when our infant daughter climbed out of her high chair and fell on her head, but she turned out to be fine. And the other time she woke me up early was on the morning of September 11, 2001, when the terrorists attacked the World Trade Center and the Pentagon. When Kennedy was shot, I worried about the future of the world that I was bringing my daughter into. And when the terrorist attacks occurred, I worried about the future of the world that my grandchildren will grow up in. But my hope then and now is that even during dark days and terribly uncertain times, there will always be room for humor to help us make it through. We all need to find a way to laugh in order to survive.

GARRY MARSHALL *has written for such sitcoms as "The Dick Van Dyke Show" and "The Lucy Show" before producing "The Odd Couple," "Happy Days" and "Mork & Mindy." His feature directing credits include* The Flamingo Kid, Nothing in Common, Pretty Woman *and* Runaway Bride.

And so, avoiding Texas was not an option for Kennedy. Quite the contrary. Theodore Sorensen noted, "He regarded Dallas' reputation for extremism as a good reason to include it on his schedule, not a good reason to avoid it."[12] As for the potential dangers, Salinger wrote that the President "was the last person in the world to be concerned about his personal safety. On the several occasions the subject had come up in discussions with him, he always replied: 'If anyone is crazy enough to want to kill a President of the United States, he can do it. All he must be prepared to do is give his life for the President's.'"[13]

November 20, 1963 - Danish foreign minister gives Soviet Premier Khrushchev teak-and-black leather rocking chair

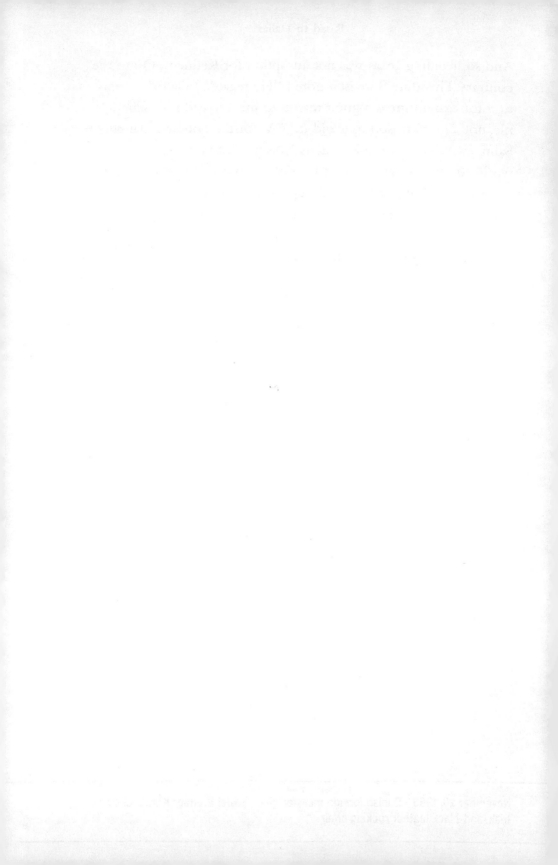

2
Men in Space

Mr. and Mrs. Kennedy landed in San Antonio, Texas, on Thursday afternoon, November 21, and estimated crowds of 125,000 greeted their motorcade. The friction continued between Yarborough and Johnson, with Yarborough refusing to ride in an appointed car with the Vice President. (When asked if he would ride with Johnson when they arrived in Austin, Yarborough said, "We will get to that when we get to Austin.")[1] The first stop for the Kennedys was the dedication of the Aerospace Medical Health Center at Brooks Air Force Base. There, he spoke to the crowd and remembered a book by Frank O'Connor:

"...as a boy, he and his friends would make their way across the countryside, and when they came to an orchard wall that seemed too high and too doubtful to try and too difficult to permit their voyage to continue, they took off their hats and tossed them over the wall—and then they had no choice but to follow them. This nation has tossed its cap over the wall of space, and we have no choice but to follow it."

WALLY SCHIRRA

I vividly remember we were on the flight line at Ellington Air Force Base, which was near our quarters at Houston. John Glenn, Scott Carpenter and I were sitting together when we heard the horrible news.

We, of course, were motivated by Sputnik and we talked about the dog, Laika, which we referred to as Muttnik. The result of it was we were kind of shook that we were going nowhere and we had a lot of delays from monkeys and chimpanzees and we finally got (Alan) Shepard off. And at about that time, President Kennedy said, "We're going to the moon and back," and we were all in shock. But then, the nation committed itself—I love that word, commitment. He committed the nation to a space program and, as a result, those who worked in it really committed. I can recall union employees working way beyond overtime, just to get something done.

The fact that he said we would go to the moon and back is very significant. Even the TV announcers said, "Going to the moon" and left out "and back." I always say we confirmed a round-trip ever since the President suggested we do it. At that time, Jackie Gleason was very famous for saying, "I'm gonna send you to the moon;" we said, no, we'd rather do it in the Kennedy style than in the Gleason style.

A favorite anecdote was when he was presenting Shepard with a medal for his initial flight and he dropped it, inadvertently. And we were all in shock, and the President said, "This medal comes from the ground up" and picked it up.

My favorite story about the Kennedys, of course, is from October, 1962—it was during the Missile Crisis. We were invited to the White House and I was to meet my wife, son and daughter in the Oval Office. We went in, and we started chatting. And somehow or other, the subject of Macaroni (Caroline Kennedy's pony) came up and the President—in his calm, cool way, in his rocking chair—said, "Come on outside and I'll show you Macaroni." And this is right during the Missile Crisis. It was kind of a funny little event to tie together with the nation under tremendous pressure.

WALLY SCHIRRA *was one of the original Mercury 7 astronauts and orbited the earth six times on October 3, 1962. Since retiring from NASA, Schirra has headed several financial and consulting firms.*

Scott Carpenter

Two people were crucial to the Apollo lunar landing program. One was John F. Kennedy, whose vision and charisma and edict to land on the moon galvanized the nation behind that effort. The other was Wernher von Braun, who showed us how to do it. By the time Kennedy was in office, the space race and Soviet competition were already underway, but he held that preeminence in space was a condition of our survival, and we achieved it.

Kennedy was all sorts of good things—handsome fellow, ex-Navy with combat experience and a great orator. He was an all-American boy grown up.

SCOTT CARPENTER *was one of the original Mercury 7 astronauts and became the second man to orbit the earth. on May 24, 1962. He is an author and consultant in space and ocean technology.*

Then, it was on to Houston, with a quick detour to a League of United Latin American Citizens dinner, where Mrs. Kennedy was serenaded by a mariachi band and then addressed the crowd, partly in Spanish, to the delight of those gathered.

And finally, the main event: the honorary dinner for Representative Albert Thomas. At the packed Sam Houston Coliseum, over 3200 people came to honor Thomas. Kennedy proclaimed, "I don't know of anyone who has helped get the job done more than Congressman Thomas," and praised him for his leadership in advancing the space program. During his speech, Kennedy recalled his early days on Capitol Hill, wryly noting that a new congressman "spends the first six months wondering how he got to Congress, and the next six months wondering how the others got there."

"But why, some say, the moon? Why choose this as our goal? And they may well ask why climb the highest mountain. Why, 35 years ago, fly the Atlantic? Why does Rice play Texas? We choose to go to the moon. We choose to go to the moon in this decade and do the other things, not because they are easy, but because they are hard, because that goal will serve to organize and measure the best of our energies and skills, because that challenge is one that we are willing to accept, one we are unwilling to postpone, and one which we intend to win."

(John F. Kennedy, speech at Rice University, Houston, Texas, September 12, 1962)

November 21, 1963 - World Muslim Congress holds reception at Karachi honoring Mowlana Hazar Imam

DR. ROBERT C. SEAMANS, JR.

One evening in mid-November 1963, just after arriving home, I received a call telling me that President Kennedy was thinking of a trip to Cape Canaveral.

Julian Scheer, NASA's public affairs officer, came down to my office, and several of us sketched a map on the blackboard indicating where the President might land, what he might see up close and what he might fly over.

The next morning, November 16, 1963, the President flew from Palm Beach to the Cape, where he was greeted by Major General Leighton I. "Lee" Davis and Dr. Debus, the respective heads of military and NASA operations at the Cape, as well as by Jim Webb and myself. He was accompanied by Senator George A. Smathers of Florida, a good friend of his.

There was about a fifteen-minute briefing there with all kinds of models. When the briefing was over, he stood up and went over to the models. He expressed amazement at the fact that the models were all to the same scale, because the Mercury launch vehicle was completely dwarfed by the Saturn V. This may have been the first time he fully realized the dimensions of future NASA projects.

We then went out to the pad where the Saturn SA-5 (the fifth Saturn I) was sitting. We stood out in the open with Dr. von Braun, discussing the Saturn and its dimensions. Before leaving, President Kennedy wanted to walk over and stand right underneath the Saturn. This eventuality had come up for discussion with the Secret Service the previous day. They hadn't wanted him to get too close to the rocket. But no matter what anybody thought, President Kennedy was going to go and stand under the Saturn. "Now," he said, "this will be the largest payload that man has ever put into orbit? Is that right?"

"Yes," we said, "that's right."

He said, "That is very, very significant."

We then climbed into the President's helicopter, which had been flown down from Washington on a transport plane for his use. My job was to sit with him as we flew over the new construction area on Merritt Island and to point out the future location of such things as the Vehicle Assembly Building and the launchpad (Complex 39). Afterwards we flew about 50 miles offshore to watch a live test of a Polaris missile.

On the way back, he brought up the matter of the Saturn SA-5. "Now, I'm not sure I have the facts straight on this," he said. "Will you tell me about it again?"

I explained (among other things) that the usable payload was 19,000 pounds, but that we actually would have 38,000 pounds in orbit.

"What is the Soviet capability?," President Kennedy asked. I told him. "That's very important," he said. "Now, be sure that the press really understands this, and in particular, see…" (he mentioned one reporter by name). Just before we landed, he called in General Clifton, his military aide, and said, "Will you be sure that Dr. Seamans has a chance to explain to…" (he mentioned the reporter's name again).

We got off the helicopter and walked quickly over to the President's plane. He shook hands with Jim and the others, then turned back to me and said, "Now, you won't forget to do this, will you?" I said I would be sure to talk to the reporter.

"In addition," he said, "I wish you'd get on the press plane that we have down here and tell the reporters there about the payload."

"Yes, sir," I answered. "I'll do that."

Six days later, on Friday, November 22, I was holding a meeting in my office, when I got a call from Nina Scrivener, Jim Webb's secretary. She said, "Something dreadful has happened in Dallas. You'd better come on up to Jim's office."

"You mean the President's been hurt?"

She said, "It may be worse than that."

Jim Webb had three televisions in his office, so that he could have all three networks going at once and flip on the sound of the one

he wanted to hear. We sat there watching all three networks. Finally, Walter Cronkite came on and said the President had died.

The following day, we had scheduled our regular monthly program review. I argued strenuously that we ought to go ahead with the meeting, that President Kennedy had been very interested in NASA's programs, and that he would have wanted us to press ahead. As a result, we were probably the only federal government organization doing business that day. When the review was over, Jim turned to Hugh and said, "I'm going over to the White House. Do you and Bob want to come along?"

The three of us and our spouses stood in line in the East Room, where the President was lying in state with a Marine at attention by his side. Everyone wore black. The casket was closed and draped with the flag. There was immense grief on every face, and many significant symbols, such as the Great Seal of the United States of America over the door, were draped in black. There were no flowers, no music, only the murmur of hushed voices and the shuffle of feet. It was the saddest place and the saddest time in our lives.

The following day I was scheduled to give a talk at church. I had to comment on the assassination and tried to be positive, not maudlin. On Monday, Gene and I walked over from our Georgetown house to watch the funeral procession, pushing through the mourning crowds outside Arlington National Cemetery. After the committal, fifty fighter planes, representing the fifty states, flew over our heads in formation. They were followed by Air Force One, the President's own. The same plane that had flown President Kennedy to Cape Canaveral nine days before dipped its wing as it flew over his final resting place.

DR. ROBERT C. SEAMANS, JR. *was associate administrator and then deputy administrator at NASA during the 1960s. He later became secretary of the U.S. Air Force and dean of MIT's School of Engineering.*

BETTY FRIEDAN

I remember I was in Seattle, Washington, lecturing at a conference. It was right after my book *The Feminine Mystique* was published and I was off traveling and promoting my book.

Esther Peterson, who was assistant Secretary of Labor at the time, was with me when the news that the President was shot came on TV. She had to get right back to Washington and left immediately.

John Kennedy was, somehow, very inspiring to me. After many years of the "Hooverish"-no inspiration-no leadership in government, there was a sense of a new generation, a new vision-"don't ask what your Nation can do for you, ask what you can do for your Nation." He was giving a new positive note to political involvement and service after a very critical time in our Nation. I liked all that. I thought he was going to be a very inspirational leader and then that was, sadly, cut short for me.

I was shocked and sorry for our Nation's loss. I had great admiration for Jack Kennedy and of his leadership.

I never had the opportunity to meet him but I did meet Jacqueline. I think she identified in some way with me. She introduced me to many people that could help me by giving money for the women's movement, and I liked her a lot.

BETTY FRIEDAN *wrote the landmark book* The Feminine Mystique *and helped found the National Organization for Women. She has continued to explore the dynamics of social and cultural order in* The Second Stage, The Fountain of Age *and* Beyond Gender: The New Politics of Work and Family.

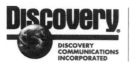

John S. Hendricks
Chairman and Chief Executive Officer

DISCOVERY
COMMUNICATIONS
INCORPORATED

On November 22, 1963, I was eleven years old and some might expect that the assassination of President John F. Kennedy should not have a great and lasting effect on someone so young at the time. They would be wrong.

In 1958, my family moved from Matewan, West Virginia to Huntsville, Alabama where my father had found steady and dependable work in his trade which was building residential homes. Huntsville was the home of NASA's Von Braun rocket team and the town was bustling with new construction during the Kennedy administration as the new President pledged to "land a man on the moon by the end of the decade and to return him safely to earth." The scientists and engineers who had re-located to Huntsville from cities across America assumed the awesome responsibility of constructing the mighty Saturn 5 rocket which would ultimately launch Apollo 11 to the moon in 1969 and fulfill President Kennedy's pledge.

Although a boy fascinated with science and space could not find a more exciting place to grow up, Huntsville, like other cities in the deep south, suffered through the most troubling aspects of a society deeply divided over civil rights and race relations. My father was a Kennedy Democrat and he was proud of his liberal convictions. My father's views about racial equality certainly influenced my attitudes and over time and it was apparent that our family was becoming alienated from the native Alabamans in the neighborhood who believed as strongly in segregation as we did in integration. To this day, I remember the taunts by a classmate: "I heard your father is a n_ _ _ _ _ -lover, does that make you one, too?" And so, by age 11, I had become quite skilled at defending myself, my father, and the progressive ideas of President Kennedy.

Like my father, President Kennedy had become a central, guiding figure in my life. This was an unusual connection, made largely through television, that was a unique product of the times and my own circumstance. When President Kennedy addressed the nation on television, I hung on every word. His dreams for space exploration, for racial justice, and for the spread of freedom worldwide became my dreams. I had a genuine hero.

And so on that day in the sixth grade, just after we had returned from the lunchroom, our principal, Mrs. Collier, addressed us over the classroom loudspeaker and delivered the horrible news. She then instructed all classes to re-gather in the cafeteria where we all listened to the radio reports of the assassination attempt. And then, when the report of the President's death was confirmed, school was dismissed. I remember walking home, shattered.

Today, nearly 40 years after that awful November day, I am struck by the profound and lasting impact which President Kennedy had on my life. President Kennedy urged us to undertake great and challenging tasks. He taught us to give all citizens the dignity and respect they deserve. And he was the first modern President to advise us to think globally.

President Kennedy's critical support of the space program led to the creation of satellite communications, without which my entire business career, my life's work, would not be possible. There would be no Discovery Channel.

Even more important than President Kennedy's contribution to our ability as humans to communicate globally through the fruits of the space program is his enduring legacy as a passionate advocate for the equality of all men and women. His passion lives on in the hearts and minds of all those who were fortunate to hear his words during his time with us He gave many of us the courage to dream and that gift has served us well.

John S. Hendricks
Founder of the Discovery Channel
 and
Chairman and Chief Executive Officer
Discovery Communications, Inc.

JOHN S. HENDRICKS *is the founder and CEO of Discovery Communications, Inc., and creator of cable TV's The Discovery Channel. He also formed the Women's United Soccer Association in 1999.*

Kennedy had begun in the House of Representatives in 1948, rising to the Senate and then the White House. The son of multi-billionaire businessman Joseph P. Kennedy, John was taught from the earliest age to compete and win at all things in life. Educated at Choate and Harvard, he was described as a popular if unfocused young man, who began to grow after serving in the Navy and shouldering the burden of following in the footsteps of his older brother, Joe, Jr., killed during World War II. The tension between what was expected of him, what he was and how he needed to be perceived to achieve his goals created the Kennedy persona. As *Time* magazine White House correspondent Hugh Sidey put it, Kennedy was perhaps "the first man in this nation's history to train for the Presidency from the cradle."[2] His election in 1960 was, to put it mildly, not a mandate—he beat Richard Nixon by a margin of 112,881 votes out of 68,838,565 cast—and as Sidey noted, "If Kennedy was not nervous, the country was. It knew him, yet it did not know him. It wanted him, yet it did not want him."[3]

November 21, 1963 • The Ecumenical Council allows use of vernacular languages for Roman Catholic sacraments

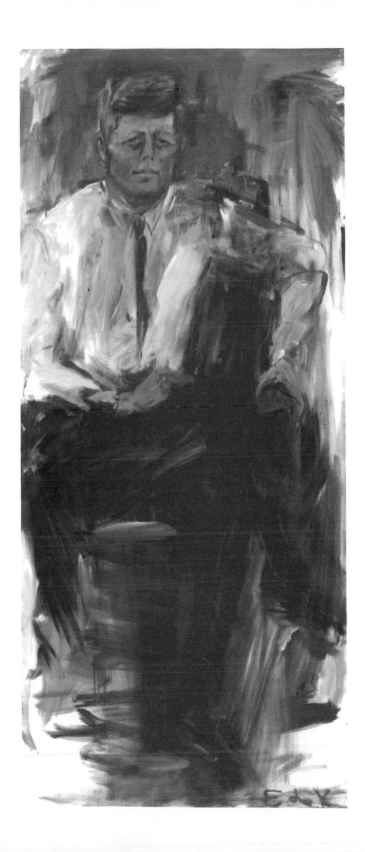

Gilbert Cates

I was on 57th Street in New York City walking to the Friars Club for lunch. It was around 12:30. Suddenly, a woman ran out of a store shouting, "The President has been shot." I was stunned. People began to ask her how serious it was. She said she didn't know and ran back into the store. There was general confusion on the street, which was pretty crowded.

I half walked and ran the remaining three blocks to the Friars Club. Once inside, no one seemed to know for certain what had happened. Several of us went to the third floor, which had a television set, and watched as the awful events unfolded. The only clear station we could get was CBS, so Walter Cronkite told us the story.

It was a terrible day and a terrible moment when the final, sad news of President Kennedy's death reached us. We all died a little that day. We lost a piece of our lives that has never been returned. I hope never to see a day like that again.

Gilbert Cates

GILBERT CATES' *extensive credits as director and producer include the Oscar-nominated* I Never Sang for My Father *and* Summer Wishes, Winter Dreams, *numerous TV movies, and more than ten Academy Awards shows. He was dean of UCLA's School of Theater, Film and Television for seven years and is currently producing director of Los Angeles' Geffen Playhouse.*

Maury Maverick, Jr.

I gave Senator Kennedy a tour of the Alamo when he was running for President, and learned that he had a wonderful sense of humor. It was on the morning of the day when he was speaking in Houston before all the Protestant preachers who were going to ask him about a Catholic being the first President of the United States. And he said, "Get me out the back door of the Alamo—I've got to get on the plane to Houston." And I said, "Senator—there isn't any back door. That's why they were all heroes." And he just started roaring with laughter and he called over all his Irish buddies and told them and they turned into 100 percent Boston-Irish. And I liked him for his good-natured reaction to that.

MAURY MAVERICK, JR. *was a Texas state representative and civil rights attorney and wrote a political column for the* San Antonio Express-News.

PALISADES PRODUCTIONS, INC.

Never Another Sunrise

On November 22, 1963, Charlton Heston was recording a narration for me at Universal Studios. I was the writer-producer of a documentary film concerning Mental Retardation called *To Solve A Human Puzzle*. It was financed by the Kennedy Foundation and Eunice Shriver, the President's sister, was my "boss." She had scheduled a screening of our film at the White House on December 10th and I had written a prologue, hoping to entice Mr. Kennedy into filming it for us. Our premiere was scheduled for a black-tie fund-raiser in New York City in January, 1964.

Mr. Heston was a family friend of the Kennedys and recorded our narration for free. He was easy to work with and patiently responded to our director, Archer Goodwin. We completed his narration in less than the three hours allotted to us.

Both Heston and I were graduates of Northwestern University's School of Speech and we discussed this as we exited into the sunlight. Dozens of people moved frantically in front of us. "What's going on?" asked Heston. "President's been shot in Dallas!" was the reply.

Charlton led me to the nearby cottage of Doris Day. We entered and listened to a radio on a secretary's desk. The secretary dutifully held a phone to the radio; her hand was shaking and tears ran down her cheeks. I never learned who was listening on the other end of the phone line.

"I'm going home," stated Heston. We said good-bye and both of us hurried to our cars. Hundreds of studio employees moved by us and huddled around small radios. Some wept, others seemed stunned. I was staying at the Hotel Bel Air and drove there with a sense of urgency. I listened to the unfolding tragedy on the car radio until I reached the parking lot and ran into the bar.

I phoned my wife, Patty, who was visiting her mother in Chicago with our two small children, Shannon and Michael. Together, we watched Walter Cronkite declare President Kennedy dead, remove his glasses and choke back tears.

As Irish Catholics, Patty and I were immensely proud of JFK's election victory in 1960. We stayed up all night waiting for Nixon's concession speech. Patty was thrilled that I was working for the Kennedy family and looked forward to meeting the President and Mrs. Kennedy at the New York banquet in January. Now, our small dreams and the much larger 'anything is possible' dreams of our nation were shattered. The incomprehensible had happened; our young, witty charismatic leader was gone. We cried together and concluded our call.

I'm not used to drinking during the day and, yet, I wanted to. I asked Spence, the bartender, for a suitable drink. He suggested a Sunrise, a combination of gin, orange juice, and a touch of Grenadine and ice in a tall glass. I ordered two, one for him and one for me. The two of us sipped our drinks and silently watched television. Slowly, the enormity of the assassination overwhelmed us.

I've had my share of drinks since then. But never another Sunrise.

Sincerely,

Jim McGinn

Jim McGinn

JIM MCGINN *has written and produced extensively for television and film in Chicago (his hometown), Toronto, New York and Los Angeles. For 25 years, he developed and supervised programming for the Bristol-Meyers Squibb Company. He currently writes plays and screenplays and teaches writing at the USC School of Cinema/Television.*

"Abraham Lincoln came to the Presidency in 1860 after a rather little-known session in the House of Representatives and after being defeated for the Senate in '58 and was a distinguished President. There is no certain road to the Presidency. There are no guarantees that if you take one road or another that you will be a successful President."

(John F. Kennedy, from the first televised
Nixon-Kennedy debate, September 26, 1960)

And, indeed, Kennedy's rise from the House to the Senate and finally the Presidency seemed at first a plunge into public office that was forged by inevitable destiny and only later, did a more mature world view take shape. The wit, the effortless charisma, the thoughtfulness, the lurking sexual bravado—the iconic image of a virile, life-affirming man (all the more amazing when one learns of the intense physical pain which plagued him throughout his life) were the qualities that instantly connected with people. There was also a reserve, a knowingness that seemed tailor-made for the media age. David Halberstam has written that "Kennedy's coming represented the confluence of the man and the technology, a new political force and politician with the skills and instincts to exploit it."[4] TV journalist David Brinkley recalled, "He looked on television like what he was, a younger, livelier, handsomer president than Americans were accustomed to seeing after years of older, more settled, statelier gentlemen named Hoover, Roosevelt, Truman, Eisenhower."[5] Image was important to Kennedy, but, as Laurence Leamer observed: "He did not believe, as some would have, that image was everything, but he did think of image as a kind of costuming that allowed him to walk where he wanted to walk and do what he wanted to do."[6]

November 21, 1963 • U.N. General Assembly approves resolution to make 1963 International Cooperation Year

Aaron Spelling
Chairman Of The Board
Chief Executive Officer

THE DAY JFK DIED:

I will never forget what happened on November 22, 1963. I was producing three shows for Four Star, when I got a phone call from my mentor and boss, Dick Powell. He said 'Aaron, you've got to do me a favor. I can't stand to do it myself.' I told him I would do anything and how could I help. He told me the horrible news. President Kennedy had just been assassinated in my hometown of Dallas, Texas, and he asked me to go to every set, stop production, and tell everyone to go home. I started crying over the phone and I told him I would do it.

There was a young man in my office, who the girl I was dating asked me to see about a job. I asked him to go with me to the sets to make sure I didn't collapse on the way. I went to three sets and told the cast and crew what had happened to our President. I have never seen an entire crew break into tears, but it happened on all three sets.

When we got back to my office, my Associate, Renate Kamer, who is still with me, begged me to leave and go back to my hotel. I agreed if she would get the young man I was suppose to interview to come with me and he did. We arrived at the hotel in about 30 minutes, and it was only about 30 minutes later when I got a tremendous pain in my side and called my doctor. He quickly came over, and he said I had appendicitis and rushed me to the hospital for an operation. That's how much the President's assassination and doing what Dick Powell had asked of me affected me.

By the way, after the operation, I was told I could not drive my car for quite awhile. So my interviewee started with me as a driver. I must also say he was with me throughout my illness at the hospital and at the hotel. He was very bright and grew to be a writer and producer. His name is Larry Gordon, and this year he just won the Lifetime Achievement Award from the Producer's Guild.

Aaron

Renowned producer **AARON SPELLING***'s TV credits include* *"The Mod Squad," "Charlie's Angels," "Dynasty," "Beverly Hills 90210," "7th Heaven" and "Charmed." He is listed as the all-time most productive TV producer in* The Guinness Book of World Records.

Raymond L. Flynn
American Catholic Alliance, President
U.S. Ambassador 1993-1997
Mayor of Boston 1984-1993

I happened to be in the U.S. Army in November of 1963 and stationed at Aberdeen Proving Ground in Maryland. I was looking forward to the upcoming weekend, where I was going to play professional basketball for the Wilmington Delaware Blue Bombers. My teammate and friend, George Ravling, was going to pick me up and drive me to our weekend games in Pennsylvania and New Jersey.

While attending a lecture on the base, a soldier at the back of the classroom, spontaneously shouted out, "Oh my God, the President has been shot." We had no idea what he was talking about or where he could ever get such information. He quickly acknowledged that he had an earphone and was listening to the radio when the emergency bulletin was made.

A few minutes later, an eerie alarm sounded, summoning the entire military base to assemble and listen to the message of the commander. At first, we were told that both President Kennedy and Vice President Johnson had been shot and that Kennedy had died.

The base commander told us to return to our quarters and wait for further orders. Our platoon sergeant told us that because of our close proximity to Washington, D.C., it was possible that we could be called to D.C., especially if the assassination was an attack on our country as some were speculating. The Cuban Missile Crisis and Communist Berlin Blockade were still big stories in the news.

I was given permission by my company commander to go to Washington, D.C. with a group of volunteers for official standby security duty. We arrived in Washington early Friday evening. I proceeded to the Capitol to see if I could see my friend, U.S. House Speaker John W. McCormack of South Boston.

The Capitol was under heavy guard and the members of Congress and their staff were visibly shaken by this day's events in Dallas. Mr. McCormack was not in his office, but several stunned staff people were there, talking about the shooting in Dallas. The Speaker was the next in line of succession if the President and Vice President died. I was in a military uniform, plus most of the staff knew me, so I was not someone with whom security people would be concerned. The Capitol offices were soon ordered closed and we were told that Mr. McCormack was at the White House and the motorcade bearing President Kennedy's body and President Johnson was on its way there.

Several of us were driven over to the White House and were allowed to wait immediately outside the main gate as members of the Kennedy family and the Cabinet arrived. We waited for the hearse to arrive with the beloved assassinated President in it. After standing outside the White House gates for a couple of hours, I then walked over to the Washington Hotel where Mr. McCormack and his wife Harriet had stayed. I left a note for Mr. McCormack with the desk clerk, expressing my profound grief and sadness.

Several days later, I received a call from Speaker McCormack telling me how much he appreciated reading my note that unforgettable night of November 22nd, just after he had returned from the White House where his deceased friend President John F. Kennedy had been brought back from Texas.

I stayed that night at The Catholic University of America dormitory with college friends. The chapel was filled with students the entire evening, praying and crying. The next week, I went home for a couple of days for the Thanksgiving holiday. While there, I met Boston Globe sports reporter Bob Monahan from South Boston who told me that his eight year old son had received a letter from President Kennedy which arrived at his home on November 22, 1963 at 3pm, just as his son was coming home from school. To this day, that eight-year-old boy knows exactly what happened on that day many years later and so did this G.I.

RAYMOND L. FLYNN *is a former Massachusetts state rep-resentative, mayor of Boston and U.S. ambassador to the Vatican. A best-selling author, Flynn is national president of Catholic Alliance of Washington, D.C. & Boston and hosts a daily political radio talk show in Boston.*

DANIEL PETRIE

On that crisp fall day I drove from Ardley, NY, to Goshen, NY, to have lunch with old friend and collaborator Frank Gilroy, the playwright. Frank lived near Goshen's harness-racing track that formerly housed the annual championship race the Hambletonian—the harness-racing equivalent of the Kentucky Derby.

Frank and I sat in the clubhouse restaurant by a huge picture window that overlooked the track. Since it was off-season, there were only a half-dozen or so horses and drivers working out. Even though there was no race, there was excitement in the high-stepping trotters and pacers. The weather was idyllic, the setting delightful. It was one of those "good to be alive" days.

Seated near us was a portly gentleman whom Frank identified as the editor of the Goshen weekly newspaper. We became distracted from the colorful activity on the track when a waiter hurriedly approached the editor and told him—loud enough for us to hear—that he was urgently wanted on the telephone. The editor was back at his table in what seemed like seconds, looking stricken. He threw some bills on the table, and as he turned to leave he looked at us and in the softest, most anguished whisper said, "President Kennedy has been shot!"

Frank said, "Follow me. I'll guide you back to my house." As we drove out of the parking lot, I turned on the radio. The news was bad. The President had died. No matter how I tried to suppress my tears, they continued to flow, to the extent that I couldn't see to drive. Everything blurred. I drove onto the shoulder as I desperately blew the horn at Frank for fear I'd be lost along those country lanes. I bent over the steering wheel. After a while, Frank's car returned. He pulled to a stop on the opposite side of the road. We both sat there, across from each other, for a long time.

DANIEL PETRIE *has produced and directed many acclaimed TV movies, such as* Sybil, My Name Is Bill W. *and* Wild Iris; *he won Emmys for* Eleanor and Franklin *and* Eleanor and Franklin: The White House Years. *His feature credits include* A Raisin in the Sun *and* Resurrection.

November 21, 1963 · Actor Henry Morgan Voices Opinion on divorce law

Dorothea G. Petrie
— PRODUCTIONS —

On November 22, 1963, the Petrie family was living in Irvington-on-Hudson, New York. That morning, I was doing errands, and the car radio was on. Suddenly the music was interrupted, and it was announced that President Kennedy had been shot in Dallas, Texas. All the announcer knew was that the motorcade had been fired on and that President Kennedy had been hit. Almost unable to breathe, I turned around and started for home. I thought, "This can't happen in America - he'll be fine." Our young son was sitting in front of the television when I arrived. He was watching the news, tears streaming down his face. President Kennedy was dead.

Dorothea

DOROTHEA G. PETRIE *began as an actress and has since produced such TV movies as* Love Is Never Silent, Foxfire, Caroline? *and* The Echo of Thunder.

JFK: This shows a rate of economic growth and therefore, it is not with too much concern that I say a raise from 25 to 35 is not completely out of accord, when compared with the current financial deficit on hand. Now, I trust that answers your question about your weekly allowance, Caroline. Next—next question.

Jackie: Yes. I should like to ask a question about—

JFK: Would you please stand?

Jackie: Yes. I should like to ask a question about—

JFK: Would you identify yourself, please?

Jackie: I'm your wife...I notice that you didn't touch your salad, either at dinner tonight or at dinner last night. Would you tell us why, please?

JFK: Well, let me say this about that. Now, number one in my opinion, the fault does not lie as much with the salad as it does with the dressing being used on the salad. Now, let me say that I have nothing against the dairy industry. However, I would prefer—I would prefer it if in the future we stuck to cole slaw. Next? Next question—yes, the baby in the back row, baby John?

Baby John: Da da da goo da, dee goo da da.

JFK: Well, I—I believe I answered that question at dinner last night.

(from "The First Family," produced by Bob Booker and Earle Doud, featuring Vaughn Meader, Cadence Records, 1962)

November 21, 1963 - Bunge Corporation announces that millions of pounds of soybean oil missing in New Jersey

Kennedy seemed the right man for the right time—cool, confident, stylish—but there was more. Leamer wrote, "He was an immense puzzle of a man, his character so complex that no matter how one turned the pieces around and tried to put them together they never quite seemed to fit."[7] Sorensen, remembering his early days with then-Senator Kennedy, wrote, "Gradually I discovered that the simplicity of this man's tastes and demeanor was, while genuine, deceptive as well as disarming."[8] With youth and passion on his side, Kennedy sought out and surrounded himself with the best and brightest young minds as staffers and advisers and, in turn, this New Frontier inspired a generation of young people to become interested in politics. He was constantly searching for information, viewpoints, differing opinions, and demanded to be on top of all the particulars and functions of the government. In short, as Hugh Sidey wrote, "He wanted all the lines to lead to the White House, he wanted to be the single nerve center."[9]

At the Thomas dinner, Kennedy told the crowd: "Your old men shall dream dreams, your young men will see visions, the Bible tells us. Where there is no vision, the people perish." When he was finished, the President and Mrs. Kennedy left the Coliseum and headed for the airport, bound for Fort Worth, continuing to lay the groundwork for a victory in 1964.

November 21, 1963 - Ex-Nazi officer who arrested Anne Frank reveals she was betrayed by former Dutch employee of the Franks

3
Wanted for Treason

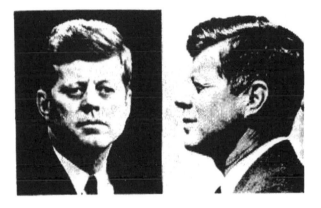

WANTED

FOR

TREASON

THIS MAN is wanted for treasonous activities against the United States:

1. **Betraying the Constitution (which he swore to uphold):**
He is turning the sovereignty of the U. S. over to the communist controlled United Nations.
He is betraying our friends (Cuba, Katanga, Portugal) and befriending our enemies (Russia, Yugoslavia, Poland).

2. He has been WRONG on innumerable issues affecting the security of the U S. (United Nations-Berlin wall -Missle removal - Cuba. Wheat deals -Test Ban Treaty, etc.)

3. He has been lax in enforcing Communist Registration laws.

4. He has given support and encouragement to the Communist inspired racial riots.

5. He has illegally invaded a sovereign State with federal troops.

6. He has consistently appointed Anti-Christians to Federal office: Upholds the Supreme Court in its Anti-Christian rulings.
Aliens and known Communists abound in Federal offices.

7 He has been caught in fantastic LIES to the American people (including personal ones like his previous marraige and divorce).

By the time Kennedy arrived in Texas on November 21, hand-bills had been distributed around Dallas which featured a sher-iff's-type poster of Kennedy with the headline "Wanted for Treason" and a list of his "treasonous activities," such as "betray-ing the Constitution" and "turning the sovereignty of the U.S. over to the Communist controlled United Nations." The November 22, 1963 *Dallas Morning News* featured an advertise-ment from The American Fact-Finding Committee, which also accused Kennedy of treason and asked questions such as "WHY has Gus Hall, head of the U.S. Communist Party, praised almost every one of your policies and announced that the party will endorse and support your re-election in 1964?" and "WHY have you scrapped the Monroe Doctrine in favor of the 'Spirit of Moscow?'" Seeing these headlines prompted Kennedy to remark, "We're heading into nut country today," and he observed that the previous evening at the Coliseum "would have been a hell of a night to assassinate a president...There was the rain, and the night, and we were all getting jostled. Suppose a man had a pistol in a briefcase...Then he could have dropped the gun and the briefcase and melted away in the crowd."[1]

I have a rendezvous with Death

At some disputed barricade,

When Spring comes back with rustling shade

And apple-blossoms fill the air—

I have a rendezvous with Death

When Spring brings back blue days and fair.

November 21, 1963 · JFK to present Robert Oppenheimer with Enrico Fermi Award on December 2

It may be he shall take my hand

And lead me into his dark land

And close my eyes and quench my breath—

It may be I shall pass him still.

I have a rendezvous with Death

On some scarred slope of battered hill,

When Spring comes round again this year

And the first meadow-flowers appear.

God knows 'twere better to be deep

Pillowed in silk and scented down,

Where love throbs out in blissful sleep,

Pulse nigh to pulse, and breath to breath,

Where hushed awakenings are dear...

But I've a rendezvous with Death

At midnight in some flaming town,

When Spring trips north again this year,

And I to my pledged word am true,

I shall not fail that rendezvous.

(Alan Seeger, "I Have a Rendezvous With Death,"
one of John F. Kennedy's favorite poems)

November 21, 1963 - Pop artist Robert Rauschenberg ends show at New York's Leo Castelli Gallery

Peace Corps:
The Vision of a Great Man

The legacy President Kennedy left by virtue of the Peace Corps is immeasurable. The legions of great men and women who have served in the Peace Corps and now serve others in public and private life can be attributed to President Kennedy's vision. Kennedy's belief that there is enough know-how in America and enough knowledgeable people willing to help nations help themselves continues to drive the Peace Corps and the Peace Corps Volunteer today. [1]

President Kennedy was truly one of the great visionaries of our time. His belief of what was good for our nation and what could be good for the world is the premise on which the Peace Corps was built. A premise that can be defined as an understanding of the innate quality of mankind and American goodwill.

As a son of parents who had been migrant farm workers, I explored my world in search of a hero. I was seeking someone who could inspire me to believe in my human potential and realize my dreams. President Kennedy was that hero. Through his words and his vision, I came to understand the value of coupling hope with hard work. As a child, my father taught me a Bible scripture that says, "Where there is no vision, the people perish." President Kennedy had vision and through him many were inspired to a life of service to others. The day Kennedy died was the day I not only lost my President, but my hero as well. Through our work today thousands of Peace Corps staff and volunteers sustain and expand on President Kennedy's legacy of service to those in greatest need.

President John F. Kennedy provided me with the inspiration to public service that has become my life's work. His death affirmed to me that not even an assassin's bullet could deter the ideal and importance of public service that is crucial in our time. President Kennedy's inspiration of becoming the world's leader for peace and giving to one's fellow man continue to resonate today. The tool he suggested to meet this end was and continues to be the Peace Corps. His words remain and drive the Peace Corps in the 21st Century:

> "Give me a fulcrum," Archimedes is reported to have said, "and a place to stand and I will move the world." The tools I have suggested can be our fulcrum—it is here we take our stand—let us move the world down the road to peace.[2]

Perhaps the greatest legacy that President John F. Kennedy gave to America and the world was the founding of the Peace Corps. Kennedy inspired a cadre of young people to not only give up two years of their lives to serve, but to give up the comforts of hearth and home to face an unknown world abroad. President Kennedy was able to tap into that special something that can only be described as the American Spirit to inspire all Americans to look to something greater than themselves. That spirit is what Kennedy captured when he created the Peace Corps and that legacy lives on to inspire Americans today.

1 Speech of Senator John F. Kennedy, Cow Palace Auditorium, San Francisco, California, November 2, 1960.
2 op. cit.

GADDI H. VASQUEZ *was nominated by President George Bush and sworn in as director of Peace Corps in 2002. He had previously worked as division vice president of public affairs for the Southern California Edison Company and was involved in numerous community organizations.*

JERRY LEWIS

Jack and Dean Martin and I struck up a marvelous friendship when we were playing in Chicago at the Chez Paree. Jack had just gotten out of the service and was staying at the Ambassador East Hotel on the 12th floor, where Dean had his suite and I had mine. It was a three-suite floor—Dean, John Kennedy and myself—and we became very, very good friends. Not so much Dean because he was really into golf and he didn't stay out at night—he had to be in bed early so he could play at seven in the morning—and Jack and I had all the nonsensical evenings and the fun. Jack was not married at the time, so we let him meet some of the nice ladies in the chorus that we were working with, including Helen O'Connell, and he was just smitten with Helen. We made sure that everything was nice and comfy and we had just the best time. One night, he came in to see me and he said he'd just titled a thing he was going to write called *Profiles in Courage*. The reason I remember it is because I was writing some material at the time for Dean and myself, and I had my stuff out on a desk and I just wrote it down. I thought it had such a wonderful sound to it and never thought about it again until, of course, he sent me a copy years later.

When Jack was stomping for the presidency, I made it clear that I would love to do what I could. Jack asked me to meet him in Los Angeles at the Polo Lounge in the Beverly Hills Hotel during the campaign. He said to me, "I don't want you to stomp for me—please don't do that. I don't need you to do that and you will just put yourself in terrible jeopardy." I said, "Jack, what the hell are you talking about? I'm a citizen of this country, I have every right to do what I want to do." He said, "Yeah, but come Labor Day, every Republican will turn on you and you'll hurt your kids." I never thought of it. So, I didn't stomp, as he requested. But once he became President, I was flown from Dulles on Marine One, the chopper, and was picked up, taken to the Rose Garden, and went down into the bowels of the White House per the President's wishes. And that was the only way he would meet with me in the

Oval Office—the press never knew I was there. And we did that six or seven times throughout the beginning of his Presidency. The press never knew of our friendship—ever. It was amazing because I went into Hyannis Port the same way, in disguise or at night, and that was the way he wanted it for me. It was all for me—it had nothing to do with him.

He was that caring and he believed so much in what I did for my kids all year. He knew of my involvement, he knew what I was doing with MDA and he knew that was something I wouldn't ever put in jeopardy if I could help it. I was getting frustrated because I recognized that organizations like the Ford Foundation would give $400 million to a particular area and then all of a sudden, a vaccine would be found. So, I went to Jack and said, "According to my understanding, as a citizen of this country, I have a right to ask for an audience with the Congress if my particular reason for being there is in the best interest of the public." He said, "There is that rule. I could probably get you to do that." I said, "I've got to do that—if I can borrow $500 million, I can get it back in maybe ten telethons." He said, "I'll do it for you, but understand something. You can get on the phone right now and order a wheelchair and it'll be delivered to that child's home tomorrow at nine in the morning. You will never have the opportunity to do that again. Congress will be your partner and they will write a requisition and you'll never get a wheelchair to a child. Do you want that?" I said, "I think I'll continue to do it the way I'm doing it." And here we are now—$1.8 billion later. And he was right.

I had never seen Jack Kennedy more emotionally touched by something that someone was doing, mainly by what I did every year with MDA. He always spoke to Ethel about what he thought she could do, and the boys and the family, to help me. He was noble, he was meaningful, he was bright—Jesus Christ, he was bright. He had the mind of a Rhodes Scholar and treated it lightly because it was funny to him. Always great stamina, tremendous spirit and energy. Both Jack and I suffered desperately with our spinal columns—his problem was not unlike mine. I played golf with him and the swing that he

would have to take was devastating because it diminished him as a man. And we used to talk about that. I said, "Jack—I'll let you meet some of my kids that can't hold a golf club." He always called me "The Preacher" when I would get on something like that. He'd say, "Oh—the Preacher's arrived. And a Jew preacher is the worst!"

He had a plaque at the White House, a gift from a foreign government which apparently said something meaningful had you been able to read it, and I used to tease him about it. The last time I was at the White House, he gave me a gift—he duplicated the look of that wonderful plaque and it said: "There are three things that are real—God, human folly and laughter. Since the first two are beyond our comprehension, we must do the best we can with the third." And then it said, "Love, Jack."

The last show John Kennedy saw before he died was mine—I did his last birthday at the Armory in Washington. And he was dead a short time after that. I was at Paramount, in my office, and I was in final post-production on *The Nutty Professor*, just before shipping. And someone ran in to interrupt and said they had heard it had happened and, of course, we threw every television set on we had. We caught the television at the time they were racing toward Parkland Hospital. My heart, of course, gets very heavy when I even think about it. I read a line that someone wrote: "The death of John Kennedy diminished us pretty good, but it wasn't as devastating as the thought of what might have been."

JERRY LEWIS *is one of show business' most beloved and respected talents, known for his partnership with Dean Martin and his solo film career as director, writer and star of classic comedies like* The Nutty Professor *and* The Errand Boy. *His annual Labor Day Telethon has raised nearly $2 billion for the fight against muscular dystrophy.*

TED BERGMANN

Early in 1963 several members of the board of directors of the National Association of Recording Arts and Sciences, NARAS, approached me to enlist my help in getting their annual Grammy awards on network television. After canvassing the networks it became evident that the last thing they wanted was another awards show, especially one whose awards were unknown outside of the record industry. One network executive asked if these awards were given to grandmothers. Since an awards show was not acceptable I decided that a "performance" show might be, and I created one titled, "The Best On Record," which would present ten top Grammy winners after the awards were announced, recreating their winning performances introduced by top stars associated with the record industry. I sold the show to Timex through their advertising agency, Warwick & Legler, who bought time on NBC.

The first show was introduced by Frank Sinatra and included Bing Crosby, Dean Martin, Eddy Arnold, Andy Williams and others as presenters and Henry Mancini, Tony Bennett, Steve Lawrence and Eydie Gorme, and Vaughn Meader among the performers. The show was taped in New York and Burbank, and was delivered to NBC the week of November 18th to be aired Sunday night, November 24th from 10 to 11 p.m.

On Friday morning, November 22nd, my lawyer and I walked down Madison Avenue headed for the Timex attorney offices when we observed Bill McDaniel, the president of the NBC radio network, running up Madison Avenue toward 49th Street. I asked him why he was in such a hurry and he shouted "the President has been shot in Dallas."

We continued to the Timex lawyer's office to find the entire staff clustered around a portable radio listening to the tragic news from Dallas. Kennedy had died. When the shock began to wear off that afternoon, we knew we had a problem. The network cancelled all shows for that weekend including ours. Additionally, the Grammy winner for the best comedy album "The First Family," Vaughn Meader, was on our tape doing a hilarious impersonation of President Kennedy. Obviously, this had to be removed before the show could air. The show was rescheduled to air two weeks later by which time we had replaced Vaughn Meader with a performance by Tony Bennett.

TED BERGMANN *was a pioneering television executive and Vice President of Television at the advertising firms of McCann-Erickson and Ted Bates; he was also President of Parkson. He later formed his own production company, with the first annual Grammy Awards shows, "The Best on Record," and "Three's Company" to his credit.*

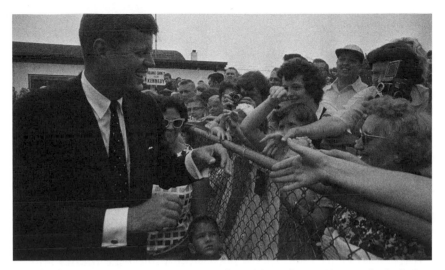

Just before 10:00 a.m. on November 22, John F. Kennedy left the Hotel Texas in Fort Worth, where he and his wife were staying, to greet crowds standing outside in the parking lot. A light rain fell. "There are no faint hearts in Fort Worth, and I appreciate your being here this morning," he said. When people in the crowd asked, "Where's Jackie?" he replied, "Mrs. Kennedy is organizing herself. It takes a little longer, but of course, she looks better than us when she does it." Kennedy returned to the Hotel Texas for a breakfast with business leaders sponsored by the Fort Worth Chamber of Commerce. The First Lady made a fashionably late appearance, wearing a pink two-piece Chanel suit with navy blue lapels, white gloves and a pink pillbox hat. John Kennedy began his speech: "Two years ago, I introduced myself in Paris by saying that I was the man who had accompanied Mrs. Kennedy to Paris. I am getting somewhat that same sensation as I travel around Texas. Nobody wonders what Lyndon and I wear." Before this, President of the Fort Worth Chamber of Commerce Raymond Buck presented Kennedy with a cowboy hat. When asked to put it on, the President politely declined, saying he would wear it back at the White House and that, "I hope you can be there to see it."

November 22, 1963 • *The Lion, the Witch, and the Wardrobe* author and Anglican scholar C.S. Lewis dies at 65

GERALD MCRANEY

November in South Mississippi can still be warm enough for high
school students to reasonably complain about their school's lack of air-
conditioning. And so it was in 1963. The school day progressed with
jokes. They had to be joking, someone said that the president had been
shot in Dallas—hit in the shoulder and only slightly wounded (Texans
couldn't shoot anymore) was the latest story. A lot of the school kids at
that time mimicked their parents' opinion of civil rights and were not
fond of JFK. Two years later, this school would integrate totally and
without incident.

Later in the day, in Mrs. Hughes' debate and speech class, the joking
stopped. It wasn't a slight shoulder wound. The President was dead.
Now there was only shock and silence. Mrs. Hughes sat behind her
desk and quietly wept. I wasn't even thinking about the man who
championed civil rights; I thought of the man who, along with his wife,
was cheered throughout the world as he traveled, representing our
country. Who proclaimed for all of us that, as a free man, he too was a
Berliner, a man whose wit kept the press and public in stitches, and
whose Massachusetts accent had every impersonator doing jokes about
the tiny island 90 miles from Florida called "Cuber."

We all walked around with our thoughts for the rest of the day. The
remaining classes were a waste of time, but we moved at the sound of
the bell like zombies to the next one. The jokes had stopped. It seemed
like speaking had stopped.

Finally, the last bell sounded. Time to go home. That usually meant a

walk about a mile for me. This day, however, as I came out into the sun with the other zombies, I saw my father's yellow Dodge station wagon. My father, who was no fan of the Kennedys, was waiting to take me home.

My father, like a lot of southerners at the time, hated Kennedy's stand on civil rights. "Those damned Yankees ought to mind their own business, clean up their own backyard, and leave us to sort out our own problems."

He had admired Kennedy's stand against the Russians over the missile crisis, but it had been after all his weakness at the Bay of Pigs that had caused the Soviets to test our resolve. He was also convinced that Kennedy had been leading us into another Korea in a small Asian country called Vietnam. In short, politically, my father disliked Kennedy quite a lot. Politically.

I sat in the passenger seat and waited (for what exactly I didn't know.) My father sat in the grim silence, his jaw muscle working quickly, as it did only when he was enraged. We sat this way for what was probably five minutes, but it seemed to be an eternity. Then I witnessed an outburst, the likes of which I had never seen from my father and have not seen since, as he repeatedly banged his fist into the steering wheel and said, "God damn it! God damn it! He was the President of the United States!"

I don't remember much of the rest of that day. We knew that the killer was some little loser from over in New Orleans named Oswald, who was a communist and Castro supporter.

That Sunday, after church, we watched as he, in turn, was killed on national TV. We watched the day of the funeral, the first time I remember hearing "Hail to the Chief," and will always think of that time when

I hear it today (even when it is played for a friend.) The country's disbelief that one little loser could have done this thing began then.

I would later live in New Orleans when Jim Garrison would try to prove that the little loser had not acted alone. His target – a New Orleans businessman who was on the board of the repertory company that gave me my first acting job. Garrison proved only that Clay Shaw was gay, something that most people around him already knew. But such was the obsession that greatness could not have been undone by pettiness. There had to have been a conspiracy.

Years later, as I sat in an ADR stage putting the final touches on a TV pilot called "Simon & Simon", I heard the news that another President had been shot; this time it was Reagan. I remember my father's jaw working and his swearing rage. Reagan was in the hospital, his shooter in custody. Someone in the room (I didn't remember who) who didn't like Reagan joked that this guy in Washington sure couldn't shoot very well. And I thought that after John Kennedy and then his brother Robert and Dr. King, that the country and this fellow in particular had become pretty cynical about assassinations. I felt my jaw muscles working and my fist clench.

I approached the joker as I felt these things, but I backed off. I realized that he was probably just too young to remember the awful, empty feeling when the joking stops.

GERALD MCRANEY *is best known to TV audiences as one half of the private eye team on "Simon & Simon" and as the title character on "Major Dad." He is married to actress Delta Burke.*

November 22, 1963 · Labor Party wins decisive victory in Dundee, Scotland

Congregation of Notre Dame

I was 15 years old when John Fitzgerald Kennedy announced his candidacy for president of the United States. I was in my second year of high school in Waterbury, Connecticut, a factory town and Democratic stronghold. That summer I had the opportunity to spend a week in New York City at Fordham University studying leadership with other teenagers. All I could talk about was the campaign for president. I was excited and enthused about Kennedy's bid. It was the first time I remember getting into the political life in discussions, reading and thinking. Another teenager at the training gave me a large Kennedy button. I hadn't seen any other buttons that big. I wore it every day.

When I returned to Waterbury, my older sister, who had just graduated from high school, borrowed the button for a trip to Cape Cod, Massachusetts. While she was there, she and her friend were looking at a sunset on a golf course in Hyannis when John and Robert Kennedy came off the course. They saw the button, came over and shook hands and thanked her for wearing the button.

I reclaimed my button when she returned and kept up my own little campaign into the fall. John Kennedy was young, happy, smart and

idealistic. He sparked a hope in young people and a belief that we could make the world a better place for all people. He encouraged sacrifice and inspired generosity of spirit.

One night in September of 1960, as the Kennedy campaign had built a strong momentum, John Kennedy came to Waterbury for a campaign stop. He was due in at 9 p.m. With all the teenagers in my church youth group, we went down to the center of town early that evening to wait. There were thousands of people waiting. His motorcade was delayed and he did not arrive in Waterbury until 2 a.m. No one had gone home. We were all still there. When John Kennedy came out on the balcony of a local hotel to greet the crowd at that hour of the morning, he quipped. "Either Waterbury has nothing going on at this hour of the night or it has the best Democrats in the country."

John Kennedy's victory in November was one of the most exciting moments in my political life. My younger brother took over the button in celebration of the victory. The snowy day in January where a bareheaded young man became president surrounded by his young family, the poet Robert Frost and cheering Americans is etched in my memory. He was one of us. I have probably never again felt such hope for all of us as a country.

His short time as president coincided with my finishing high school and beginning life as an adult. The Peace Corps, the civil rights movement, the war on poverty, the challenge to reach out to others brought out the best in American youth.

A bullet in Dallas seemed to shatter all the hopes and dreams. For a time it did. As a young teenager, I thought John Kennedy was perfect. As an adult, I know no one is perfect. John Kennedy had only a short time as president, yet his accomplishments continue. Some are measurable, like the Peace Corps. Many are unknown. They rest in the hearts of people like me who were formed into service and idealism at a time in our country when it was encouraged from many sources—family, religious, social and political. John Kennedy's zest for life was contagious and I caught it.

SISTER PATRICIA MCCARTHY *is a member of the Congregation of Notre Dame and has worked with the poor in the field of education for over 30 years. She has lectured in the United States and abroad on nonviolence and has published five books, including the award-winning* The Word of God, The Word of Peace.

Bel-Air Country Club

The day J.F.K. was shot — I
was trying to see patients in my office
in Malibu — I had to let my secretary
go, she was incapacitated. I was in
auto pilot mode and did only serious
cases.

I met JFK 1st in West Virginia
during a fund raiser — I was an intern.
I saw him again in southern California
after my training. I revered the man.

I was with Bobby — Malibu — two
days before he died.

JFK represented much more than the person he was, and we all needed it.

I still get some reaction when he is talked about, and I'll never forget those days following the shooting — gloom — sadness —

David Boska, M.D.

DAVID A. BOSKA, M.D. *is a member of the UCLA Clinical Faculty and senior medical examiner of the Federal Aviation Association. He was president of the Bel Air Country Club.*

Kennedy spoke to the Chamber of Commerce crowd about the role that Fort Worth played in the country's national defense. He discussed the responsibility that the United States had in the world arena: "Without the United States, South Vietnam would collapse overnight. Without the United States, the Southeast Asia Treaty Organization alliance would collapse overnight. Without the United States, the CENTO alliance would collapse overnight. Without the United States, there would be no NATO. And gradually Europe would drift into neutralism and indifference."

The political world had become a much darker and more complex place than it was when Kennedy officially entered the arena in 1948. Since his election in 1960, the United States' economy was strong, the gross national product was up and the country had come through the unimaginable nuclear threat of the Cuban Missile Crisis and signed the Nuclear Test Ban Treaty. Kennedy had altered the U.S.' hard-line stance against Russia, famously proclaiming in a June 10, 1963 American University speech, "No government or social system is so evil that its people must be considered as lacking in virtue." But Kennedy had not fared well with Congress, and despite honorable initiatives like the Peace Corps and the Alliance for Progress, increases in minimum wage and Social Security benefits, other legislative endeavors had been mired in the logjam of conservative Republican and Southern Democrats. Sidey noted that, "the obstinacy of Congress began to show more than ever and the congressional lethargy continued to grow until, by fall of 1963, it was one of Kennedy's biggest problems."[2] In November, Kennedy's tax cut bill had been rejected by Congress, the Civil Rights Bill delayed by the House Judiciary Committee and his proposed $4.5 billion foreign aid bill severely reduced in what Kennedy described at a news conference as "the worst attack...since the beginning of the Marshall Plan." In addition, there was the ever-nagging and

November 22, 1963 • A video message by President Kennedy taped on November 20 is transmitted to Japan from the U.S. via communications satellite, the first Trans-Pacific telecast to Japan

ill-defined American presence in Vietnam that worsened with the assassination of the anti-Communist Ngo Dinh Diem and his brother, Ngo Dinh Nhu, and inconsistent reports about plans for the removal of American advisers and technicians there.

Reporter: The Republican National Committee recently adopted a resolution saying you were pretty much of a failure. How do you feel about that?

Kennedy: I assume it passed unanimously.

(from press conference, July 17, 1963)

November 22, 1963 - Widow of late Sen. Joseph C. O'Mahoney of Wyoming dies at 77

BAST/HUSON PRODUCTIONS

On a fine April day, seemingly no different than any other, a young boy's teacher announced to her class in a quavering voice that President Roosevelt had died, and sent the children to their homes. Roosevelt had been President all of the boy's young life and, deprived of his own father, had become something of a father figure to him, someone to trust and respect, someone to admire and look up to. The death of the President was, understandably, a devastating blow to the young lad, so devastating that he cried all the way home from school on his bicycle to tell his mother the unthinkable news.

As the boy matured into manhood, he wasn't so easily given to hero worship, having learned to question leaders and authority figures before investing his loyalty in them. It wasn't until John Fitzgerald Kennedy came upon the political scene and ran against Richard Nixon for the presidency that the young man's attention was once again focused on someone he felt he could consider worthy, but still only possibly worthy, of his trust. After all, Senator Kennedy was relatively unknown, certainly in the mid-West. His aura had not impinged upon the young man's consciousness, had not awakened his passion. But the day Senator Kennedy became President, it struck the young man that this vigorous young politician transcended the commonplace, as he delivered possibly the most inspiring inaugural address in the history of this nation. And, suddenly, the young man was filled with a great new passion, a belief in the future.

Then, for the second time in the young man's life, the world stopped and time stood still. He looked up from his morning papers as news of President Kennedy's assassination was delivered on television by an otherwise imperturbable, but now visibly shaken Walter Cronkite.

The shock, the anguish, the desperate sense of loss that day had never been eclipsed for the now aging man, not until he witnessed, in a spectacle of overpowering horror, the stately twin towers of the World Trade Center collapse in a holocaust of madness before his eyes and the eyes of the world. But it was the living picture of two people, a man and a woman, as it appeared, preferring to escape the inferno inside by leaping hand in hand to their death from a hundred stories in the air, that broke the heart of this son of America for the third time.

He closed his eyes and saw the awful image of President Kennedy clutching at his shattered throat, the throat from which such inspiring eloquence had issued and given rise to his belief in the future, and he grieved once again for all the lost heroes. And his country.

WILLIAM BAST *has written for countless TV series in the U.S. and abroad. He has also written and produced TV movies such as* The Legend of Lizzie Borden *and* James Dean—Portrait of a Friend *(adapted from his book), as well as several series and mini-series.*

NEWLAND-RAYNOR PRODUCTIONS, INC.

To explain in an understandable way the emotional turmoil which invaded my mind, body and soul upon hearing of the savage murder of President Kennedy, and how it affected my life, requires a brief description of who I was at that time and the causal philosophical relationship which existed between the President and myself.

I was brought up in Chicago in an activist union home (my father was a moving picture operator in a small movie house... now he would be called a "projectionist" – a strong supporter of IATSE, his union). We were loyal members of the Democratic Party.

I grew up through the 1929-33 depression and saw the ugly face of poverty and discrimination. After graduating from the Northwestern University School of Law, I expanded my participation in causes dedicated to fighting these evils, not withstanding some big clients of the firm didn't like my agenda. In 1946, I helped form the Chicago Action Council, consisting of ten (10) young, successful men and their respective wives. Since we were privately financed, we could take on issues that other organizations, dependent on charitable contributions (which were tax deductible) couldn't touch because they would lose their charitable designation.

We fought every "hate person and group", such as Gerald L.K. Smith; "We The Mothers"; X-RAY Publications (whose magazine was filled with anti-Semitic garbage); etc. And then a rich guy from Massachusetts was elected to the U.S. Senate. He spoke the words we did and he walked the walk to back them up. It was hard to believe that here was a man who was sensitive to the plight of the poor and although Catholic supported a woman's right to choice. He refused to take money from the fat-cat lobbyists who used contributions to buy favors for their large corporate clients. The net result was NO OBLIGATIONS. So when he declared he would run for President of the U.S., we all jumped on the bandwagon and really went to work for him. AND WE WON! The opposition tried to spook our campaign by repeatedly saying that Kennedy would be taking orders from the Vatican, but it didn't work. We were a very happy bunch of campers since our beliefs in Kennedy had been vindicated.

After the election, I took my family to Washington D.C. for the inaugural. No living person will ever forget the famous line the President delivered that day in his speech: "Ask not what the Country can do for you, but what you can do for the Country". I still get goose pimples.

My birthday is November 18th and 1963 represented a big zero one for me (in strict confidence, not to be revealed, it was my 50th birthday). Since most of our dear friends, political associates and relatives still lived in Chicago we decided to throw a big birthday bash there.

On November 22nd we were invited to lunch at a restaurant on Michigan Avenue. Our lunch was going great when suddenly the manager stopped the proceedings to tell us " OUR PRESIDENT HAS BEEN SHOT!" The quiet in the room was deafening — people taking time to grasp the content of the message. Then came chaos — shouting for more information – is he going to live? – Who did it? – Is Jackie O.K.? – Tears were flowing – mine included, but I was in another world. Who would do this? – Who wanted Kennedy killed? – Always look for the motive – follow the money or who would gain from this savage, crazy act. Was it the mob because they hated Bobby Kennedy who while serving as U.S. Attorney General was attacking them. It couldn't possibly be Lyndon Johnson, V.P., even though he wanted nothing more than to be President. NO! Without a doubt there was some kind of conspiracy to get rid of a leader whose policies and goals were very disturbing to some other group!!!

We ran back to the hotel and were glued to the TV set, where we watched and prayed. When they interrogate the "crazy killer" they will get us plenty of information. And then came the doctor, all in white, to tell us, all of us, that our President had died. It was just too much for my brain to handle. I sat there dumbfounded. For the first time in my life I wanted to form a posse and lynch the killer. What a tragic waste. A brilliant leader – a good man for all. They stopped his voice. Who? Why?

Then the next great shock appeared before my eyes and senses --- a little fat man named Jack Ruby suddenly arrives in the hallway where the police were moving Lee Harvey Oswald to another location, and shoots and kills him. Ruby, by his act, destroyed forever the possibility of our learning who really was behind this tragedy. Who is Ruby and how did he get into this guarded area? So many questions but no answers ---- Ruby remained silent until his death. The jigsaw puzzle was not resolved by the appointed " Warren Commission", whose report was nothing more than a white wash.

Our V.P., Lyndon Johnson, has become our new President. He was politically aware and knowledgeable, but lacking in experience with respect to foreign affairs. The Vietnam War tore him asunder. It was a trying divisive time.

Our real and sincere hope for the future vested in Robert Kennedy, JFK's younger brother. The Kennedy charisma and charms were there and his platform, although tougher in some respects, still contained the magic language that protected and assisted all people in our country.

It seemed impossible yet we all know anything is possible. Bobby Kennedy was on his way to the Presidency when he was shot down in the corridor of a Los Angeles Hotel. Once again our lives went into a deep fall ---- chaotic and angry ---- no "rage" is a better descriptive word. Again the question --- who was behind this savage act?

I decided the time had come for me to withdraw from the political battles but found it very difficult to do so. I looked to the future with faith but also with trepidation.

I rest easier because our side has a new and powerful ally, namely: our kids are ready for the passage of the baton to them. They will carry on the fight, and I know we are in good hands. And so is the American way. We shall survive as a true democracy.

Ted Rayon

MILTON T. RAYNOR (TED) *practiced law in Chicago before becoming president of Sports Programs, Inc. He was later executive vice president of Commonwealth United Entertainment, Inc., and a partner in Newland-Raynor Productions, which produced such TV movies as* Arch of Triumph *and* Timestalkers.

November 22, 1963 - Ecumenical Council in Rome sets plan for promulgation of a dogmatic constitution, the first since 1870

THE KENNEDY THAT I KNEW

On the day that John F. Kennedy was murdered in Dallas, the world seemed to come to a dead halt. Millions mourned this young man as though they had lost a close friend. And for many people today, Kennedy lives on as vividly in memory as he did in life itself.

I first met Mr. Kennedy in late September of the year 1940.

It was the twilight of a fine California day on the Stanford campus when he and Bruce Jessup, the new student-body president, pulled into the unkempt driveway of the Kappa Alpha house to pick me up. I had expected Jessup alone and on foot, so was surprised to see him sweep up as the passenger in a brand-new cactus-green 1941 Buick convertible. The top was down, a laughing stranger was at the wheel, Jessup was laughing too, and, like many young men on the Stanford campus, they looked healthy and happy and rich. I looked that way myself.

As the heavy car crunched to a halt, I glanced into the back seat where six identical new books were slewed across the green leather. On each jacket, the title, *Why England Slept*, was superimposed on the British flag, and I knew immediately who the driver was. A week or so before, there had been an article in *The Stanford Daily* about Jack Kennedy's arrival on the campus, about his book, *Why England Slept*, and about his father's unwillingness to wear the traditional knee breeches when he presented his ambassadorial credentials to the King of England.

"This is Jack Kennedy, Harry," said Jessup, sliding over to make room for me on the front seat. It was the widest front seat I had ever seen in a car, and as I got in the skinny Irishman with the flat, smiling face leaned forward, cramped a long arm around the front of Bruce Jessup, and we shook hands. He said that he was glad to meet me, and I said that I was glad to meet him.

We swung down The Row, purring past fraternity houses at a good clip as they continued their conversation. I don't know how he drove when he got older, but in September of 1940 Kennedy drove too fast with no effort at all. We were on our way to a gathering at the Palo Alto home

of Dr. Edgar Eugene Robinson, a thoughtful, sedate professor of history.

Bruce Jessup, a mild-mannered politician just beginning his term as student-body president, was criticizing the failure of student government at Stanford. Kennedy responded immediately to the problem, explaining to Bruce that any government without power is naturally ineffective. He said that Bruce would have to find some genuine basis for power, and Jessup said that this could be done only by overthrowing the university administration.

I could tell now that neither of them would be interested in my iconoclastic view, so I just rode along, contributing nothing, breathing the pleasant odor of tar weed that suffuses the campus each fall, admiring the expensive metal dashboard of the Buick (it had a broken clock as big as a saucer), and listening to Kennedy.

Even when you didn't care much about the conversation, Jack Kennedy was compelling. He was quick to explain, to ask, and to consider. His sentences flowed spontaneously. Gags were naturally interspersed with the straight material. Illustrations and examples were brought in without effort from several locations and several centuries. I had never before heard one of my contemporaries *allude* to so many things. Learning later in the evening that Kennedy was two years older than I, I was relieved. That would give me a little time to catch up.

We arrived at Edgar Eugene Robinson's house to find about a dozen faculty members and a dozen students who could be classified as big men on the campus. It began with a cold-chicken-and-hot-coffee buffet, and then we all moved into the large, comfortable living room for a long, reserved bull session. I sat on an old-fashioned sofa between the economist, Elmer Fagan, and Clark Kerr, who then taught about the American labor movement at Stanford and who is now the President of the University of California at Berkeley.

We listened to one person, then another, and as the evening went on, we listened mostly to Kennedy. He didn't force himself upon us. The talk just seemed to move easily to him, and he responded.

I was surprised at the respect with which the faculty members treated the new arrival. Every once in a while I would get a nudge from

Elmer Fagan when Kennedy made what Fagan thought was a telling point. But nobody nudged Kennedy.

The subject, then as now, was war. Jack Kennedy's message for the remote Westerners was that there was a war on, that it had been on for a year, and that we were going to get into it. Jack Kennedy did not seem to be depressed by the news that he brought us. Even though the subject was solemn, he kept tossing bright humor into the exchanges, and several times he had the place roaring with laughter. Not only the students laughed. The faculty men were laughing, too. I sat there more envious of this skill than of his huge fund of facts, for although I was known around the campus as a capable comic, I had never been able to get a single laugh from Edgar Eugene Robinson.

As the gathering broke up, Kennedy filled the Buick with students for a drive down to L'Omelette, an elegant hangout for Stanford people on El Camino Real. He invited me to go, but I had to study, so I rode back to the campus with Bob Beckham.

"What did you think of Kennedy?" asked Beckham.

"Well, Henry Luce doesn't write a foreword for everybody's book," I replied. "I'd say the kid is a comer."

In September, 1962, on the night before the America's Cup yacht race, the Australian Ambassador, Sir Howard Beale, gave a dinner in honor of President and Mrs. Kennedy at Newport, Rhode Island.

The Australians, who were challengers for the Cup, had taken over The Breakers, the morose old Vanderbilt castle by the sea, for the affair. Three hundred guests were to gather at thirty round tables in the Great Hall, representing, according to the Newport *Daily News*, the cream of everything on the American scene.

I was there, too, but not representing the cream of anything. I was a workingman in black tie, getting material for the final touches on my script for an N.B.C. television special about the race.

At eight-thirty the President and Mrs. Kennedy arrived in a black 1961 Cadillac limousine, pulling in under a porte cochere at the bottom of a wide flight of steps that led up to the beveled-glass front door. Kennedy, tan and smiling, walked slowly, nodding to the left and right, repeating quietly,

"Hello...hello...good evening..." in a kind of generalized greeting.

I stood outside the great glass door so that the President passed a few feet away. I was surprised at his eyes. Twenty-two years before, they had been prominent, bulging eyes in a skinny face. Now they were set deep back in a massive head and almost hidden under the thick brows. I was surprised too at how big and heavy he was. I realized then that in spite of the thousands of photographs I had seen over the years, I was still carrying in my head the old live Palo Alto image of Jack Kennedy—the lanky young man perched on the edge of the chair, making a point with Elmer Fagan.

It was a splendid, sentimental, civilized evening, honoring a young President and his wife, and celebrating one of the oldest sporting events in the world. Kennedy's speech was lighthearted and completely in tune with the evening. Since he did not have to refer to test bans or tax cuts or Berlin or Khrushchev, he forgot them entirely, and concentrated on making the audience laugh. They laughed all the way, but nobody in the room enjoyed the speech more than Kennedy himself.

At the end of the program the three hundred guests stood up. Nobody had to announce to this company that they should remain in the position until the Presidential party had left the room. They knew. Escorting Lady Beale, the President came slowly the length of the head table, then walked down the long side of the Great Hall. I was standing between two Secret Service men in the wide doorway that led back out to the entry hall.

As Kennedy and Lady Beale moved toward us at a stately pace, an Australian general came up to her side, touched her elbow, and she paused to talk with him for a moment. Kennedy took a few steps beyond, then paused to wait for her. He stood alone, unable to go out the door without Lady Beale, and still very much onstage. He looked at the large waiting audience, smiled easily, then turned to look directly at me across a distance of about ten feet and said clearly, "Hello."

There was no doubt about it. Mr. Kennedy, caught in a minor social snag, wanted to talk with somebody. He had picked me. A President, as we all know, can never be left in public doing absolutely nothing. I walked

across the ten feet of polished floor, and we shook hands.

"Hello, Mr. President. The speech was delightful."

"I'm glad that you liked it. I'm glad we were able to come up here, too."

"Mr. President," I said, "I'm Harry Muheim—one of the eleven million Americans who knew you before you were elected and now expect you to remember them."

His face crinkled with enjoyment, then he cocked the big head to one side and said with a note of fake despair, "Where were *you*?"

"We weren't exactly close," I said. "But I rode with you in the green Buick one night out at Stanford—down to Edgar Eugene Robinson's place."

"Ah, yes...the green Buick," he said, considerately sidestepping the question of whether or not he remembered me. But he did remember the Buick. There was no doubt of that. His eyes looked up and off a bit to the left, his mind apparently going back across all the years and all the faces, actually trying to remember that dim night so long ago. After just a moment, he asked: "Whatever happened to Jessup?"

"He's still in Palo Alto. A pediatrician."

"Got out of politics, eh?"

"Yes, he did."

"Do you ever see him?"

"Now and then. Next time I'm out there, I'll tell him you were asking for him."

"I hope you do that, Mr. Muheim."

Mrs. Kennedy arrived with Ambassador Beale, and just before I stepped out of the picture, Kennedy turned back to me. Once again we shook hands. He said that it had been nice to see me. I said it had been nice to see him.

A year later, I was in New York when we got the hideous news about the Dallas motorcade. It came as I was standing between the Maysles brothers—Albert and David—in their film editing room at 53rd and Broadway. We were gathered in front of a clattering Moviola, using the machine to edit their film celebrating the 50th anniversary of IBM.

The first news came from a loud voice in the hallway—a shout repeating over and over that the President had been shot! The Moviola stopped. Everything stopped. Albert flipped on the small black-and-white TV screen. It was already carrying live coverage of the scene outside Parkland Hospital—chaotic and interminable—as the world waited for further news. Then Walter Cronkite appeared with the solemn announcement that the President was dead.

One of the production assistants broke into sobs, and David Maysles said quietly: "Things will never be quite the same again."

That night, I returned to my home in Washington, and three days later, I stood with my son, Mark, on Constitution Avenue waiting for the funeral cortege to pass. Kennedy was being taken to the rotunda of the Capitol, where he would lie in state.

First came the long string of black limousines, moving slowly, and then the riderless horse with the boots reversed in the stirrups, and then the six horses pulling the caisson that carried the flag-draped casket. A dozen soldiers, sailors and marines marched beside the caisson.

The huge crowd stood dead silent. Only the clatter of hooves and the roll of drums could be heard. As the caisson passed before us, Mark, who had just turned nine, tugged gently at my sleeve. I bent down to listen, and he whispered: "Is he really in the box?"

"Yes, Mark," I said quietly. "He's really in the box."

"That's too bad," said the little boy. He held tightly to my hand as we watched the caisson roll slowly up Capitol Hill.

HARRY MILES MUHEIM's *work as a writer ranged from scripts for "Philco/Goodyear Television Playhouse" and "Kraft Television Playhouse" to novels, screenplays, campaign TV spots and biographical profiles of Democratic political candidates. He also wrote nonfiction and informational/historical programs for ABC News, The National Gallery of Art and PBS.*

November 22, 1963 - Atomic Energy Commission announces low-yield nuclear test in Nevada desert

Bob Finkel

That Day

Memory has no Master. I was standing in the rehearsal hall at NBC watching with pride the rehearsal of "The Andy Williams Show" I was producing. Someone came into the hall and whispered in my ear... it was as if I was stabbed by a knife. Soon the whisper spread. The director turned to me... his mouth agape. The choreographer sat in a corner. The performers stood paralyzed...looking like statues...frozen. The dancers hung on the bar...some hung on each other. The singers huddled in the corner like frightened birds. The piano players left the room staring seemingly into space. I left and walked down the hall to my office...there was no noise anywhere...as if it was a television show and somebody had turned off the sound. The next day people returned to the rehearsal hall and went through their paces as if they were marionettes...gradually energy returned. But something had changed... something had forever changed.

Bob Finkel

BOB FINKEL *has been a producer and director of such variety shows as "The Andy Williams Show," "The Perry Como Show" and "The Dinah Shore Show" and he has produced many Christmas specials for Bing Crosby and John Denver.*

Barbara Fox

I was a girl of nine who had things on her mind like bluebird troop, skateboards and learning how to build a miniature dollhouse out of items that could be found in the kitchen.

I was playing outside in the school yard when fire alarms rang, signaling us to return to our classrooms. In a sober, unemotional style, our teacher told us what had happened…that the President had been assassinated. She seemed to be in shock. She was stoic and angry and instructed us to put our heads on our desks. We didn't get much of an explanation as to why we were putting our head down on our desks. We were left in the dark emotionally. The day felt like a big, black void…blank and empty.

Then I remember spending what seemed like an endless weekend with my family squished onto the couch of my grandparents' tiny apartment in North Hollywood, staring at the black-and-white TV coverage of the funeral. Not much was said. Every once in a while someone would utter a comment...mostly silence for what seemed like an eternity. But

the most memorable part was that my Nana stroked my arms for hours. That's what kept me sitting on the couch.

Years later, in high school, there was a JFK Presidential Physical Fitness Program. In reflecting on how JFK pushed himself to do the impossible while injured in war, I was inspired to push myself on to do the "impossible" required 50 sit-ups in a row...a miraculous feat for me at the time.

Barbara

Barbara Fox

BARBARA FOX *has pursued and participated in international peace activities for more than 30 years. She is President of The Interfaith Foundation, a nonprofit organization whose mission is to promote peace, culture and education through heart-to-heart dialogue and spiritual exchange programs in Cuba.*

November 22, 1963 - Berlin doctor accused of carrying out 18 illegal abortions, goes on trial

HARRY R. SHERMAN

The Writers Guild was on strike; as a result there was no work available in television or films. I received a call from Filmways to do a commercial (something I had not done to this point). It was a one-week job. It turned into more than three-and-a-half years, including three tours on "Shell's Wonderful World of Golf."

November 22, 1963, I was on stage early to check that sets and props were ready. This was a Dial soap commercial with the obligatory showering scenes, after which the husband comes home from work and cozies up as the wife prepares dinner (promises of things to come).

After 8:00 a.m., I got a call from the main gate at MGM. Security guard Ken Hollywood, a legend at Metro, stated there was an hysterical actress there, muttering about a shooting in Dallas. He asked me to come up and get her. I went to the gate, moved her to the passenger seat and drove her car to the stage. On the way, the radio was reporting the shooting of the President, Governor Connally and possibly more. There were conflicting accounts as to where the shots had been fired from. Make-up, hairdresser and costumer took over after I got the actress settled down. The prop

master brought out a portable radio and in between shots, we listened to continuing reports. We completed the commercial in a long, difficult day.

Having met JFK while filming his story, "PT 109," an episode of the "Navy Log" television series, it was hard to believe anyone would harbor such animosity for this man of charm and charisma other than the agent of an enemy power. After filming that episode, we had a reception for him at a club in San Diego; he charmed the entire list of invited dignitaries. Several years later, his father purchased 150 copies of that episode to use at campaign events.

Regards
Harry

Harry R. Sherman

HARRY R. SHERMAN *has produced such acclaimed TV movies as* Eleanor and Franklin, Eleanor and Franklin: The White House Years *and* The Gathering, *and the mini-series* Studs Lonigan.

November 22, 1963 - FDR, Jr. presses Senate Banking Committee to allow Russia to buy 150 million bushels of wheat

Personal Management and
Television Production

November 22nd, 1963 is seared in my memory. I was at my parents' home in Berkeley, California working on the staging of a weekend of concerts and events at the University Of California. I was on the phone when the person on the other end of the line suddenly said, "Oh my God, President Kennedy has just been shot!"

I was alone in the house and sat glued for hours (in fact days) to the television set watching a distraught Walter Cronkite report first the shooting and later the fact that the president had died. It was devastating.

I also had an immediate problem to deal with. What should be done about the upcoming shows? In retrospect it seems an easy decision to cancel them but at the time for a young businessman staring at the loss of a huge investment of time and money and stunned by the seemingly unreal events unfolding before my eyes, I hesitated. It didn't take long, however, for the obvious facts to sink in and the thought of doing anything but mourning the loss of a great and inspirational leader was impossible. The weekend events were cancelled.

I had met the then Senator Kennedy in 1958 at my University Of California graduation exercises and those few minutes (I'm sure it was seconds) had riveted me. His dramatic call to action ("Ask not what your country can do for you but what can you do for your country") had inspired my entire generation. My sister and her new husband had even gone off to Peru with the Peace Corps. President Kennedy was a master motivator, perhaps one of the best in the country's history. He got people to pull together to improve society in ways that have rarely been seen. He projected a youthful, energetic vitality for our country all around the world.

Interestingly, President Kennedy's death preserved such memories and spared him from being judged for things such as the failure of the Vietnam War. It was instead a golden moment in time. A vision of what our world could be with everyone working to make it better. In recent years many have come forth to tarnish that image with things that are perhaps better left unsaid. We need heroes. We need those who can inspire us. John Kennedy was definitely someone who could do just that. He was a great loss.

KEN KRAGEN's *credits as producer range from "The Smothers Brothers Comedy Hour" to numerous TV movies and mini-series. He created and organized the relief projects We Are the World and Hands Across America and received the United Nations Peace Medal.*

At the moment, though, in the spotlight of the campaign trail, Kennedy was in his element—concerned only with touching the electorate, winning them over. O'Donnell noted that the Texas trip "was a tough political challenge that he relished with much more enjoyment than he found in his executive duties in the White House."[3] After the Chamber of Commerce breakfast, the Kennedys flew from Carswell Air Force Base in Fort Worth to Love Field, the airport in Dallas. The schedule for the day was to begin with a lunch at the Texas Trade Mart in Dallas, and included a trip to an Air Force base, a banquet in Austin and finally, a flight to Lyndon Johnson's ranch near Johnson City. Before they arrived in Dallas, Larry O'Brien informed Kennedy that Yarborough had agreed to ride with Johnson in the Dallas motorcade awaiting them. Things were obviously looking up.

November 22, 1963 - Melvin B. Borgeson, landscape architect and FAA airport planner, dies at 66

4
Clear Skies

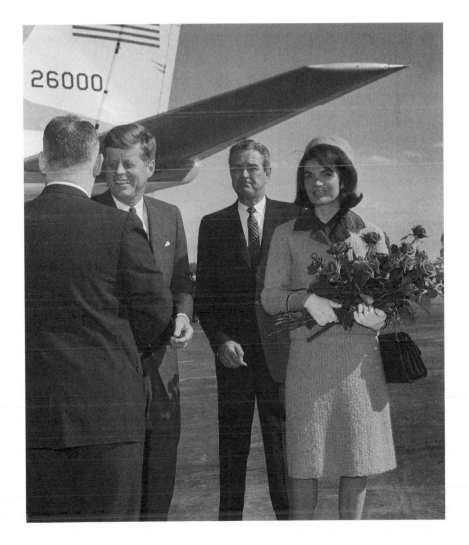

Air Force One landed at Love Field in Dallas around 11:40 a.m. The temperature was 76 degrees and the skies, which had threatened rain earlier, were starting to clear. Thousands of well-wishers were there, standing behind a chain-link fence to greet the President and his wife. Mrs. Kennedy was presented with a bouquet of roses and both she and the President stopped to shake hands with people at the fence, while Secret Service agents kept the press and photographers at bay. Jim Bishop wrote, "Hundreds of hands were sticking through and over the fence and it was obvious that Mr. Kennedy, far from feeling a sense of danger, was surprised and elated at the warmth of the greeting."[1]

The President and First Lady were then led to the motorcade waiting to take them to the Trade Mart building, near Dallas' central business district, where Kennedy would speak at a luncheon for business and civic leaders. The order of the motorcade: Dallas police motorcycles and a pilot car with Dallas police officers; more motorcycles and an unmarked Dallas police car; the Presidential limousine; more motorcycles and a car carrying Dave Powers, Kenneth O'Donnell and eight Secret Service agents; the Vice-Presidential car with Johnson, his wife, Lady Bird, and Senator Yarborough; the Vice-Presidential follow-up car; more motorcycles; a police car and several cars for Texas politicians, White House staff and press. The Presidential limousine—SS 100 X—was a 1961 Lincoln convertible with two collapsible jump seats between the front and rear seats. The President rode in the right rear seat with the First Lady on his left; Governor Connally was in front of the President, his wife, Nellie, to his left. Secret Service agent William R. Greer was at the wheel, Agent Roy R. Kellerman to his right.

November 22, 1963 · Soviet satellite Cosmos 22 returns to earth after six days in orbit

Robert McNamara

Kennedy had values and one of the objectives that he had—which many Presidents will state they have in principle, but few of them follow it to the extent he did—was to keep the nation out of war, if at all possible. And in the case of the Bay of Pigs, when it was clear that the rebel invasion was failing and the Joint Chiefs of Staff and the CIA asked for U.S. military air support, Kennedy repeated what he had said beforehand: he "wasn't going to supply that." They said, "The operation will fail," and he said, "I'm not going to have the U.S. involved in a war with Cuba." That was a very firm decision on his part and later, during the Cuban Missile Crisis, he essentially took the same position on that most critical day, October 27, 1962. He struggled all day with trying to determine how to keep the nation out of war when the majority of his military and civilian advisors were recommending attack. We didn't learn for almost 30 years that, at that moment, there were 162 nuclear warheads there, some tactical and some strategic. Had Kennedy gone ahead, we would have been in nuclear war. But, it was his determination to try every possible approach to keep the nation out of war that prevented a nuclear war.

One other objective he had was to increase the pride that our citizens had in their nation, in their government, and increase their willingness to serve the government. In recent years, there's been denigration by Presidents of government service. His value was exactly the opposite and he took many, many steps to transfer that value to the average citizen. The words in the inaugural address, "Ask not what your country can do for you, ask what you can do for your country," were typical. The result was that even in the midst of the Vietnam War, when there was tremendous tension in the country, I could still hire and bring to the Defense Department the best and the brightest because they had the feeling of satisfaction when they were serving the government and a feeling of obligation to serve.

He was the right person at the right time. But, it wasn't so much the time that was important. He had values and objectives that would have been, I think, equally critical and timely at other times. Today, for example, we could use some of those values. He reached out to people who had contrary views and who weren't even in the administration. For example, he made Ken Galbraith—who opposed the Administration's position on several things—Ambassador to India. Before Galbraith was in the government, Kennedy constantly picked up the telephone and talked to him. In the case of the Cuban Missile Crisis—apart from the view which was common in the administration that we had to find some way to get the missiles out of Cuba—he was determined that he not make a decision until he considered all possible alternatives. And he didn't want pressure on him or on the government while those were being considered. He wanted his advisors to meet without him present, so they could debate and argue and bring to him their conclusions. We lived in the tension of the Cold War 24 hours a day, 365 days a year, and that influenced his approach on the Cuban Missile Crisis.

I think the world would be different today had he lived. He had a very, very strong sense of history and that sense of history was a foundation for his behavior as President. After I left the Defense Department, I went to the World Bank, I was there for 13 years, I traveled all around the world. In the heart of darkest Africa, I'd go into a hut and tacked on the thatch of the wall would be a photograph of Kennedy, cut out or torn out of some magazine or newspaper. It's amazing the impact he had on people all over the world.

ROBERT MCNAMARA *was president of the Ford Motor Company before deciding to serve as John F. Kennedy's secretary of defense, a position he continued to hold until 1968. He was president of the World Bank Group of Institutions and has since worked on the boards of directors of many corporations as well as written books on a variety of political and social topics.*

From: Helen Caldicott
Subject: JFK

In November 1963, I was standing in the sitting room of our Canberra house holding my new baby, Philip, when my brother, Richard, a young diplomat, entered the front door and said, "Kennedy's been shot and he's dead."

I felt as if not only my world, but the whole world had collapsed. After the shock of the Cuban Missile Crisis, I felt that Kennedy had saved the world from nuclear annihilation—how could we possibly now survive in the nuclear age without him?

The funeral was devastating, with John-John saluting his father's coffin as it passed by on the gun carriage. What had we lost?

Helen Caldicott

DR. HELEN CALDICOTT *is an author, activist, instructor and one of the world's foremost advocates of citizen action to stop environmental and nuclear crises. She has founded and serves on countless international organizations, including Physicians for Social Responsibility and The Nuclear Policy Research Institute.*

November 22, 1963 - Assistant secretary of labor Daniel Patrick Moynihan tells Senate Labor Subcommittee that one third of draft age men are physically unfit to serve

CLIFF ROBERTSON

JOHN F. KENNEDY WAS, IS AND WILL FOREVERMORE BE A HERO TO MANY AMERICANS. I AM BUT ONE WHO FEEL THAT HIS CHARACTER WILL STAND STRONG IN THE ANNALS OF AMERICAN HISTORY.

IF HE HAD WARTS -- AS DO MOST OF THOSE IN PUBLIC LIFE -- THEY ARE REDEEMED BY HIS COURAGE, PERSONAL AND NATIONAL. PERHAPS HIS CARDINAL MISTAKE -- TO THIS ADDLED ACTOR -- WAS SELECTING ME TO PORTRAY HIM IN THE MOTION PICTURE "PT-109." HE INDEED CHOSE ME. I AM INDEED HONORED. AND I WOULD HOPE MOVIE-GOERS WILL FORGIVE US BOTH.

HE INVITED ME TO THE WHITE HOUSE SHORTLY BEFORE NOVEMBER 22ND. I WAS SO HONORED. WE SPENT MOST OF OUR CONVERSATION TALKING ABOUT ·OUR RESPECTIVE DAUGHTERS -- HIS CAROLINE -- AND MY STEPHANIE. HIS EYES GLOWED WHEN HE SPOKE OF HER AND JOHN-JOHN. THIS FATHER'S HEART GLOWED TO HEAR HIM.

LIKE SO MANY AMERICANS, I CONTINUE TO HEAR HIS WORDS. LONG MAY WE LISTEN TO THEM.

* * * *

Cliff Robertson

CLIFF ROBERTSON *was a journalist before he turned to acting on Broadway, and in television and films. His motion picture credits include* Picnic, The Best Man, Three Days of the Condor, Star 80, Spider-Man *and* Charly, *for which he won the Best Actor Oscar.*

WOODS DAVY

I was shooting pool at the Jeleff Boys Club, in Georgetown, Washington D.C. The balls had just been racked and I was about to break. I had a hot dog with mustard and a cold Pepsi in a Pepsi cup with no ice, both sitting on the rail of the pool table. This big Black and White TV was on, as it always was, in the games room near the pool table. Then the news flash came on, and I, of course, was stunned. I felt like I was punched in the stomach and I had to walk on eggs. I laid the pool stick against the table and walked toward the TV. I looked at the old man behind the snack bar shaking his head back and forth as he continued to organize his territory. I remembered my grandfather Myron restocking his bomb shelter during the Cuban Missile Crisis, watching him bring more canned goods (creamed corn, etc.) and fresh water down into this steel and concrete network of rooms built into the banks of the Potomac River. I don't think I ever touched the hot dog or Pepsi, and I don't think I ever played pool again that afternoon. I just continued to watch TV, and I don't remember going home that afternoon.

Best Regards,

Woods Davy

WOODS DAVY *is a California sculptor and studio artist whose work with natural materials has been installed at the Los Angeles County Museum of Art, the Xerox Corporation in New York City and Gaithersberg, Maryland's IBM facility.*

[David Gerber and Herman Rush were co-workers with General Artists Corporation, a talent agency and the predecessor to ICM. Herman had recently been appointed as President of the television division and David was Vice President, West Coast. They were a team, anxious to make their mark in the network television arena. As Herman recalls:]

Herman Rush and David Gerber

The pilot screening for ABC's mid-season consideration was set for the week of November 18 in Hollywood. David and I had two pilots in contention at ABC for mid-season. We had the opportunity of doubling our output on their schedule so these screenings were most important to us.

In 1963, once the West Coast programming department gave the green light, a screening would be arranged for the East Coast ABC management, led then by Tom Moore, and Tom would come to Los Angeles for the screening session. If Tom approved, he would take the pilots to New York where Leonard Goldenson would screen them over the weekend at his home in Westchester for final mid-season scheduling.

Therefore, it was an important and critical moment in the evolution of our young, but aggressive, talent agency and its potential success in the television packaging area. The pilots were half-hour programs: one hosted by Joel Grey, entitled "New Faces." The second pilot, entitled "The Donald O'Connor Show," starred Donald O'Connor. The production company was Desilu Studios whom we had signed as a client, a most important client, I might add.

Two shots at mid-season replacements, representation of a number of important clients and the ability to knock off two packages of our competitors!!! David and I prepared the entire week for the Friday screenings. Much was at stake!

Friday November 22 arrived.

The screening of the two pilots was set for 11:30 a.m. through 12:30, the first at the ABC Screening Room; the second at the Desilu Studios, a few blocks away. Time to screen the two projects, discuss them with the network executives, answer questions and if all went well, adjourn for lunch and discuss the potential future of the series.

We arrived at the ABC Screening Room (then on Vine Street, across from Sy Devore Men's Store, "Tailors to the Stars"). At 11 a.m., Tom Moore and his associates took their places. Tom sat next to the phone and intercom to the projection room so he could signal the projectionist when to begin – or when to stop – and control the sound. The lights dimmed and Joel Grey appeared on the screen. The "New Faces" pilot had begun.

We were into the screening for about five minutes when a stranger entered the room and whispered into Tom Moore's ear. Tom picked up the phone and began to speak softly. He hung up and dialed another number and made still another call. Joel Grey had completed his monologue, which was as funny as could be and had introduced the first act. Tom had missed it all! This was too much for me. Not only was the future of this program that we represented at stake, but so was my dignity. This was no way to treat David or me. We had worked too hard to be shunned in this manner. I was furious! I stood up. I waved in front of the projector's beam of light, waved my hands and shouted, "Stop the film." The screening came to an abrupt ending. The lights came on. Tom was still on the phone, oblivious to what I was saying or that the screening stopped. I was ready to take him on. David tried to calm me down.

When Tom hung up the phone, I looked him in the eyes and said, "What could be so important that you would act so discourteous and make phone calls during a screening of our pilot? What have I done to offend you?" Tom looked at me coolly and said in his infamous Southern accent, "Herman, President Kennedy has been shot."

I tried to fade into the woodwork. I felt like two cents, sick in my stomach as the truth set in. Needless to tell you, the "New Faces" screening did not continue. Tom had a network schedule to address, not for mid-season but for Friday, November 22, 1963, and the ensuing days.

In the midst of the turmoil and the shock that enveloped us all, we remembered that we had a screening of a Desilu pilot with Lucille Ball. We looked at each other, uncertain of what to do or not to do. We thought we'd go over to Lucy's and commiserate together about the assassination of our president. At this time, we still didn't know if he would survive or not. We met with Lucy. She just looked at us, herself in shock and definitely showing anguish at the news. We seemed to be frozen in time and finally, reaching out for reality, she just said, "I guess we should see Donald's pilot." We just nodded and went into the projection room to look at the pilot. When the lights came back on, there was just complete silence with everyone deep in their own thoughts. Lucy looked at us and said, "I think we should all just go home and pray." We did just that.

HERMAN RUSH *was an executive at Creative Management Associates before becoming chairman and CEO of Coca-Cola Telecommunications. He is a founding member of the Board of Directors of the Entertainment Institute Council and was executive producer of "The Montel Williams Show" for eight years.*

DAVID GERBER *has worked in various capacities in the TV industry as studio executive and producer, with such TV shows and series to his credit as "Police Story," "The Lindbergh Kidnapping Case" and "In the Heat of the Night."*

November 22, 1963 - India Armed Forces officers and pilot killed in helicopter crash

NEW LINE CINEMA

ROBERT SHAYE
CHAIRMAN AND CHIEF EXECUTIVE OFFICER

I was walking down Broadway somewhere around 110th Street with a Columbia Law School classmate of mine, Lester Greenberg, when the people passing us suddenly changed their demeanor from non-descript to very sad.

Neither Lester, nor I knew why, but we were aware that something profound had occurred.

Finally, somebody, a stranger, stopped us in the street. "The president has been shot," he said. It was a moment of strange bonding. Something uniquely transcendent. A public fact that cut through the privacy of strangers.

Lester and I looked at each other, shocked, and I believe both our hearts were pounding. We had been Kennedy supporters, and Lester had just come back from a law students' project registering voters in the South.

We walked into a bar on 110th Street where we found a crowd, mesmerized.

The bar TV was on, and just as we entered Walter Cronkite was incredibly, commentating, that John F. Kennedy had died, the victim of an assassin's bullet.

Lester and I looked at each other thunder-struck. And then we looked at those around us.

It was as if a supervening net of humanity, fellowships, and emotion had been cast over everyone. And much sadness. In that moment, there was no personal emotion. Except that of being an American, and that of an American's loss.

Regards,

Bob

ROBERT SHAYE *is the founder and CEO of New Line Cinema, which began as a distributor of art films, then expanded with hits like* Nightmare on Elm Street *and later blockbusters such as the* Austin Powers *films and* The Lord of the Rings *trilogy.*

The limousine had been equipped with a clear plastic bubble top—a top that was not bulletproof—but President Kennedy had decided earlier that morning not to put it on, since the weather in Dallas had cleared. Laurence Leamer has written, "All of his life (Kennedy) contemplated courage and its meaning. For him, riding on a sun-dappled day in an open limousine through the streets of Dallas was not restless disregard of the dangerous circumstances. It was the essence of his life."[2] Kennedy had tested himself over and over again since he was a young man, suffering from debilitating illnesses and physical maladies which only increased in severity as he matured. Robert Kennedy would later recall, "When we were growing up together we used to laugh about the great risk a mosquito took in biting Jack Kennedy— with some of his blood the mosquito was almost sure to die."[3] Yet, John Kennedy sought active duty in the Marines, he challenged the brutal public glare of politics and served as the most recognized figure in the world, projecting a vitality that belied his physical pain. Was it recklessness? Was it falsehood? Was it necessary—admirable, pragmatic and foolhardy—to accomplish what he felt he needed to do? Leamer noted: "He was a politician, and he needed Texas money. The top was down because he had made a covenant with the people, and in a democracy the people saw their leaders."[4]

⌭

"An interesting study could be made of 'Presidential Exposure.' That it is dangerous is clear, yet recent Presidents, and none more than Johnson who seems to have a manic compulsion to make physical contact with as many citizens as possible, have considered it a necessary part of their job... 'Presidential Exposure' is one way of symbolically bridging, or rather concealing, the chasm between the too-powerful insiders and the

November 22, 1963 ▪ Michigan officials say Chrysler to build new stamping plant in Macomb County, not in Ohio

*too-powerless outsiders; a ritual compensation for an imbalance that
makes both sides uneasy, for the time of the kind of autocratic power
exercised by Louis XIV is past, at least in the West. 'L'etat, c'est nous,'
the American President says, and he needs reassurance from 'his' people
that he is their democratic equal as much as they need from him the
reverse assurance."*

(Dwight Macdonald, "A Critique of the Warren Report,"
Esquire Magazine, March 1965)

The Presidential motorcade departed Love Field around 11:50;
roughly 45 minutes was given for the caravan to make its way
along the route that had been described for days in the local
papers: the cars and motorcycles would move through downtown
Dallas on Main Street, turning north at the intersection of
Houston Street, just in front of Dealey Plaza, then to Elm Street
and, eventually, under the Triple Underpass where Main, Elm and
Commerce Streets converged. After that, it was only a short dis-
tance to the Stemmons Freeway and finally, the Trade Mart. As
the motorcade slowly approached Main Street, the President had
the limousine stop twice: once to shake hands with a group of
children who held a sign that read, "Mr. President, Please Stop
and Shake Our Hands," and then, to chat briefly with a nun who
was also with some children.

**November 22, 1963 - At 10:10 a.m., Pacific Time, an Oxnard, California supervisor
overhears a woman say the president will be killed**

FREEWAY CONVERGENCE AT TRIPLE UNDERPASS
DALLAS, TEXAS

Commission Exhibit 2113

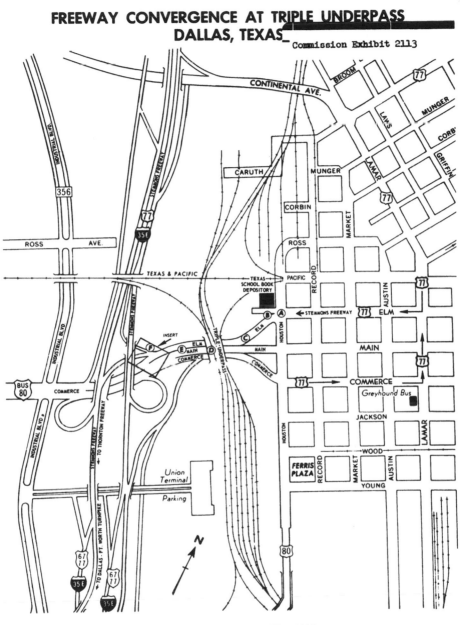

COMMISSION EXHIBIT No. 2113

Map, Freeway convergence at Triple Underpass, Dallas, Texas; NARA, Record Group 272, Warren Commission Exhibit 2113

Wendy Scott

MAKE LOVE, NOT WAR

No teenager likes braces but it was made worse for me one Friday when I had to walk to the orthodontist's office. At the age of 15, walking rubbed against my adolescent sense of justice. Certainly I should be 16 already and driving my own car.

The good news was that the late morning appointment meant leaving school for a few hours while my peers ached over Algebra or sat comatose in French immersion class, a newly introduced language lab of audio tapes entirely in French. Instead of absorbing French, however, we were learning the only thing we could understand in English: The name of the company producing the tapes, "Harcourt, Brace, Jovanovich." I walked out of Arcadia High School into the autumn air and down the street in a green wool dress with a high round collar that for once wasn't excessively warm for the Southern California weather. Jackie Kennedy's fashion sense had been endemic over the last few years and she definitely would have approved of my elegant outfit with matching belt, finely stitched. Of course she would have approved of my learning French as well, since she and the President had been to France and his quip at her popularity still lingered in our ears, "I am the man who accompanied Jacqueline Kennedy to Paris."

My thoughts, however, were not on the First Lady as I continued along the sidewalk, nor was there any foreknowledge that fate

would move me to Paris one year later to the day, or that I would eventually follow in Jackie's footsteps to Vassar College precisely because she had gone there. Instead, my thoughts were on my mother, who had been sick for a long time, and on my grandfather, cursing and blessing him for having saved his money as a night watchman at Farmer John's to enable him to give me the "gift" of orthodontia.

But once in the parking lot of the medical building, all thinking abruptly ended when I noticed something completely out of place: a nurse in her white uniform. She was not at work, where she should have been at that hour, but sitting instead in the driver's seat of a brown car, the door wide open, her feet flat on the pavement, as if she had rushed to the car and sat down without fully getting in. I glanced a little further down and saw a man in a suit halfway in his car. I had no way of knowing then that they had run to their cars to listen to news updates on the only radio accessible from work in those days, the one in the car. It wasn't until entering the orthodontist's office that I learned from the receptionist the terrible news they had been hearing: John F. Kennedy had been shot.

And it was terrible news, even to a teenager worried about her teeth. JFK had brought visceral joy and hope to the world. Our parents were happier, more hopeful; as kids, we could *feel* the hope and happiness. He was bright, articulate, humorous, handsome, and, my goodness, that incredible smile—just *looking* at him made people optimistic about the future.

The orthodontist did have a radio in the office, presumably to take his young patients' minds off the pain he was about to inflict. As he tightened the wires on my teeth, he tried to talk of normal things, but there was no talking at all when the broadcaster announced the news that JFK had died. I remember turning my

head in the chair to look at the clock on the wall, checking California time against Dallas time, trying to make what I had just heard fit into a sense of reality that had never had to make room for such a thing.

Finding no comfort at the orthodontist's even on the best of days, I went to my mother's hairdresser across the driveway from the medical building, called home, and asked my mom to pick me up. It did feel better to be there, normal and homey with the familiar sounds of hair dryers in use and someone sweeping the floor, but still, I sat by the door in a daze, looking for my mother.

My mom finally came, tears in her eyes, and hugged me. She didn't often cry and she didn't often hug, so it set me off into a new round of tears. She wanted to go to church to pray for JFK. One of the customers said the only churches open every day were Catholic. We were Protestant. My mother became so angry at having no church of her faith available that if we could have changed religions right then and become Catholic, we would have.

I had tickets to the taping of "The Steve Allen Show" in Hollywood that night. He was my idol at the time because he was smart and funny, and his humor had been part of my own healing during my mother's long illness. I called the show to see if it would please, please still be on, I need it to be on, but my head dropped in new sadness to hear the operator say the show had been canceled because JFK had died. I kept the tickets for the show that never happened in my scrapbook because the printed date on them memorialized the life-changing day: Friday, November 22, 1963.

On Saturday, my mother was more determined than ever to do something special in memory of JFK, so, sick as she was, we went to a memorial service for him at the Los Angeles Coliseum, where he

had been nominated by the Democratic Party for the office of President of the United States. It was a moving tribute that cemented my first personal sense of history—I was where he once had been.

I came home from church on Sunday, turned on the television, and saw Lee Harvey Oswald shot and killed in Dallas. It was unreal. Reality for 15-year-olds was curlers in our hair, arguing about how much makeup we should be allowed to wear to school, wondering who would be Homecoming Queen. We didn't know guns. We didn't know assassination. We didn't know death. And a day later, on Monday, we came to know what we never thought it possible to know: a mournful widow, more beautiful than she had ever been, veiled in black, her precious children at her side, one saluting his slain father as the casket passed by.

But the assassination killed more than the man. It killed an entire psychology. We had all been caught up in Camelot, joyously so, and it was over in an instant, just over, and hope died as quickly in all kinds of ways. For me, the end of hope came when my mother was finally so ill that I was being sent to France to live with my American father, whom I did not know, and to be immersed in a language Harcourt, Brace, Jovanovich had made certain I did not know.

Others might have worn bright colors to celebrate going to Paris and, by that point, celebrate going without braces, but, like Jackie Kennedy at the funeral, I was dressed entirely in black, for the day I was to take my first airplane ride—a ride halfway around the world into a new and difficult life with a father who did not want me—was November 22, 1964. The black was in honor of JFK, marking not only the grief of his death still in my heart a year later, but the grief that my life had been turned absolutely upside down since that terrible day.

The sense of nothing ever being the same again when John F. Kennedy died was clearly proving true. I would be gone from my country for three years, and many of my school friends, once struggling over Algebra or sleeping through French, would soon be gone from the country as well—not to the City of Light, but to the darkness and death of Viet Nam. Our joint return would find America almost unrecognizable with protests in the streets, drugs on every campus, sit-ins, a sexual revolution, unrelenting assassinations as Martin Luther King and Bobby Kennedy were gunned down, Jackie fearing for her life and that of her children and marrying someone as hard to accept as a replacement for her husband as Lyndon Johnson had been as his replacement for President...and all through the chaos a constant plea from my generation that became a command, one we hear today in the even more unimaginably terrible times of 9/11, only now it is a global cry—"Make love, not war."

The bullets from the Book Depository in Dallas that November day were, for us, "the shot heard 'round the world," and we are hearing it still, echoing down the corridors of so many countries, because the world hasn't yet mastered the blessing of love as well as it has mastered the curse of war. But there is hope, springing up again nonetheless, because war always brings with it, by contrast, the undeniable advantage of love. We can and will choose love again and one day make of the entire world a Camelot that cannot end.

WENDY SCOTT *is a native of California, the mother of two sons, Tim and Chris, and the author of* Meet Divine Mother: An Intimate Introduction to the Other Half of Heaven.

TRANS-LUX

Four months before the assassination, my wife gave birth to twin boys. When I turned on the television and heard what was happening in Texas, I was shocked but was standing next to the playpen in which the twins, Tom and Matt, were trying to crawl. I wanted to laugh and make them smile at the same time that I wanted to cry and scream.

My thoughts concentrated on how I would explain this day and the events occurring to my sons when they were old enough to under-stand—to understand that they were actually alive when Kennedy was shot.

As the video scenes were shown over and over again, I wondered how I could possibly make my sons happy while being so distressed. I never told my sons about that day or my feelings, until I was asked to remember them when requested to express them in writing.

A LESSON LEARNED

The end of life for JFK
How could I laugh, how could I play
When sadness overwhelmed my mind
From an event that's so unkind

Yet with baby boys in playpen near

I knew my tears must disappear

And so I forced myself to smile

Disaster swallowed for a while

Thus finally I shall explain

To Tom and Matt in mild refrain

How truly might one overcome

The need to cry—Now beat the drum

Kindest Regards.
Sincerely Yours,

Richard Brandt

RICHARD BRANDT *has served as a member of the Board of Theatre Owners and the National Association of Theatre Owners, is a trustee of the American Film Institute and was chairman of the board of Trans-Lux Corporation.*

Billy Dee Williams

My grandmother and I were sitting in our kitchen, on 110th Street between Lennox and Fifth, Central Park North. The radio was on and we were talking and all of a sudden, the news came on and it was reported that Kennedy had been shot. My grandmother and I were in a state of shock, and I remember just standing there, frozen and weeping. And I thought, my God, I don't even know this man and yet, you felt like he was part of the family. I remember that we all—as most people did—felt like he was family. The whole Kennedy mystique sort of permeated everybody's life at that time. I think Kennedy represented something beyond the whole question of partisanship—he sort of brought an energy that everybody felt at that time. When that day happened, it was like taking a piece of your own flesh or taking a piece of your heart and destroying it. Kennedy was like this centrifugal force or energy that affected everybody's life. I remember at that time, I worked with Jerome Robbins, who started a company for performers—actors who also performed as dancers. He was trying to create something that was similar to Japanese Noh theater. And I remember—it was a unique idea at the time—that he was trying to structure an idea that revolved around Kennedy as a kind of center, a centrifugal force that affected so many different people's lives. This was after the assassination and Robbins was trying to give some kind of revelation to that event. We were in this workshop he had created and we were probably going to perform it, but it just never reached that fruition. We never performed it.

BILLY DEE WILLIAMS' *illustrious acting career includes the films* The Last Angry Man, Lady Sings the Blues, Mahogany, The Bingo Long Traveling All-Stars & Motor Kings, The Empire Strikes Back *and* The Visit.

From: Gerry Abrams
Subject: JFK

On November 22, I was at lunch with Brock Peterson and Doug James, two broadcast salesmen, at a restaurant in New York City. Although the exact name of the place has been lost in my memory, I do remember that as we were leaving, word reached us that JFK had been shot. At the time, it didn't sound that serious but as the afternoon wore on, the news that, in fact, President Kennedy had been mortally wounded reached the nation.

My most vivid memory of that day was the train ride from Penn Station to Great Neck. Every single rider on that packed commuter train sat in complete silence. No one, not one person, talked the entire trip.

gerry abrams

GERRY ABRAMS *has been a prolific television producer and executive CEO of The Hearst Corporation, Television Division. His producing credits include* A Woman Called Golda *and four-hour mini-series* Nuremberg.

November 22, 1963 · Iranian team investigates downing of survey plane by Soviet jet

T GEORGE HARRIS
Editor, Media Technology
UCSD CONNECT

The World JFK Made Personal

Sometimes it did feel like Camelot, but mainly John Kennedy made
Uncle Sam personal as hell with all our human imperfections and vulnerabili-
ties. The walls of social institutions were melting, no longer limiting and shel-
tering us. He was us, and we knew how fallible we were. He hadn't dodged
combat, as so many of our Ivy League chickenhawks do today, and he hadn't
backed away from his Catholicism or hidden behind it. When my boss's wife,
Clare Boothe Luce, blasted me over dinner—"the first Catholic President has
to be a GOOD Catholic, and Kennedy is not"—I suddenly knew how even our
spirituality is a function of choice, not a given. He'd gone straight to the core
of political choice in his *Profiles of Courage*, laying out the drama of politi-
cians who'd had the courage to make a decision that could, each knew, mean
political death. What's it worth? When is service more important than survival?

His contribution to American values was personal, and in a personal
style of individual action. It sure as hell wasn't in policy and accomplish-
ments. Late that summer, dawdling over lunch in Washington, Pat Moynihan
and I agreed that the Kennedy Administration wasn't going anywhere, no leg-
islative record or policy revolution. Yet, he tapped the deepest veins of ideal-
ism. His Peace Corps gave idealistic thousands the chance to make a differ-
ence, not just berate government. His green berets turned the U.S. Army

upside down, to bet on individuals, not regiments. His War on Poverty, OEO, under his brother-in-law, secretly sponsored research showing that independent nonprofits like the Urban League did far more than government bureaucracies to job-train the poor and reshape communities; therefore, the OEO concentrated on dispensing funds and clout to community organizations, often at war with local political machines. VISTA volunteers in action often operated like Junior Leaguers, yummy mummies in alligator pumps, but they also served. In confrontations such as Ole Miss, JFK and Bobby worked through West Wing nights to head off a bloody massacre. Beginning early that summer with the Birmingham riots, they had built the fastest, most effective integration program ever known through an underground network of business leaders and civil rights protestors. The CEOs of drug-counter chains, hotels, movie houses and dozens of others would agree on a date when all segregation rules would be dropped in a town, so the KKK could not divide conquer. By November, no less than 68% of all Southern and Border State towns and cities had made major integration moves. The story remained secret because its release date, November 22, filled the media with other news of JFK's vulnerability.

—T. George Harris

T. GEORGE HARRIS is a decorated U.S. Army veteran who has worked as a contributing editor for Time *magazine and as senior editor for* Look *from 1962–68. He was a founder and editor-in-chief of* American Health, *editor-in-chief of* Psychology Today *and currently works on numerous magazines such as* Science & Spirit *as well as on the Web Site* BELIEFNET.com.

BERNIE BRILLSTEIN

It was a Friday. It was the week before Thanksgiving so we got paid every other week. So we got paid that day. It was big time so we could go out for a big lunch. So Arnie Sack and myself went to the Studio Club, which was on 57th and 7th, owned by a theatrical manager, George Graves. His family did it for his mother and father. The food was great and expensive. So we're sitting in a booth. It wasn't very crowded. And they had a radio up on a shelf. Arnie was talking—he spoke very softly anyway—and I thought I heard "and the President has been shot in Dallas and he's on his way to Parkland Hospital." I said, "Arnie...Shhh" like that because I couldn't believe it. I thought I was hearing things. And then whoever it was—it must've been Dan Rather—said it again. And so we paid the check quickly and went back to the office because I guess there's something where you need a crowd, you didn't want to be alone, thinking about it just now. We went back to my office at William Morris and everyone was waiting for me to come back. There were about 10 people in this little cubicle of an office watching my little television set. I don't think it was continuous

coverage, I mean if I remember. But I do remember Cronkite taking off his glasses, or maybe I don't, but seeing it so many times as the years went by...and I know the office closed down. And I didn't leave my apartment, which was a block away, till Sunday at about twelve o'clock when I went to the football game. And that's the day Ruby shot Oswald. And that was even crazier. Once that happened, I think everyone said, "Okay, what's going on here?" No one knew who Lyndon Johnson was—or cared, by the way—and all of the sudden he was the president. Kennedy had such a presence. I mean, it was the Kennedys who ran the country. And Lyndon Johnson was just another person. I think if you would've asked, nine out of ten people, they wouldn't have known Johnson was going to be the President. It was very scary. But it was an amazing thing. And it took all through the next weekend. It was the Thanksgiving weekend. It was cold and crisp and God it was weird.

BERNIE BRILLSTEIN *began his career in the entertainment industry in the William Morris mailroom and became a top manager, consultant, producer and packager for movies and TV. His company, Brillstein-Grey, with Brad Grey, is responsible for such shows as "Just Shoot Me," "Politically Incorrect" and "The Sopranos."*

As the cars turned right on Houston Street, the vehicles headed toward the Texas School Book Depository at 411 Elm Street, a privately owned company that processed book orders from schools throughout the Southwest. On the sixth floor of the depository, a 24-year-old ex-Marine and self-proclaimed Marxist named Lee Harvey Oswald waited. Oswald had unsuccessfully attempted to defect to the Soviet Union some years earlier and while he was living there, met and married Marina Nikolaevna. When she became pregnant, they returned to the U.S. They now lived apart, he in an Oak Cliff apartment, she and their two children in the home of Ruth Paine, a friend in Irving, Texas. Oswald had been working at the depository for just over a month; now he aimed a 23-year-old Mannlicher-Carcano Italian military rifle which he ordered for $21.45 from a sporting goods company in Chicago. Below on Elm Street stood Abraham Zapruder, a 65-year-old clothing manufacturer, who had gone home to get his 8-mm Bell and Howell Zoomatic movie camera on the advice of his employees. He now waited with his secretary to get a better view of the President.

The motorcade had about five minutes to go before it reached the Trade Mart. The crowds along the route had been enthusiastic in their reception of Kennedy. As the limousine headed onto Elm Street toward the underpass at 11 miles per hour, Nellie Connally turned to the President and said, "Mr. Kennedy, you can't say that Dallas doesn't love you."

November 22, 1963 • California Water Commission rejects Secretary of Interior's plan for Southwest's water problems

"We in this country, in this generation, are—by destiny rather than choice—the watchmen on the walls of world freedom. We ask, therefore, that we may be worthy of our power and responsibility, that we may exercise our strength with wisdom and restraint, and that we may achieve in our time and for all time the ancient vision of 'peace on earth, goodwill toward men.' That must always be our goal, and the righteousness of our cause must always underlie our strength. For, as was written long ago, 'except the Lord keep the city, the watchmen waketh but in vain.'"

(part of John F. Kennedy's prepared speech for the Dallas Trade Mart luncheon, November 22, 1963)

5
Six Seconds

"On the basis of the evidence reviewed in this chapter, the Commission has found that Lee Harvey Oswald (1) owned and possessed the rifle used to kill President Kennedy and wound Governor Connally, (2) brought this rifle into the Depository Building on the morning of the assassination, (3) was present, at the time of the assassination, at the window from which the shots were fired, (4) killed Dallas Police Officer J.D. Tippit in an apparent attempt to escape, (5) resisted arrest by drawing a fully loaded pistol and attempting to shoot another police officer, (6) lied to the police after his arrest concerning important substantive matters, (7) attempted, in April 1963, to kill Maj. Gen. Edwin A. Walker, and (8) possessed the capability with a rifle which would have enabled him to commit the assassination. On the basis of these findings the Commission has concluded that Lee Harvey Oswald was the assassin of President Kennedy."

(President's Commission on the Assassination, Warren Commission Report: Report of President's Commission on the Assassination of President John F. Kennedy, Bantam Books, 1964)

12:30 p.m. As the limousine turned onto Elm Street, shots were fired. Governor Connally was struck in the chest. The President was hit, first in the neck and back, and then in the head. Roughly six seconds had passed. Debate and confusion over the sequence of events and what actually transpired during that short amount of time has continued to this day, in print, on television, on film and in the minds and hearts of people across the world. Were there more than the assumed three shots fired at the limousine and were they fired from locations other than the Texas School Book Depository? Does the footage that Abraham Zapruder took of the assassination prove this? Was Lee Harvey Oswald the lone assassin, as claimed by the Federally sponsored Warren Commission in 1964, or were others involved? Has the truth been intentionally hidden all these years and, if so, by whom and for what purpose? Whatever the answers may be were irrelevant as the results of those six or so seconds played themselves out.

After initially slowing down the limousine, Agent Greer now hit the accelerator. Mrs. Kennedy climbed on the trunk of the limousine as Secret Service agent Clint Hill—running from the presidential follow-up car—jumped on the back of the limousine and pushed her back into the car seat. Kenneth O'Donnell recalled:

"On the Thanksgiving weekend after the President's funeral, when Dave (Powers) was visiting Jackie and her children at Hyannis Port, he showed her the color pictures of herself on the back of the car taken at the scene by Abraham Zapruder's movie camera and published in that week's *Life*. She had no recollection of leaving the back seat after the President was shot. 'Dave, what do you think I was trying to do?' she asked."[1]

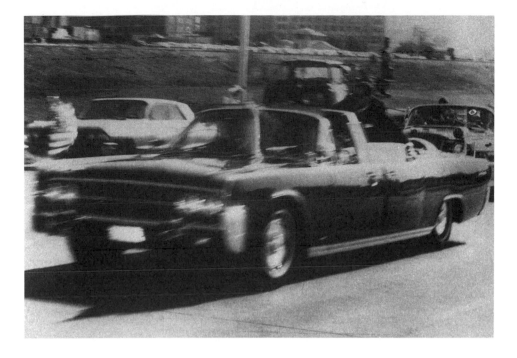

"The best tribute to the solidity of the (Warren) report comes from its critics. It would, I should have thought, have been obvious even to an amateur that he could not make much impression on the structure of this report unless he had a charge of high explosives to put under some parts of it. But all that the critics seem to be doing is to clamber about on the surface, chipping away with a hammer and a chisel as if the height of their ambition were to deface the exterior slightly."

(*Lord Devlin, "Death of a President: The Established Facts,"* Atlantic Monthly, *March 1965*)

November 22, 1963 - Michigan Governor George Romney disagrees with fellow Republican Barry Goldwater on civil rights and labor issues

Senator John Kerry

I remember most President Kennedy's optimism. His grip on our generation, his call to make God's work our own here on earth, his call for us to get involved in the Peace Corps, the military and in forgotten reaches of our country from the inner city to the Mississippi Delta had a profound impact on so many of us. But it all stemmed from the powerful impulse of hope—he made us believe we could do great things and—in those simple words—"we can do better"—he offered up a mission for all of us. I remember first seeing him when I came out of a T stop in Boston and heard him speaking at a campaign rally. After he finished speaking, I immediately signed up as a volunteer—he made service really seem—for an instant—like a noble calling. I remember the day he was killed. I was playing in the Harvard-Yale soccer game and they called the game to a halt and sent everyone home. We were stunned. But we thought our generation had a special responsibility to carry on. We hadn't lost hope. Vietnam tested our faith. Losing Martin Luther King and Robert Kennedy shocked us beyond belief. But still we have faith that we can make a difference—our generation still has work to do in what President Kennedy reminded us was a long twilight struggle.

SENATOR JOHN F. KERRY *is serving his fourth term as Democratic Senator from Massachusetts. A Yale graduate, Kerry was decorated with three purple hearts for service in Vietnam and co-founded the Vietnam Veterans of America before becoming a prosecutor and being elected to the Senate in 1984.*

ALPHONZO BELL, JR.

The most tragic thing that happened during my early days in Congress was of course the death of President John F. Kennedy, having been assassinated by the misfit, Lee Harvey Oswald. This made for a very startling and unhappy situation. It is a matter that has been the subject of numerous books and movies so I will not recount the widely known events of that day.

I do recall one thing that happened that I have not seen reported elsewhere. I was in Washington, D.C., when President Kennedy was shot in Dallas, Texas. Immediately after the assassination occurred, nobody in the Congress, House and Senate offices, or in all of Washington could telephone out—all the phone lines were down. I know because all of us in our offices that day gathered out in the hallways to exchange information. Apparently the only telephone services in Washington working were the lines to the White House. I was told later, that it was felt by security officials that because the assassination might have been connected to an international plot, such as a military move by the Soviet Union, that every precaution was taken to insure reliable communications for the executive branch. This meant making sure the rest of us did not overwhelm the lines with unnecessary calls.

After the investigation of the assassination by the Warren Commission, I talked with fellow Congressman Gerry Ford about the findings, as he was a member of the Commission. Gerry felt that the general description of Oswald and how he had shot the President was accurate but he was not sure that everything else, such as the real motivation for the assassination, was in sync. He told me that there was much information that the Commission did not have, due to national security issues. He did not like that but there was

nothing much the Commission could do, especially since Oswald was killed before he could be questioned. Under those circumstances, there was no other answer but for the Commission to conclude that Oswald was acting alone.

ALPHONZO BELL, JR., *the son of the founder of Bel Air, California, was a rancher, a business executive and a United States congressman from 1961 to 1976. He helped to found the Santa Monica Mountains Conservancy and made San Onofre a public beach.*

In the Vice-Presidential car, Secret Service Agent Rufus Youngblood—sitting in front of Lyndon Johnson—immediately pushed the Vice President back as the gunshots went off, then shoved himself on top of Johnson, for protection. Parkland Hospital—about four miles from the Depository Building—was alerted as the lead cars in the motorcade raced onto the Stemmons Freeway. Jacqueline Kennedy, covered in blood, held her husband's head. Tom Wicker of the *New York Times* reported that, as the lead cars of the motorcade headed for the hospital, Senator Yarborough saw, "a Secret Service man in the car ahead beating his fists against the trunk deck of the car in which he was riding, apparently in frustration and anguish."[2]

November 22, 1963 • Revised student dress code goes into effect at Stamford, Connecticut's Dolan Junior High School

Joseph Paolella

The Kennedys had a home called Rattlesnake Mountain in Northern Virginia, which was in the horse country, about 60 or 70 miles from the White House. It was about 40 acres and had stables and horses and the house was surrounded by a metal fence. We stayed at a small house that had a lot of electronic equipment, so that anybody who approached the gate or any of the surrounding fence would be picked up by sensors. I was en route to Rattlesnake Mountain and got word that the President had been shot. Initially, it was reported that a Secret Service guy had been shot, too, but that turned out to be false information. So, everybody was told to return to the White House, for the burial of the President and the fact that visiting dignitaries from all over the world would be arriving. At that time, nobody knew what the extent of the assassination was—was it a global kind of thing? Or a coup? So, every available person—FBI, everybody—was there to protect not only President Johnson, but all the Kennedys and the funeral entourage.

I remember I went back to the White House when the car was returned from Bethesda Naval Hospital and doctors from Bethesda had to pick up some of the scalp and brain and tissue that was still in the car. We had to guard that car so nobody else would have any access to it. It was part of the crime scene, so to speak, and we had to guard the car and allow the Bethesda people to take any of the remains of the President.

I think everybody loved President Kennedy. He was a nice person to everybody, it didn't matter what your status was—he would treat the White House maid the same way he would the King of England. He was always friendly to the Secret Service agents. There was a chauffeur named Muggsy O'Leary who had been with the Kennedy family for years, who came along with the President and became kind of an honorary Secret Service agent.

When Kennedy first became President, the Secret Service detail would more or less stand at attention and never really acknowledge him or look him in the eye. This was the way it had been when Eisenhower was President and we were used to a more structured President like that, who had been a General. But, Kennedy noticed and told O'Leary, "You know, these guys should be called the Silent Service instead of the Secret Service." Well, after that we started to say, "Good morning," and at least acknowledge him. He made you feel at ease. He was at ease with himself and he made you feel at ease, too.

Many times on a parade route, he would stop and shake hands—especially for nuns or priests—and that would scare the crap out of us, because you become kind of a sitting duck, once the motorcade stops. But, he was like that all the time with people—very friendly and gracious.

Jack Kennedy seemed made for politics and in Washington, Jack Kennedy became a sought-after figure. His big family, his fortune, his sense of fun, his style and grace made him immediately appealing, especially to the young. He was the first Catholic president of the United Staes, fulfilling his father's ambitions for him and for his entire family. It was, in a way, a completing of the circle—a vindication of the Irish, who had struggled so long in their homeland and in America to achieve the recognition they deserved.

Before Kennedy became President, Eisenhower personified the stoic and stable 1950s. The Korean War had ended, the Cold War was in full force, but America was relatively isolated from the outside world. It felt nice and safe and secure, but boring. Kennedy brought in a feeling of vitality and youth and change.

I remember during the Kennedy funeral march from the White House, that the streets were lined with grieving Americans, but it appeared to me that

the blacks lining the route seemed like their hope for equality and salvation was erased with the death of President Kennedy. I feel they believed he really wanted to end segregation and help them achieve the American dream.

As an American of Italian descent, I could understand the struggle Irish-Americans had to achieve equality. A generation later, the Italians were going through the same struggle and, two generations later, Black Americans, led by Dr. Martin Luther King and helped by the Kennedy Administration, started on their road to equality.

People have called the Kennedy era "Camelot" and I believe rightfully so. Prior to his inauguration, the country was at a standstill. But, when Kennedy became President and his wife, Jacqueline, became First Lady, it seemed to start in the effort for us to finally realize what our forefathers intended for this country—a level playing field where everyone, depending on their ability and perseverance, can make it without being held back because of religion, sex or race.

Joseph Paolella

JOSEPH PAOLELLA *served under four presidents as a special agent in the U.S. Secret Service, beginning in 1960. He is a licensed polygrapher and private investigator and founder of West Oaks Security Services and the American Academy of Police Sciences.*

Tom Pollock

Of course I remember EXACTLY where I was when Kennedy was shot. I was in French class at Stanford, where I was a junior. Twenty years old. The class went from 11–12 and while we were reading Camus in French, someone went by the window and shouted, "The President's been shot. Kennedy has been shot." We started talking in English, and our French professor, who would not allow us to use English in the classroom, insisted that we tell the other students what had happened IN FRENCH. So I said, "Le President etait assassinee!" I was corrected for my poor use of the past perfect of the verb, "to be," and class was immediately dismissed. I got in my car and drove to Berkeley, where my girlfriend lived, and stayed there watching television for the next three days.

Tom Pollock

TOM POLLOCK *was an entertainment attorney before becoming chairman of Universal Studios and later, vice-chairman of MCA. He is currently partnered at Ivan Reitman's Montecito Picture Company and served as chairman of the Board of Directors of the American Film Institute.*

Gary Cartwright

All I know is that until the assassination, everything in my world seemed clean, transparent, and orderly. Nothing has seemed clean, clear, or orderly since.

One of my last unambiguous memories is those minutes leading up to the assassination. It was a crisp, bright, surreal afternoon in November. Bud Shrake and I had walked from the apartment we shared on Cole Avenue to the corner of Lemmon and Turtle Creek Boulevard to watch the presidential motorcade. We were young sportswriters for the *Dallas Morning News* back then, longtime friends between marriages, and our apartment had become a late-night hangout for musicians, strippers, and other nocturnal creatures. One of our regular drop-bys was George Owen, manager of the University Club, a former SMU basketball player who had dated the fabulous Candy Barr before the Dallas power structure sent her away on a phony marijuana charge. Two other regular visitors were Jack Ruby, the cheesy little hood who owned the Carousel Club, and Jada, an exotic stripper who was the club's headliner that year. Shrake was having an affair with Jada, which caused Ruby great distress and occasionally complicated things around our apartment.

We had talked all week about Kennedy's trip to Dallas. For most of us, his election was a landmark event. He wasn't just the first president I'd ever voted for—in fact, the first *politician*—JFK connected me with the system. He made me feel good about the country and about myself. He had emerged as our national cheerleader, hero, and role model. Not long after his election the president urged the nation to become more physically active, suggesting that anyone under the age of 40 should be able to walk fifty miles at a stretch. Our entire sports staff did the walk, or at least attempted it.

As the motorcade turned onto Turtle Creek for its final leg into downtown, Kennedy looked directly at us, his famous grin flashing like a polished diamond, his hand flicking a sort of salute of recognition, as though

to say *I've heard all about you two Cole Avenue rogues!* Ten minutes later, as we drank coffee in the drugstore across from the SMU campus, a radio whose existence we hadn't previously noticed stopped us cold with an urgent bulletin. The president had been shot! It happened as the motorcade approached the triple underpass on the eastern edge of downtown, a landmark that we could have seen from our desks at the *News*, if we'd been at our desks. The motorcade was at the moment racing for the emergency room at Parkland Hospital. Shrake and I traded small, silly smiles, the way people do when they suspect someone is putting them on. The announcement was so off-the-wall, so intrinsically unbelievable, that we at first assumed it was a joke. Some moronic disk jockey begging for attention. For a long time nobody in the drugstore moved or spoke above a whisper. As journalists, our impulse was to rush to the scene of this breaking story, but rush where? There was no scene; there was only chaos. This was before the days of CNN, before television's ability to crank up instant news coverage, so each of us created his own images from the series of radio updates that fell like black snow. After a while the terrible truth enveloped us. The president was dead! The clock had stopped. The end of the world might well be at hand.

When the clock started again—how many minutes or weeks later?— it was one of those Dali clocks, a metaphysical meltdown in which perceptions of reality were grotesquely warped, where common objects that you saw every day during your lunch break became Rorschach tests for the severely paranoid. Dapples of sunlight transposed themselves into snipers. A rainbow viewed through the spray of a fountain gradually refocused as an exploding skull. Daily affairs and routines, once predictable and comfortable, threatened to become nightmare excursions into the unknowable. It was as if we had dropped through a rabbit hole into a void where lies were truth and truth a dark deception. The entire cultural upheaval of the sixties—the drugs, the music, the free love, Vietnam, the ghetto riots, the rejection of traditional values—was a reaction to the murder of John Kennedy, and the subsequent murders of Robert Kennedy and Martin Luther King Jr. And to a perceived Armageddon. The forces of

evil had conspired to ethnically cleanse or at least neutralize those who would deny them absolute power. Or so it seemed. Of course the threat of cultural genocide was mostly in our minds, and yet the shock waves of that upheaval were real. They defined us politically and culturally in the sixties, and they define us today.

Gary Cartwright

GARY CARTWRIGHT *has been on the staff of* Texas Monthly *since 1982. In addition to his work as a newspaper editor and freelance writer, he has also written several books, including* Blood Will Tell: The Murder Trials of T. Cullen Davis, *and co-wrote the screenplay for* J.W. Coop.

At Parkland Hospital, trauma rooms were prepared and a dozen doctors headed for the emergency area. About five minutes after the shots were fired, the President and Governor Connally were brought inside the hospital; Connally, conscious but in intense pain, was wheeled into Trauma Room Two, President Kennedy was wheeled into Trauma Room One. As Mrs. Kennedy and Mrs. Connally waited, Governor Connally's right lung was expanded and later, Dr. Robert Shaw sutured the lung and damaged muscles. Kennedy's condition was considerably more grave. The doctors present in the trauma room initially heard what they thought were heartbeats in the President and thought he was alive. Dr. Charles J. Carrico put an endotracheal tube into Kennedy's bronchial area; Dr. Malcolm O. Perry performed a tracheotomy; Drs. Paul C. Peters and Charles Baxter inserted chest tubes for blood and air to be drained.

November 22, 1963 • Venezuela business and labor leaders form Committee for the Defense of the Democratic System

ROBIN BERLIN

I was six years old in 1963. My naive, idyllic childhood was halted when our entire elementary school was called to an emergency assembly on the playground.

The school's principal wept as she stood behind a microphone and addressed the students. "A great tragedy for our country has taken place," she said. "Our 35th President, John F. Kennedy was assassinated today. Our world has changed."

The children looked nervously at each other, whispering and shifting our feet, none of us realizing the magnitude of what had taken place. We could tell by the solemnity of the teachers that it was devastating, but couldn't comprehend how something so seemingly distant from us could have such an impact.

Despite our daily recitation of the Pledge of Allegiance, we'd never understood what it meant to be united as a nation, but we were suddenly and shockingly made aware that what held us together had been shattered.

We returned to the classroom, and our teacher asked us to take out our pencils and paper. She said, "Today is an important day in our nation's history, and you are witnesses. I want you to record it and save it and remember it."

And I did as I was instructed in silence, writing:

> November 22, 1963
> Our President, John F. Kennedy,
> was shot today in Dallas, Texas.
> Signed,
> Robin Ann Berlin

We returned home from school, and the mothers in our cul-de-sac were in the street, crying. They ran to us, and held us tightly.

I was a witness to history, and I did record it and remember it, and yes, I did save it to this day.

Sincerely,
Robin Berlin

ROBIN BERLIN *has worked as a producer on* Entertainment Tonight *and helped develop shows for MTV and Oxygen Media. She also produced the award-winning short* Dodgeball *and wrote the book* The Upside of Being Downsized.

"God, that was a beautiful day. The sun was out, been raining all morning, the air was...The first shot sounded like a firecracker. I looked over and I saw him, I could tell that he was hit. I don't know why I didn't react. I should have reacted. I should have been running flat out. I just couldn't believe it. If only I reacted I could have taken that shot. That would have been all right with me."

(Jeff Maguire, from the screenplay *In the Line of Fire*, 1993)

In the midst of all the chaos, Vice President Johnson and his wife had also been brought to Parkland Hospital and moved to a quiet area of the emergency room. Johnson, still sore from Agent Youngblood pushing him down, was rubbing his shoulder, which led to rumors—and even reported news—that he had been injured during the assassination and that he had suffered a heart attack. (Johnson had had a very real heart attack in 1955.) Neither Johnson nor the Secret Service agents—nor anyone in Washington—knew whether a wider plot existed to assassinate other government officials and the agents' goal at the moment was to keep Johnson alive and to ensure the transition of the Presidency, should Kennedy not survive.

November 22, 1963 - Navy divers search waters off Florida for Air Force pilot whose U2 plane crashed November 20

VANTAGE ENTERPRISES

November 22, 1963

I'd been in the big new office a few months but I know the truth...even though I'm a Vice President at a Hollywood studio, I'm still a kid in a grown-up's job.

Bob Gray runs Special Effects and we hunt and scuba dive together. I'm surprised to see him in my office...he's comfortable on the back-lot, not in the executive building. As well as I know him; I can't read the expression on his face --- sort of hurt and puzzled at the same time, like a man having a heart attack but in denial. He tells me Kennedy has been shot. My first thought is that it can't be too bad, he's the President. The doctors will fix him.

The scene on television is chaotic and I feel like I'm watching from underwater. Kennedy is in surgery and again I think the doctors will fix him. But an obscure and unconfirmed report chills me. An unnamed FBI agent had seen the President carried into the hospital and said that his injury was fatal. Before it's announced to the country, I know in my heart he is gone.

I become aware of the sound of a woman sobbing in the hallway. Callow fellow that I may have been, at that moment I realize how profound the change will be.

The next several days are surreal. There is an emotional umbilical between me and the television set. As I watch I drink, but I can't get drunk. Viewing the funeral, the production manager part of my brain marvels that an event of that scope and pageantry can be organized and come off flawlessly in those few days.

Although I had never met Kennedy, I begin to feel a personal sense of loss as I remember conversations with people who knew him well. I feel he represents the very best of we Americans and that ours is a colder and poorer country with his loss.

But I am young and strong and emotionally tough and no stranger to death close at hand. I do not cry.

December 10, 2000

I'm in D.C. and decide to walk. I walk all the monuments: Washington, Vietnam, Lincoln, Korea and FDR. I head across the bridge to Arlington and am drawn to the tomb of the unknown soldier. I watch the changing of the guard. The resolute faces of the young sentries seem to say "sleep well, we're here, we'll watch you".

I follow the winding path through the forest of marble and granite. The flame is before me, marking the surprisingly simple resting-place of John F. Kennedy. Suddenly, unexpectedly, a wave of emotion rolls over me. I feel a profound sense of grief.

Gone is the closely guarded unknown soldier who had given his last full measure...

Gone is a President, a man of elegance and grace and unrealized promise....

And gone is the youth who witnessed that long-ago tragedy but was then too strong to cry.

Standing before JFK's grave, after thirty-seven years, finally I weep.

Norman S. Powell

NORMAN S. POWELL's *TV credits as producer range from "The Big Valley" to "Rescue 911" and "Evening Shade" to Fox's current hit, "24."*

November 22, 1963 - Army reveals that U.S.-guided missile accidentally killed nine North Korean peasants

I was at aqueduct Racetrack in N.Y. with my father. after the 4th race of a 9 Race program, the announcer "FRED CAPPESELA" said over the loudspeaker.

Ladies and Gentlemen, I regret to inform you that the President of The United States JOHN F Kennedy has been assassinated. Racing will be discontinued.

There were about 20,000 people in attendance and yet you could have heard a pin drop

M. SAVARESE

It was complete Silence.
Every one was stunned.
Usually Race track crowds are
very loud and unruly. But
not this time. They all
quietly left the track in almost
Silence. Some were weeping

I will never forget it

Dick Van Patten

DICK VAN PATTEN *began acting as a child in Broadway classics like* The American Way *and* The Skin of Our Teeth. *He later became known for his TV work as Nils on "I Remember Mama" and as father Tom Bradford on "Eight Is Enough," as well as for appearances in numerous Disney films and Mel Brooks comedies.*

KATE MANTÍLINÍ

We had just recently opened the brand-new Brentwood Hamburger Hamlet in November of 1963. I was there working when my wife, Marilyn, called screaming to me about the President being killed! She said, "WE HAVE TO CLOSE!" "WE HAVE TO CLOSE!"And we did. The whole world was mourning.

Harry L. Lewis

HARRY LEWIS *was a former Hollywood actor who, with wife Marilyn, founded the popular Hamburger Hamlet restaurant chain, as well as the popular Kate Mantilini.*

Gene Reynolds

I HAD VISITED MY DENTIST IN THE MEDICAL BUILDING AT LINDEN AND WILSHIRE

AND WAS WAITING IN THE PARKING LOT FOR MY CAR. THE ATTENDANT'S STAND HAD A

TINY RADIO THAT WAS BEING GIVEN SERIOUS ATTENTION BY A SMALL GROUP OF MEN.

THEIR CONCENTRATION LED ME TO MOVE CLOSER.

I HEARD A REPORT FROM DALLAS DELIVERED WITH INCREDIBLE URGENCY.

AN ANXIOUS REPORTER DESCRIBED A LIMOUSINE, ESCORTED BY A SQUAD OF

MOTORCYCLES, RUSHING UP TO A HOSPITAL ENTRANCE JAMMED WITH ANXIOUS

ONLOOKERS.

" WHAT'S GOING ON?" I ASKED.

NO ONE ANSWERED. FINALLY, "THE PRESIDENTS BEEN SHOT"

ONE OF THE LISTENERS TURNED TO ME AND NODDED HIS HEAD.

IN OUR PARKING LOT ONE OF THE CARS WAS DELIVERED BUT ITS OWNER DIDN'T MOVE..

THE ATTENDANT WAITED PATIENTLY.

"YOU MEAN KENNEDY? KENNEDY'S BEEN SHOT?"

"THAT'S RIGHT."

THE RADIO BARKED."VICE PRESIDENT JOHNSON HAS EMERGED FROM HIS LIMO. HE IS

APPROACHING THE ENTRANCE OF THE HOSPITAL, HIS RIGHT HAND HOLDING HIS LEFT

ARM ABOVE THE ELBOW. "

"IS IT SERIOUS?" I ASKED.

NOBODY ANSWERED.

"DO THEY KNOW WHO DID IT?"

A GRIM FACED MAN TURNED TO ME, HIS MOUTH TWISTED IN A SLIGHT SMILE..

"ONE OF THOSE KU KLUX KLAN GUYS. ONE OF THOSE…"

TO THE OTHERS, HIS OPINION SEEMED TO HAVE MERIT.

AS I DROVE AWAY, I WAS AWARE HOW DIFFICULT IT WAS FOR ME TO ACCEPT THE NEWS.. I WAS GRATEFUL THAT JOHN KENNEDY WAS SO BLESSED WITH LUCK THAT HE WOULD SURVIVE AN ASSASSIN'S BULLET. BUT AS I LISTENED, THE NEWS BECAME DARKER AND THERE APPEARED TO BE A STRONG POSSIBILITY OUR PRESIDENT WAS NOT SO FORTUNATE. THE BODY HAD BEEN WHEELED INTO THE HOSPITAL, JACKIE AT HIS SIDE, DETERMINEDLY ATTENTIVE. DOCTORS WERE LABORING OVER THE PRESIDENT. THE NEWS KEPT GETTING WORSE.

LATER THAT DAY AS I WATCHED TELEVISION, I WITNESSED TWO COMMENTATORS IN WASHINGTON RECEIVING WORD FROM DALLAS. ONE MAN LOOKING STRAIGHT AT THE OTHER, RATHER THAN AT THE CAMERA, ANNOUNCED TO A STUNNED AMERICA "JOHN KENNEDY IS DEAD."

I AM A LIFELONG DEMOCRAT. I WAS A SUPPORTER AND ADMIRER OF JOHN KENNEDY AND I SAW IN THIS ACT A TERRIBLE LOSS OF TALENT, PRODUCTIVITY, LEADERSHIP, A CHANCE FOR PEACE IN VIET-NAM AND HOPE FOR MY COUNTRY, FOR OUR PEOPLE, AS WELL AS THE END OF AN OUTSTANDING INDIVIDUALS LIFE.

GENE REYNOLDS

Multi–Emmy Award winner GENE REYNOLDS was an actor for many years before he turned to producing, writing and directing television comedies and dramas, ranging from "Room 222" to "M★A★S★H" to "Lou Grant."

November 22, 1963 - In Atlantic City, middleweight champion Dick Tiger of Nigeria is examined for his upcoming bout against Joey Giardello at Convention Hall

And despite the doctors' attempts, they knew that the President would not survive when he was brought in. Fathers Oscar L. Huber and James N. Thompson of the Holy Trinity Church—Huber had seen President Kennedy in the motorcade only a short time before—were immediately called to the hospital to administer last rites, as Mrs. Kennedy watched. Shortly thereafter, Dr. William Kemp Clark told her the President had died. The time was fixed at 1:00 p.m., after the President had received conditional absolution. He was 46 years old.

I was an 18-year-old student at Hunter College Uptown (renamed Lehman College), in the Bronx, New York, when the word started to spread that President Kennedy had been shot. The student body was largely Democratic and this news was extremely devastating on many levels. We were idealistic then and many of us felt that President Kennedy epitomized all that we hoped to be and wanted to live up to, when he said, "Ask not what your country can do for you, ask what you can do for your country."

After hearing that the President was shot and indeed had died, the sense of hope that a better, more just society could be created—the hope that he engendered in us, and the desire to achieve for the greater good—was dashed in one murderous moment. There was deep mourning, along with shock and disbelief on the campus.

I was particularly very, very grief stricken, because I as a political science major and had just been accepted into a program at American University in Washington, D.C. called, "The Washington Semester." Students from different colleges were to meet people from all branches of the government, the media, lobbyists, etc., and the thought was that, maybe, I could get to meet President Kennedy in the spring. The realization came crashing down on me that I would be going to Washington, but there was no longer a chance of meeting the President I admired so much.

Therefore it was with a heavy heart that I alighted the public bus to go home, because Hunter College was an urban commuter public school, with no dormitories. I got on the bus and sat down behind two young men.

The neighborhood was heavily Jewish and Irish-Catholic. As a matter

of fact, until I was about 12, the word "Protestant" was unknown to me. I thought "Catholic" and "Christian" meant the same thing. There was an ethnic mixture of either Irish or Italian Catholic, or Jewish; all working- and lower-middle-class people. On the bus, I overheard the two young men, obviously Irish-Catholic, saying what a terrible thing the assassination was and "if we find out that it's a Jew who did it, there's gonna be a massacre here."

It was as if someone had punched me in the stomach. Here I was, in the midst of my own grief and sadness, and to be thought of, immediately, as a potential traitor to my country was extremely distressing for me. It actually was one of the reasons that I did leave the country for five years. The first thing I thought of was, "all you have on your mind in your time of grief is that you're 'gonna get the Jews.'" It was reminiscent of something that would happen in Europe. It pierced my heart that in this day and time, young American men would be saying the same hateful thing that had been said in Europe for hundreds and hundreds of years.

It was extremely distressing and demoralizing for me, especially since my father's mother, sister and her family had perished in the Holocaust. My mother was the sole survivor in her family, having arrived in the United States in June 1939. To them, America was truly the "Goldeneh Medina," the Golden Land. During my childhood my mother would sometimes caution me to be wary of gentiles, even seemingly good-willed neighbors, retelling the story of my father's 13-year-old nephew, who was hung by the Nazis in the town square in Dukla, Poland. He had been hiding and was betrayed by Polish neighbors.

After graduation, I worked in Washington for the Office of Economic Opportunity, Job Corps. I then received a graduate scholarship, and was the first woman to receive a New York State Legislative Internship in Albany. I earned a master's degree in human relations and group dynamics from New

York University. All the while the thought of wanting to be part of the majority, and not part of a religious minority, was germinating in my head. It began, I think, from the moment those two young men said those brutally cutting, anti-Semitic words that tragic day in 1963.

After working for the American Jewish Committee researching the history of bigotry in the United States, I worked for the National Council of Jewish Women. In December, 1970, I did finally move to Israel, on my own, without my family.

Living in Israel for five years and going through the Yom Kippur War and volunteering and helping the war effort while my Israeli husband fought on the front line in the Sinai Desert, gave me the sense of pride, strength and belonging in being a Jew that I needed.

I returned to the United States with my husband and young son. I settled in Houston, Texas, in a very welcoming community, both Jewish and general, feeling much more secure in knowing who I am—a "Jewish American," who is equally proud of the adjective and the noun.

Helene Wallach Zadok

Helene Wallach Zadok

HELENE WALLACH ZADOK *and her husband, Dror, own Zadok Jewelers in Houston, Texas. She serves on the boards of the city's American Jewish Committee, the Holocaust Museum and Houston's Home Instruction Program for Parents of Pre-School Youngsters.*

November 22, 1963 · Australian doubles players Ken Fletcher and Tony Roche, and Margaret Smith and Robyn Ebbern win the men's and women's finals at the South Australian tennis championships

BRUCE HORNSBY

I was sitting in my third-grade classroom, at the end of a Friday school day, listening to the voice on the loudspeaker announcing school bus departures. "Bus #47 for the Upper County children now boarding." All of the sudden the steady, but mellifluous drone of announcer Mrs. Driscoll was interrupted by the sound of a voice from a radio or TV broadcast coming through the speaker, stating, "President Kennedy has been shot in Dallas, Texas." Instantly, well over half the class (it seemed like virtually everyone) cheered and screamed, "Hooray! Now Nixon can take over!" Coming from a fairly liberal family, I was pretty shocked at this, but stayed quiet. Our teacher, Mrs. Nimmo, instantly scolded the kids.

Looking back, it's easy to see that this was a perfect example of kids parroting their parents' views, showing what a generally conservative area Williamsburg, Virginia was in 1963.

Bruce Hornsby

BRUCE HORNSBY *and his band,* The Range, *won the Best New Artist Grammy for their debut album,* The Way It Is. *Hornsby followed with many other group and solo projects as writer, producer and sideman, and was a part-time member of* The Grateful Dead *in the early '90s.*

November 22, 1963 • French government considers expanded agreement with Cambodia for economic assistance

Secret Service Agent Clint Hill appeared on "60 Minutes" more than a decade later to discuss the hazards of protecting a President and recalled the events of November 22, 1963 with Mike Wallace.

Hill: Had I turned in a different direction, I'd have made it. It's my fault.

Wallace: Oh, no one has ever suggested that for an instant! What you did was show great bravery and great presence of mind. What was on the citation that was given you for your work on November 22nd, 1963?

Hill: I don't care about that, Mike.

Wallace: "Extraordinary courage and heroic effort in the face of maximum danger."

Hill: Mike, I don't care about that. If I had reacted just a little bit quicker, and I could have, I guess. And I'll live with that to my grave.[3]

November 22, 1963 • Amalgamated Sugar reports earnings up 74 cents

6
Wayside...Roger and Out

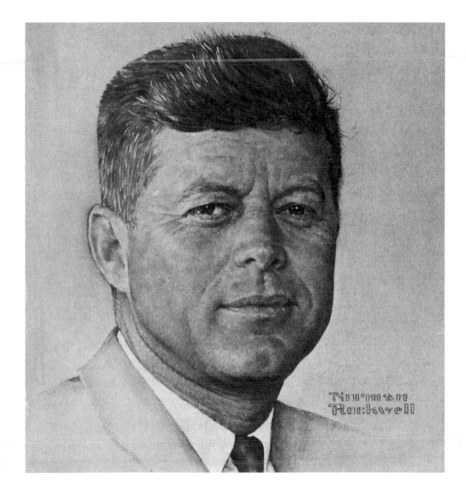

Riding in the press pool car on its way to Parkland Hospital, United Press International reporter Merriman Smith contacted the Dallas UPI Bureau via the car's radio phone. Within minutes, the wire services had picked up the news, interrupting a story about a murder trial in Minneapolis. Smith's first words that UPI transmitted came at 12:34, Dallas time: "Three shots were fired at President Kennedy's motorcade in downtown Dallas." Smith rode in the press pool car to Parkland Hospital and phoned the Dallas UPI number, relaying more information as word of the attack started to break and the horrible details came in pieces. By 12:39, the news flash read: "Kennedy seriously wounded perhaps seriously perhaps fatally by assassins [sic] bullet." Information from Dallas trickled out to newscasters, journalists and citizens at about the same speed, because of errors in communication, overloaded phone lines and the understandable chaos stemming from fear, the need for answers and the absolute surrealism of the situation.

Lee C. White

It was, obviously, a very traumatic day all over the country, but the enormity of it seemed to come piling in on me as the casket came awkwardly down that runway—a staircase, one of those portable staircases. Pierre (Salinger) and a gang of Cabinet officers were on their way to Japan and turned around and came back. For a while, with Pierre in the air and Mac Kilduff down in Texas; and Andy Hatcher, who was the other assistant press secretary, that Friday afternoon, had gone to the racetrack. So, I raced up the steps to the press secretary's office, which is the only place at that time where there were television sets, and I began to watch and all of a sudden, I realized that there was nobody there except for two women, who were sobbing. And I designated myself as the acting press secretary. And pretty soon—you know, all the regular people were down in Texas with the Presidential entourage—all of a sudden, the reporters started piling into Pierre Salinger's office and who did they find, but little old me. I called Mac Bundy, who was still in Washington in the White House, and he wanted to know what I knew. I said, "I don't know anything more than what I see on the television set. What do you know?" He said, "Nothing." It was bedlam. I was there for about two or three hours and a fella by the name of Charlie Horsky, who was special assistant to the President for District of Columbia affairs, an old friend of mine, showed up and

said, "If you want to take off for a little while, go ahead." Which I did. It was confusion squared. Or maybe cubed.

For me, I'm such a plodder—I go from A to B to C to D to E. Kennedy's mind was such, he would go from A to Q and then back to F and then over to Z and then over, maybe at T and stop at G. He was very quick and he was easy to work for. One of the early things he had to handle was the proposed execution of a soldier at Fort Leavenworth, Kansas. The crime had happened before Kennedy became President. It had gone all the way through the military command and got up to Eisenhower and he said he wasn't going to change the sentence of death. So now, it landed on the new President. Presidents very rarely handle a potential death sentence and this was only because it came through the military channel. And boy, did Kennedy go into that thing; I handled it from a legal point of view and General Ted Clifton, who's a military advisor, handled it from the military point of view. And God, he just grilled us and grilled us—wanted to know what...told us to get some more information, psychiatric information and what had been done and who had done it. The material was assembled, we went back probably a month, maybe six weeks later and, again, this guy remembered every single detail of the situation and what had happened. He finally decided that he was not going to change Eisenhower's decision.

He did have that charm, that sparkle, and if you have seen some of the repeats of his press conferences, they're masterful. One of the things I got to do occasionally was prepare for a press conference with him— with a lot of other folks. What a terrific way of finding out what's going on in your government, because woe be unto the Information Officer who didn't tell him about some damn thing he should have told him about. Now, he's having a conference and somebody asks him a question and honest to God, nobody could have prepared him for that: (the journalist) says, "Mr. President—you know, we journalists are in a competitive business. And it's obvious to us that you knew some of those reporters before you became President and you seem to be continuing your relationship with them and it puts us at a competitive disadvantage." And he paused a little bit, sort of smiled—you know, the damn smile, just amazing—and he said, "Well, yeah, I hadn't thought about it from that point of view, but let me tell you the way I see it. This is not a very good place to be making new friends, so I think I'd better stick with my old friends." Just the manner and how he handled that, showed his quickness and how deft he was on his feet.

Lee C. White

LEE C. WHITE *was a White House staff member from 1961 to 1966, handling civil rights issues, drafting and receiving Presidential executive orders, pardon applications and executive privilege questions. He later was chairman of the Federal Power Commission and is currently counsel at Spiegel & McDiarmid in Washington, D.C.*

BUCK HENRY

In the fall of 1963 I was working as a staff writer for "The Garry Moore Show." On November 22nd, we were going to tape (or kinescope—I'm not sure which) the show in front of an audience in the old Ed Sullivan (now home of David Letterman) Theatre on Broadway.

On my way to the theater, I got the news that something bad had happened in Dallas but no one was as yet sure how bad it was. Ordinarily, the atmosphere inside the theater was lively, noisy and funny. It was quiet on this day. Rehearsals had to go on until the network pulled the plug. So Garry and his sidekick, Durward Kirby, and the guest stars were singing and dancing and going through the sketches like automatons.

Just inside the stage entrance was a doorman's booth where keys were kept and messages were sent and given. The doorman was an old Kennedy fan. He had torn a photograph of the President from a magazine and pinned it to the wall in back of him. In removing it from the magazine, he had torn part of Kennedy's head away. That image haunted us for some time.

We hadn't gotten far into rehearsal when Walter Cronkite made his unforgettable announcement. But rehearsals went on for another 15 or 20 minutes until the network called and told us to wrap it up. For that period of time, the dancers—a line of eight or ten really pretty girls—were working out a routine at the front of the stage. The last thing I remember before I went home was the sight of those girls—all in a line—their arms around each others' waists—weeping as they kicked in unison.

Buck Henry

BUCK HENRY's *numerous credits as a writer include co-creating "Get Smart" and the screenplays for* Catch 22, The Owl and the Pussycat *and* To Die For. *He was nominated for Oscars for co-writing* The Graduate *and for co-directing* Heaven Can Wait. *He has also acted in such films as* Taking Off, The Man Who Fell to Earth *and* Short Cuts.

As details of the assassination began to spread, the White House staff was in disarray. Secretary of Defense Robert McNamara and Special Assistant to the President McGeorge Bundy were in the Pentagon, while Secretary of State Dean Rusk and five other Cabinet members were in a Boeing 707 jet—aircraft 86972—over the Pacific, on their way to Tokyo for a state visit. Pierre Salinger, who had met the Kennedy staff the day before in Honolulu, was also traveling on the jet and had a special mission: to put out feelers about Kennedy possibly visiting Japan in 1964. The jet was headed to Wake Island to refuel before proceeding to Tokyo when Rusk, the ranking Cabinet member onboard the aircraft, read the first UPI reports from a newspaper Teletype on the plane. Salinger recalled, "I kept reading it over and over again...The words stayed on the paper. They would not go away."[1] As Rusk considered which staff and Cabinet members should go to Dallas and which should go back to Honolulu, Salinger received reports from the White House Situation Room, with conflicting information about the President's condition and instructions on where or how to proceed. The Situation Room was following the press reports, just like everybody else in the country.

Situation Room: "Hold on the line there, Wayside (Salinger's code name). We have some more information coming up. I read from the AP bulletin: 'Kennedy apparently shot in head. He fell face down in back seat of car. Blood was on his head. Mrs. Kennedy cried, "Oh no," and tried to hold up his head. Connally remained half-seated, slumped to the left. There was blood on his face and forehead.' I have nothing further for you now. I will contact you if we get more."

Salinger: "This is Wayside, roger and out."

November 22, 1963 • Toronto and Montreal Stock Exchanges close on news of assassination

Tom Snyder

On that day in November, I was shopping at a men's clothing store on Wilshire Boulevard. Around 10:30 that morning, a man ran in and yelled, "Kennedy's been shot in Dallas. He's being taken to a hospital." Without hesitation, I ran to my car and headed for the Hollywood studios of KTLA, where I had been working as a television news reporter for about six months. Back in the studio, another reporter, Stan Chambers, was on the air live, relaying information from Dallas that was coming over the wires. And from Walter Cronkite. A television receiver in the room near the studio was tuned to CBS. Cronkite was on the air from New York. The Dallas part of the story was being covered by correspondents there, including Dan Rather if my memory is correct. Suddenly there were five bells ringing on all the teletype machines, indicating at the time what was called a news flash. The flash was two words: "KENNEDY DEAD." As Walter Cronkite reported the President was dead, his voice cracked and his eyes welled up with tears. As did everyone's in the KTLA studio. It was the beginning of a four-day telethon covering the death of JFK. It still seems surreal after all these years. And America hasn't been the same since.

Tom Snyder

TOM SNYDER *is one of TV's most recognizable broadcasters, as the host of NBC's* Tomorrow *from 1973 to 1982 and* The Late Late Show with Tom Snyder *from 1994 to 1999.*

Janet Leigh

November 22, 1963,
I was driving merrily along on my way to NBC Studios in Burbank to rehearse for a Bob Hope Show. The music from the cassette blasted loudly, but my mind was thinking through the final arrangements for my daughter's birthday party that night.
I approached the gate and the guard ran toward the car.
"Miss Leigh-- Miss Leigh-- the President-- shot-- Dallas---."
The poor man was so agitated he could barely talk, but I understood enough to make me hightail it to the main building. I left my car haphazardly in the middle of the street and dashed up the steps. The doorman pointed excitedly, "Everybody's in the projection room watching the news-- right down that hallway-- second door on the left-- it's terrible-- terrible---."
When I opened the door I could see shapes sitting, staring at the big screen, listening to Walter Cronkite. "--- shots were fired at President Kennedy's motorcade in downtown Dallas. The first reports say that President Kennedy has been seriously wounded by this shooting."
In deafening silence we heard reports from Texas, bulletins from Associated Press, live broadcasts from the Trade Mart where the President was to have attended a luncheon. There was an ominous visual image, workmen removing the presidential seal from a podium on the dais.
Suddenly, Walter Cronkite reappeared and read a note he held in his trembling hand. "From Dallas, Texas, the flash apparently official, President Kennedy died at 1:00P.M. Central Standard Time."
Obviously emotional, Cronkite hesitated and looked at the clock, "Some thirty-eight minutes ago!"
I will never forget that moment or the overwhelming despair that enveloped my soul. On Sunday my children witnessed an unexpected actual murder on television, the killing of Lee Harvey Oswald by Jack Ruby. And I realized the world would never be the same again. We all had been robbed of our innocence.

Janet Leigh

As a teenager, JANET LEIGH *was spotted by Norma Shearer and signed to a contract with MGM, leading to her debut film* The Romance of Rosy Ridge. *Other classic film credits include* Prince Valiant, My Sister Eileen, Touch of Evil, The Manchurian Candidate *and, of course,* Psycho, *for which she was nominated for an Oscar.*

Television was quick to respond with the facts that they could obtain. In his memoir, David Brinkley—then the NBC anchor with Chet Huntley—recalled, "We decided to lead that night's news program with Kennedy's trip to Texas. Not because it was such a big story. It wasn't. But because that day there was nothing else."[2] CBS broke the news at 1:40 p.m., Eastern Standard Time—interrupting the soap opera "As the World Turns"—as anchorman Walter Cronkite spoke off-camera from the New York newsroom: "In Dallas, Texas, three shots were fired at President Kennedy's motorcade in downtown Dallas. The first reports say that President Kennedy has been seriously wounded by this shooting." In Dallas, CBS News reporter Dan Rather had run to the CBS Bureau at KRLD-TV and phoned Parkland Hospital. In *The Camera Never Blinks: Adventures of a TV Journalist*, Rather remembered an operator telling him that the President had been shot; he then spoke with a doctor.

"'The lady on the switchboard says that the President has been shot and I'd like to verify that with you.'

'Yes', he replied, 'the President has been brought in and it is my understanding that he's dead. But I'm not the person to talk about it.'

I said, 'Would you repeat your name for me, Doctor?'

He said, 'I'm not the person you need to talk with,' and there was a click on the line."[3]

The day the President was assassinated, I was sitting in a conference room with other executives of the CBS Radio Network discussing the current business status. Someone brought a message into the meeting that the President had been shot in Dallas.

There was a black and white television set in the conference room so we turned it on.

While we were watching, Walter Cronkite removed his glasses, looked at the clock, and with a slight choke in his voice, announced that President Kennedy had died.

At that time, the CBS Radio Network was located in its own building on 52nd Street just off Madison Avenue. A senior executive who knew I was Catholic, suggested we walk one block south to St. Patricks Cathedral and say some prayers for John F. Kennedy.

And we did, on November 22, 1963.

Sincerely,

Gene F. Jankowski

GENE F. JANKOWSKI *is Chairman of Jankowski Communications Systems and an advisor managing director at Veronis Suhler Stevenson, a leading independent merchant bank. He was President and Chairman of the CBS Broadcasting Group from 1977 to 1989 and co-wrote the book* Television Today and Tomorrow.

TELEVISION BUREAU OF ADVERTISING

The Media Department of any Advertising Agency is a constant buzz of activity-
but on this Friday, November 22nd in 1963 the air of noisy chatter in mid-
sentence was squished into a velvet hush.

I was then a Media Supervisor at Dancer-Fitzgerald Sample, (now part of Saatchi
& Saatchi Advertising) - and that Friday morning was no different from any other
day on the very busy Media 6th floor at 347 Madison Avenue in New York.
Suddenly the outside chatter softened and disconnected words: *President, Shot,
Dallas* - punctured the air. It was midday and I had lunch at my desk and was
getting ready to finish the afternoon and head home for the weekend. This
change in the outside noise level was curious – somewhat annoying in fact - and
so I stuck my head into the outer bullpen to find out what it was all about.

I couldn't come to grips with anything concrete. Somebody obviously heard
something and it was like an unconfirmed story slithering from person to person.
You couldn't connect to anything. The chatter was not specific and it seemed to
wander. The sense was that something tragic had just happened, but what? And
those words continued to rise over the din; *President, Shot, Dallas.*

It was unsettling. I needed to find out what the heck was going on. I quietly and
quickly walked up one flight of stairs to the seventh floor where I knew there was
a television set in the Conference Room. I wasn't the first one to get there.

Walter Cronkite was on the screen. He said the President had been shot, was
taken to Parkland Memorial Hospital and that the situation was grave. He soon
after reported that a Priest had just been summoned to give the President last
rites. Then - I think just after 1:00pm – he said; "the President Was Dead". He
removed his glasses, sort of wiped at them and one could see that he lost it for
just a bit.

It was over. The worst had been confirmed. The story started to unfold and over
the next several days we all watched as the world turned upside down. Through
the weekend we stayed glued to the television set in a hazy devotion to the
happenings of a funeral, the mourning and dirge music that goes with that. We
watched from morning through a good part of the night with a sense of anger and
a large pit sitting in the bottom of my stomach. We watched as a heartbeat of
Americana passed into history.

Ave Butensky

AVE BUTENSKY served as president of the International Radio and Television Society and the IRT Foundation and is a past president of the Television Bureau of Advertising.

As Rather was confirming his information, KRLD News Director Eddie Barker—reporting from the Trade Mart where Kennedy was to have appeared—had confirmed the President's death with the Parkland Chief of Staff. The information about Kennedy's death was inadvertently passed onto CBS Radio before confirmation was obtained, however, and Cronkite, waiting for official word from the hospital, finally reported at 2:37 p.m.: "From Dallas, Texas, the flash, apparently official. President Kennedy died at 1:00 p.m., Central Standard Time, two o'clock Eastern Standard Time." The sight of Cronkite taking off his glasses, clearing his throat, and struggling to keep his composure is part of journalism and television history. The television coverage continued for hours, for days. Theodore H. White wrote that television "achieved greatness in November, 1963, by reporting true drama with clarity, good taste, and responsibility, in a fashion that stabilized a nation in emotional shock and on the edge of hysteria."[4] David Brinkley put it more succinctly: "I believe it was television's finest hour."[5]

November 22, 1963 - Music program on Budapest radio is interrupted to announce President Kennedy's death

Houston Chronicle

On November 22nd, 1963, I was Research and Promotion Manager of the Houston Chronicle. My responsibility was the promotion of the Chronicle in circulation, advertising and public affairs.

A bunch of us junior executives at the paper had lunch regularly at the old Rice Hotel coffee shop, right across the street from the Chronicle and on that day the group included most of the circulation execs along with a couple of our news editors as well as me. While we were just finishing our meal, a young circulation fellow appeared at our table telling us about Kennedy's being shot. We all jumped up and ran out almost forgetting to pay the check.

We were yelling at each other as we crossed the street about increasing our press run for the last edition (we were an all afternoon paper then) and how fast could we could print newsrack cards for distribution and how soon could we get announcements over the air on the paper's affiliated radio and tv stations.

Inside the paper the news desks were going crazy as Kennedy had spent the previous night in Houston, at that Rice Hotel across the street, and interviewers and photographers were all over the hotel.

The hectic pace continued for days and finally returned to somewhat normal, but the effects remained and secondary stories about why Kennedy was in Houston, etc., continued for weeks.

All good wishes,

RICHARD J.V. JOHNSON *began his career at the* Houston Chronicle *in 1956, and became the paper's president in 1973. He is currently chairman emeritus and received the Houston Advertising Federation's Lifetime Achievement Award.*

**SARNOFF
ENTERTAINMENT
CORPORATION**

THOMAS W. SARNOFF
President

On the date of November 22, 1963, I was at home preparing to take a trip to Las Vegas with my wife for her birthday that weekend. Needless to say, like almost everyone else in America, I think we were glued to the TV set watching the news reports of the unbelievable events of that day.

Just the night before, on November 21, I was functioning in my capacity as Chairman of the First Annual Brotherhood Testimonial Dinner of the National Conference of Christians and Jews for the Broadcasting and Motion Picture Industries. Our honoree was Danny Kaye. Long after that fateful next day, I realized that I had received one of the last telegrams, or perhaps the last one, ever sent by President John F. Kennedy. It was a chilling feeling. A copy of that telegram is enclosed herewith.

I sat next to Sandy Vanocur, who spoke at our Dinner, and I remember him telling me of his concern about the President traveling to Dallas the next day. He must have had some inexplicable prescience.

Although I was not politically a supporter of President Kennedy, I shared the horror and disbelief of millions of other Americans. He was my President, the most powerful man in the most powerful nation on Earth, and he was eliminated by one insignificant human like any other mere mortal.

I was a member of the Television Industry, but I was still very impressed with the coverage on that day and the dark days that followed. Television proved beyond any doubt that it was the most significant means of communication ever devised. I was even more impressed, however, by the smooth transition in leadership that took place. It confirmed that no matter what catastrophe our Country might face, it would always be strong enough to survive.

Sincerely,

Thomas W. Sarnoff

Telefax • Telefax

(3)

434P PST NOV 21 63 LB283 OE369
SPF360 LE238 OB381 PB440 O P WB242 RX GOVT PD
THE WHITE HOUSE WUX WASHINGTON DC-21 618P EST
THOMAS W SARNOFF, REPORT DELIVERY
FIRST ANNUAL BROTHERHOOD TESTIMONIAL DINNER LE GRAND TRIANON
 BEVERLY WILSHIRE HOTEL , CARE ASST MGR ON DUTY
 BEVERLY CALIF
ON THE OCCASION OF YOUR FIRST ANNUAL BROTHERHOOD TESTIMONIAL
DINNER I AM DELIGHTED TO JOIN THE MEMBERS OF THE BROADCASTING
AND MOTION PICTURE INDUSTRIES IN THIS TRIBUTE TO DANNY KAYE.
THAT YOU HAVE SINGLED OUT DANNY KAYE-- KNOWN AND ADMIRED THROUGHOUT
THE WORLD FOR HIS WORK ON BEHALF OF UNICEF FOR YOUR FIRST AWARD
IS MOST APPROPRIATE. DANNY KAYE HAS GIVEN GENEROUSLY OF HIS
TALENTS TO ALL PEOPLES OF THE WORLD, PARTICULARLY TO CHILDREN,
AND I AM HAPPY TO EXTEND TO HIM MY CONGRATULATIONS AND WARM
BEST WISHES.

1270 (1-51)

WESTERN UNION

Telefax • Telefax

2/OPW3242

THE WHITE HOUSE HAS RECENTLY FELT THE ABSENCE OF ITS MOST CONSTANT
WATCH-DOG, SANDER VANOCUR, AND IT IS ENCOURAGING TO KNOW THAT
MR SARNOFF IS EXERCISING HIS EXECUTIVE PREROGATIVE IN PUTTING
HIM TO WORK AGAIN THIS EVENING. I HOPE THAT HIS TALENTS AS
AN ENTERTAINER IN BEVERLY HILLS WILL NOT PERMANENTLY IMPROVERISH
US OF HIS NEWS SENSE IN WASHINGTON.
 TO ALL OF YOUR MEMBERS WHO ARE JOINED IN A COMMON CONCERN
FOR THE HUMAN RIGHTS AND OPPORTUNITIES OF ALL AMERICANS, I
EXTEND EVERY GOOD WISH
 JOHN F KENNEDY

1270 (1-51)

THOMAS W. SARNOFF *was president of NBC Entertainment Corporation and later formed Sarnoff Entertainment Corporation in 1981. He has been on the boards of numerous institutions, including the American Film Institute and former president of the National Academy of Television Arts & Sciences. He is currently chairman and CEO of the Academy of Television Arts and Sciences Foundation.*

"...on my desk all twelve of my incoming lines were lit. As I stared, one of them blinked dark and I grabbed it hoping to get an outside line. And she said with all the broad 'a's that pass for culture in America:

'Hello, hello, hello. Is this CBS?'

I reported that she had reached our newsroom.

'I want to complain,' she complained, 'of your having Walter Cronkite on the air at a time like this, crying his crocodile tears when we all know he hated Jack Kennedy.'

I was in no mood to listen to such unfair and distorted reasoning. I asked the lady's name and it was, as her accent indicated it might be, hyphenated. Something like Mrs. Constance Llewellyn-Arbuthnot. She also threw in her Park Avenue address for full measure of her importance.

With all the outraged dignity I could muster, I told her: 'Mrs. Llewellyn-Arbuthnot, you are speaking to Walter Cronkite, and you, madam, are a damned idiot.'"

(Walter Cronkite, *A Reporter's Life*, Alfred A. Knopf, 1996)

November 22, 1963 · All commodities on Chicago Board of Trade drop following news of assassination

Norm Crosby

On Nov. 22, 1963 I was appearing with the McGuire Sisters at a nightclub in South Boston called Blinstrub's. Blinstrub's was the largest nightclub (1700 seats) in the New England area and, as such, was home to many political functions including many by the Kennedys and was frequented very often by Richard Cardinal Cushing, who was the Kennedy family priest.

Cardinal Cushing and Stanley Blinstrub were very close friends and Mr. Blinstrub would turn the club over to the Cardinal on Easter, Thanksgiving and Christmas, when the Cardinal would put on a white apron and serve free holiday brunches to the poor and homeless. The McGuire Sisters and I were appearing on a live local TV show the afternoon of Nov. 22nd and when we exited the studio we discovered the entire building in chaos. Someone shouted that the President had been shot and we all ran into the newsroom and listened to the reports coming in over the wire.

After a while I drove home; I lived in Dorchester then, and found my Mother in tears. "The President is very seriously hurt," she told me because that's what was being broadcast at the time. Shortly after, I received a call from Gloria, Mr. Blinstrub's secretary,

informing me that the club would, of course, be closed for the evening. About an hour later Gloria called back and explained that an insurance company had invited about 800 people from all over New England to a dinner that evening in Blinstrub's and there was no way possible to contact everyone and cancel. We would have to come in after all.

It is possible to sing songs or dance perhaps to a saddened and shocked audience but I am a comedian and performing for 800 stunned and devastated people in a nightclub that Jack Kennedy frequently attended on the very night that he was assassinated was certainly one of the most difficult things that I have ever done in 40 years of entertaining.

Fortunately the audience understood, they recognized my grief and we were able somehow to make it work. You asked if I remember the day that President Kennedy was shot? Sure I do, I can never forget it.

Norm

NORM CROSBY, *that master of malapropisms, has been entertaining audiences with his stand-up comedy routines for more than 40 years.*

Sharon Goodman

I was six years old the day JFK was killed and too young to have my own feelings about his death. However, that event is one of the very few I remember from my early childhood, because I experienced it through my mother's eyes. I was sick and stayed home from school that day. When the news broke about the shooting, I was in my parents' bedroom, watching children's programming on PBS. I was startled when they cut to a "Special Report" and, although I didn't understand what was going on, I knew it was important. I called out to my mother telling her to come quickly, that something had happened. She came into the room with a smile on her face and flopped down on the bed, on her stomach. I watched her as she watched the TV. As she began to grasp what had happened, her smile disintegrated and a look of horror took its place. She wouldn't let me see her break down, so she ran out of the room. I was confused and scared and will never forget that moment.

Sharon Goodman

SHARON GOODMAN, *a lifelong resident of New York City, works in marketing and administration for a large international law firm. She is also an actress who has performed in theater, film and television. Ms. Goodman is a graduate of Yale College.*

Meanwhile, the Cabinet members aboard 86972 also received the grim news.

Situation Room: "This is Situation Room, relay following to Wayside. We have report quoting Mr. Kilduff in Dallas that the President is dead. That he died about 35 minutes ago. New subject. Do you have that? Over."

Salinger: "The President is dead. Is that correct?"

Situation Room: "That is correct. That is correct. New subject. Front office desires plane return to Washington with no stop Dallas."

Allan Burns

When I write I tend to have the radio or a recording playing in the background; the soothing sound of music, turned low, helps to fill in all those awful empty spaces when I wait for my brain to provide inspiration for my fingertips as they hover over the keyboard.

On November 22, 1963 I was one of a gaggle of comedy writers working for the lovably loony Jay Ward, creator and producer of the now-legendary *Rocky and Bullwinkle* cartoons, who had decided, after many years of doing successful animated programs, to attempt a venture into the world of live television. I, like all of Jay's minions, had been turned loose to come up with funny material for a CBS pilot called *"The Nut House"*, an hour-long grab-bag of sketch comedy, animation and song that, had it succeeded, might have been to 1963 what *"Laugh-In"* became a few years later. As one might imagine, Jack Kennedy, (who was to comedy writers in the sixties what Bill Clinton was to become in the nineties -- the comedian Vaughn Meader had sprung out of obscurity with his dead-on impressions of JFK and became a sensation on tv and records), was a rich lode of mineable material for our writing staff. I was in the middle of a rewrite of a JFK sketch when our pretty blonde receptionist stuck her head in my office door and saw me busily typing away. "Turn up your radio. The President's been shot," she said, her voice trembling, then, seeing the look of confusion on my own face as the impact of her words hit me, turned up the volume herself. I realized that the background music I had only been half aware of had been replaced by an urgent-sounding newsman trying to keep up with bulletins coming over the teletype . People started coming out of their work cubicles looking baffled and stricken, and saying things like "Oh, my God" and "Jesus!" and shaking their heads in disbelief until someone found a little tv set and turned it on and there was Walter Cronkite, the imperturbable one, looking a bit shaky himself, giving us, as best he could, a running commentary on the events as they played out. It was, I remember someone saying, eerily like watching Cronkite on "You Are There", but this time it the 'you' was us and the 'there' was now. I don't need to describe the expression on Walter's face when the final, awful news came; it is forever etched into our collective consciousness, like the video pictures of the hijacked jet crashing into the second tower of the World Trade center.

Outside, on Sunset Boulevard, we and a bunch of other people from nearby buildings milled about, all of us looking pole-axed by the news, before we headed, for some unexplicable reason, down the block to a nearby outdoor hot dog/hamburger joint called 'The Plush Pup' that was, oddly, in this moment of national shock, doing land-office business. People were eating, maybe just for the comfort it gave them, but no one seemed to be talking. Well, almost no one -- one of the comedy writers, unable to resist the temptation, made a tasteless Kennedy joke and someone else (could've been me) told him to shut the fuck up.

It was two days later, after having been unable to tear myself away from the relentless television coverage of the events except to sleep, that I eventually came back to my office. The half-written sketch was still in my typewriter. I yanked it out, started to read it, found I couldn't get past the first couple of lines, balled up the paper and dropped it into the wastebasket.

I've often wondered what poor Vaughn Meader must have gone through that day.

Seven-time Emmy Award winner ALLAN BURNS *has written for such shows as "Get Smart," "He and She" and "Room 222," and co-created "The Mary Tyler Moore Show" and "Lou Grant" with James L. Brooks.*

Vaughn Meader

Coming out of the Village, where I was at the time, were a number of people who started to do a little political humor and stuff like that. That's what I started to do in my act, material from newspapers. And I would spoof politicians—Senator Dan Haskins said, "Too bad unemployment comes when so many people are out of work"—with different dialects and so forth. And one night I said, "Well, the President said last night..."—and the place cracked up. So, I kept it in. A talent scout—who later became my manager—came through the Village, saw me, and got me up to audition for the producers of a summer replacement show called "Celebrity Talent Scouts." They kind of liked my material and it was the first show of the summer and I got out-of-sight press coverage. A writer, Earle Doud, called Bob Booker, a friend of his, a DJ from Miami, also a writer, and said, "Hey, I saw this guy on television. It would be a great idea for an album." They started writing in August and did a demo, like one or two bits, and they took that around and tried to sell it—and nobody bought it. None of the majors wanted it. In fact, somebody at Columbia said, "We wouldn't touch it with a 10-foot pole," and at Christmas, Earle Doud sent the guy a 10-foot pole.

So, finally Archie Bleyer at Cadence Records said, "We'll give it a try." And so, he funded it and it was put together and we went in and recorded it on the night Kennedy made the speech about the Cuban Missile Crisis. The actors were in the bar listening to the speech and the audience was out in the studio drinking, having a cocktail, right before we went in for the final take. Had the audience heard that speech, they might not have had the audience reaction. It was put on

the air—unbeknownst to anybody—by a friend at WINS, a rock and roll station at the time, slipped it on to do Earle Doud and Bob Booker a favor. The DJ was a friend and it was late at night and they figured nobody would hear it anyway, so he slipped it on and played it—just for a goof. He didn't clear it with the station manager or anything. But the reaction was so strong, and then other DJs—the hip, liberal DJs in New York—started playing it and they couldn't stop it.

(Pierre) Salinger was driving to town and he came back to the White House and reported he had heard a voice on the radio that was unmistakably John Kennedy replying to a question about a Jew being President. Salinger didn't hear the setup or anything, he just tuned in and heard the question, "What do you think about a Jew being President?" And the answer was, "Well, I think it'd be proper. I know as a good Catholic, I couldn't vote for him, but other than that..." And then he heard the joke and then he heard the DJ mentioning it and he got to the White House and said something has to be done. And they took it very seriously. They went to the point of calling radio stations to get it bounced. I had my enemies in the Oval Office! It was so quick, they had to put their best face forward and there was a press conference where Kennedy said, "I think he sounds more like my brother, Teddy, than me." They wanted to show themselves as pretty good guys. But Schlesinger, Salinger, there were a couple who were really paranoid—you know, wag the dog—and they got scared that I'd pick up the phone and call Russia or something.

The interesting thing is a lot of people, young comedians, who tried to do the voice of John Kennedy actually were doing my voice. And the

fact that people think, when they recall the sound of John Kennedy, they really, in a way, recall me as well and maybe more so because they heard Kennedy maybe once a week or once a month at a press conference but during those days, they were listening to that album—every day, every night. It was phenomenal.

I was called to do a concert for the Democrats and I was getting in a cab in Milwaukee to go entertain. You know, I heard so many of the Kennedy jokes—they'd recognize me and boom boom, the first thing I'd get is a Kennedy joke or, "Listen, Mr. Meader, listen to my son do..." And the cab driver turned around and said, "Hey, did you hear about the President getting shot in Dallas?" And I said, "No—how does it go?" And at that moment, I heard on the radio behind him the news from Dallas. So, needless to say, the joke was over. It was, you know—you're not funny, man, anymore. And pity was the worst thing, especially for a comedian and a funny man. The next week or something, I'll never forget, I'm walking up Madison Avenue in New York, and this big bruising, hard-hat guy with a rivet gun was riveting up the cement in the streets. And he saw me and he stopped and he turned off his jackhammer and he walked over to me and he pumped my hand and, almost with tears in his eyes, said, "I'm really sorry, man."

VAUGHN MEADER's *performance as John F. Kennedy on the album* The First Family *was recognized with Grammys for Best Comedy Album and Best Album of the Year for 1962. He went on to make more recordings, like* Have Some Nuts!!! *and* The Second Coming.

November 22, 1963 • Critics' screening of "Dr. Strangelove" canceled; later director Stanley Kubrick replaces a specific reference to Dallas by character Major Kong (Slim Pickens) with "Vegas"

⯀ BOB BOOKER PRODUCTIONS

Earle Doud and I saw Vaughn Meader on a "Talent Scouts" program and then we went down to a small club in the Village where he was working. And to us, he was the guy.

Doud and I died with almost every record company we tried. We got it to ABC-Paramount and the President, Leonard Goldenson, wanted to hear it himself. So, we went up to the offices and there was Goldenson, about eight attorneys and Eisenhower's former press secretary, who had been hired by ABC Television as a news consultant. About 80 percent of the demo was in the final album and, I mean, not a laugh, not a smile in 35 minutes. Eisenhower's guy got up and said, "I think it'll be a great thing for the Communists all over the world. I think it's a pure attack on the United States government and Mr. Kennedy, and I wouldn't touch it ever."

On the night of the taping—October 22nd, 1962—we knew Kennedy was going to speak so we had a TV set put in the green room behind the studio—Fine Studios on West 59th Street in New York. We watched the speech and the audience didn't. And we went out and did the show and, of course, it worked like a million bucks. And we did it in one take. I talked to Archie Bleyer afterwards and he was very down because of Kennedy's speech and he said, "Well, as far as I'm concerned, you know, you can burn it, you can forget it." I said, "I think you're jumping to conclusions." We went ahead with the production

and, of course, everything eased off down in Cuba and we released the album on November 13th. It sold six and a half million copies in about six and a half weeks.

I think the reason that Kennedy loved it so much himself is because we humanized him. The thought that Doud and I had going into it was this man is not only the President of the United States, he's a movie star. He's bigger-than-life. And we said if we take that figure and put him in everyday simple situations—fish-out-of-water—that's funny. And that's what we did. Kennedy bought a hundred copies and gave them as Christmas gifts.

Merriman Smith was the senior White House correspondent, with the *New York Times* and UPI, and was with Kennedy constantly. Right after the album came out, he called me from Washington. He said, "I was in the Cabinet meeting with Kennedy this morning. He came in and said, 'Today, we are here to discuss the problem with Cuba, the steel industry, but first...' And he takes out a record player and plays the album for the entire Cabinet. He referred to it as 'my album.' He actually said to people, 'Have you heard my album?'" Smith said, "Bob, you would have died. First of all, every time Jack laughed, they all laughed."

There was a press conference in which they asked Kennedy about the album. Now, if there is a commercial question, you have to present it in advance to the President and it's decided whether he will answer it. So, they submitted the question to him about the album and he said that he would be happy to discuss it. And he said, "It sounds more like Teddy." Then, they went to Teddy the next day and Teddy said, "Well, it sounds

more like Bobby." Then they went to Bobby...we got three days out of that on network.

I was having lunch with Allen Ginsberg and Bobby Dylan in a joint down in the Village when I heard about Kennedy getting shot. Allen was starving to death in those days and any kind of free meal, you know, Allen would take advantage of and rightfully so. I got a call from my secretary. And I took the phone and, like everybody else, I thought it was a joke. And then—everybody left.

It was about seven days after the assassination and Lenny Bruce was scheduled to come back to New York. It was his first appearance after a couple of years, so he went ahead with it, despite the fact that most Broadway shows had shut down. So, Lenny came out on stage that night—a Loews-Fox theater downtown on the east side of Manhattan— jam-packed. And, as Lenny did many, many times when he came out on stage, he would stand there maybe two or three minutes. He had notes he would take out of his pocket and look at them. He walked up to the microphone and he didn't say good evening or anything—you could hear a pin drop. And he said, "Boy, did Vaughn Meader get fucked."

Bob

BOB BOOKER *has written and produced more than two dozen comedy albums, including "The First Family." He has also pack- aged, written, produced and directed numerous variety and music shows, and sitcoms like the syndicated "Out of This World."*

Robert Kennedy was at his home in McLean, Virginia, discussing organized crime with New York attorney Robert M. Morgenthau when he was telephoned and told about the shooting by FBI director J. Edgar Hoover. Kennedy's brother Edward, serving his first year as Senator from Massachusetts, was at the rostrum in the Senate—substituting for Lyndon Johnson—when press liaison officer Richard Riedel tearfully told him what had happened. Later that night, Edward and his sister, Eunice Shriver, drove to Hyannis Port to visit their parents and break the news to their father, who was in bed recovering from a stroke. Their mother, Rose, pleaded with them to tell him on Saturday and allow him a night of peace before learning about the death of another beloved son.

7
Transition of Power

As assistant press secretary Malcolm Kilduff prepared to officially announce President Kennedy's death to the press at Parkland Hospital, Lyndon Johnson and his wife were being driven in an unmarked police car to Love Field. Since Mrs. Kennedy had refused to leave the hospital without her husband's body, Johnson decided to board Air Force One and wait for Mrs. Kennedy and the late President before returning to Washington. From the Presidential cabin, Johnson called several people, including

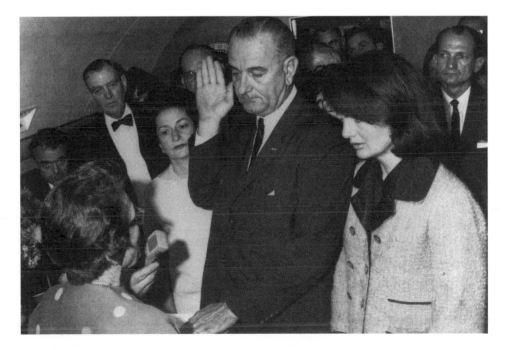

Robert Kennedy, to solicit opinions about when and where to take the oath of office for the Presidency. Johnson ultimately decided it should be done on the plane as quickly as possible, and tracked down 67-year-old U.S. District Judge Sarah T. Hughes—a 1961 Kennedy appointee, whom Johnson had lobbied for—to come to Love Field immediately. Kenneth O'Donnell recalled: "I was flabbergasted. I could not imagine Bobby telling him to stay in Dallas until he had taken the Presidential oath. This was no time to be waiting around at the airport to swear him into office...Taking the oath is just a symbolic formality and there is no need to hurry about it."[1] Jim Bishop noted, "...even though Johnson automatically assumed the burden of the Presidency the moment Kennedy was incapacitated by a rifle shot, he had none of the executive powers until he was sworn in. He was President but could not act as one until that oath had been taken...This lapse cost the nation the services of a Chief Executive for two hours and five minutes."[2]

November 22, 1963 • Eugene Ormandy cancels Philadelphia Orchestra's Friday afternoon concert following assassination

CECIL STOUGHTON

"Great Job, Captain!"

If, on the night of 19 Jan. 1961, you had told me that the next day my life would be changed forever, and that I would see the person responsible nearly every day for the next almost three years, I would have laughed you out of town! But it happened, in spite of a bone-chilling, knee-deep snowstorm. For on Inaugural Day, 20 Jan. 1961, I made my first photograph of the new President of the United States, John F. Kennedy. His presence on that Doric-columned platform gave off the heat, and the warmth reached into all of our senses. We were enchanted with his visions of the life before us, and from that day forward being near him was every-one's wish. People would say, "He touched me!" or "He looked right at me!" and be thrilled.

I'm not sure how these rambling thoughts are going to stack up against the erudite essays of the intelligentsia who surrounded the President during those halcyon days, but after all, I am only a pho-tographer. However, I did have the unusual perspective of seeing him nearly every day in many different situations, but always close-up for my camera. This proximity to his greatness was not wasted on me, for I could notice his style and feel the love and compassion when he was in the company of friends, and especially his beautiful family. One day I heard what sounded like someone trying to sing, this from the Oval Office. Mrs. Lincoln told me to go on in and take some pictures of what was happening. I found the President sitting in a high-backed chair making some God-awful noises, and clapping

hands while in the middle of the room on the Great Seal of the President were Caroline and John, Jr., dancing and giggling just like the children they were! I quickly shot a dozen frames of this warm familial display, and left them to enjoy their visit. My lab supplied me with some 8x10 prints in a few hours, and I was soon standing behind the President's desk while he thumbed through them chuckling all the time. "Great job, Captain!" he would say. Then, on the intercom to Pierre Salinger, his press secretary, he ordered, "Come to the office, Pierre." On his arrival the President gave a print to him saying, "Let's give this to the press...they are always looking for a handout." As it was late October, and the children's birthdays are in November, the timing was right, and soon the "Dancing Children" was on the front page of most metropolitan daily papers, and 'double-truck' in many slick paper magazines, and it became a signature image of a father enjoying his children. Later the JFK Library would display a huge transparency in the Oval Office for all to enjoy.

This would be but one of many such vignettes that I would be a part of, and privileged to share with the rest of the world. I often have said that this is the only job I have ever had that I couldn't wait to get to work in the morning.

Let the others tell you of his politics, his power, and the effects of his leadership in the company of his peers, but my daily exposure to him gave me an insight into his fatherly genomes as I watched him rolling on the floor with his beloved John, Jr. His love of those two children is imprinted on thousands of negatives for the rest of time. While my family missed me during those busy days, they are

proud to know that our legacy is intertwined with the family of John F. Kennedy.

In closing, let me tell you about a series of photographs which will be forever etched in the annals of history.

Riding in a '63 Impala convertible in the triumphant motorcade through the crowded streets of Dallas, my White House press colleagues and I heard three loud noises which to us sounded like shots. The tall buildings around us made finding the source impossible, and we soon became aware of the cause as the cars in the front of us had sped away, leaving the area in a state of confusion. People were lying on the ground, policemen were off their motorcycles and were running up an incline—soon to be called the "Grassy Knoll." I told our driver to get us out of there and to follow those cars. We ended up at Parkland Hospital. Dashing wildly in the emergency room entrance, I found more disorder and confusion. I spotted Merriman Smith of the United Press in a phone booth dictating what was to become his Pulitzer Prize–winning story of the assassination as it was happening before his eyes. (He mentioned me in his story.)

General Clifton and I were together outside the emergency room where the wounded President and Governor Connally were being tended to by many doctors and others. We watched as two priests came down the darkened corridor and into the room. One of my Signal Corps colleagues was dialing a phone on the counter by the entrance, and had just made contact with the switchboard back in Washington. Then he had to leave and was handing me the receiver to keep the line open when I spotted the Vice President and Mrs.

Johnson leaving rather hurriedly, and I asked my friend where he was going, and he replied, "The President is going to Washington." This was my first clue as to the severity of the shooting...Kennedy was dead and Johnson was the new President. I immediately handed the phone back to the technician and said, "So am I!" and left the room to find a ride to Love Field where Air Force One was standing by awaiting instructions. We had a wild ride out to the airport, and the Secret Service man, as well as two of Johnson's staff people and I, actually sped up the active runway toward the plane. I learned later of one policeman training his rifle on us and almost blew us off our course.

I dashed frantically up the ramp and spoke briefly with the pilot, Colonel Swindal, to guarantee a seat aboard the plane as I was sure there would be a swearing-in ceremony, and it behooved me to be there with my cameras. Johnson loved pictures. In a moment, I was briefed by Malcolm Kilduff, the acting press secretary who said to me, "Thank God, you're here, Cecil. The President is going to take his oath aboard the plane and you are going to have to service the press." (This meant seeing to it that both wire services got identical photos at the same time.) I quickly changed from color to black and white film in my Hasselblad camera. I soon learned of the arrival of the ambulance carrying the President's casket, as well as Mrs. Kennedy, and I went to the front ramp and shot a series of photos of the casket being loaded aboard the plane. Mrs. Kennedy, in her blood-splattered pink suit, followed it slowly up the steps. Inside the office again, I was approached by Johnson who asked me, "Where do you want us, Cecil?" and I replied, "I am going to have to stand on this seat up against the wall, and you will have to be

over there," and I pointed to a spot just a few feet from where I was standing. I was fortunate to have borrowed a new wide-angle lens for the Hasselblad, and I was able to get the principals in the frame as the oath was being taken.

There was a small delay while a Dictaphone recording device was made operational, and you can see Kilduff holding a small microphone in the photograph. Soon, Mrs. Kennedy came forward from the small bedroom in the aft section of the plane. The office area was very crowded and beginning to get warm. I was soaked with perspiration. I watched as Jack Valenti eased his way into the foreground, and my boss, General Clifton, moved out of his way. Congressman Albert Thomas was very visible behind Mrs. Johnson, as was Dallas Police Chief Jesse Curry. Homer Thornberry was behind Mrs. Kennedy. Kenneth O'Donnell was at Mrs. Kennedy's left and just out of frame of this now-famous photograph. I used a 35mm camera for some available light candids, and the ever reliable Hasselblad for the ceremonial negatives. These 20 negatives constitute the beginning of the Johnson Years as President, and continue to be seen around the world. As Kilduff said, "Thank God you're here, Cecil."

Cecil Stoughton

CECIL W. STOUGHTON *served with the First Motion Picture Unit during World War II and the Office of the Secretary of Defense before becoming White House photographer on January 20, 1961. He continued his military assignment to the White House until 1965, then later worked for the National Park Service.*

STACY KEACH

It was a cold, overcast morning in New Haven, Connecticut, as I left my apartment and headed off to my first class as a first-year acting student at the Yale School of Drama. I remember being in the elevator on the 10th floor and on my way down, when the traditional sound landscape of 'musak' (undoubtedly supplied by a local radio station) gave way to a male voice saying, "President Kennedy has been shot in Dallas". The elevator stopped on the 3rd floor, a couple of passengers entered, and I found myself instinctively relaying the news. They said that, yes, they knew…they had just heard about it on TV.

We descended the final three floors in silence, waiting for further news, complete strangers now bonded by the impact of a national tragedy.

As I arrived at my class, all of the students were gathered around the TV in anticipation of the most recent events, and a decision was made to suspend class in light of the circumstances.

However, the Drama School was also engaged in November rehearsals for a January opening of a Main Stage production of G.B.Shaw's **The Devil's Disciple,** and the primary question on everybody's mind then became, "Are we going to have rehearsal today?" As the actors began to gather at the rehearsal hall, our director, Professor Frank McMullen, asked us what we would all like to do? Everyone had mixed feelings. Some of us wanted to rehearse, to continue doing what we would have done under "normal" circumstances, and I would place myself in that category. Selfishly, I was playing Richard Dudgeon, more or less the hero of the play, and as we were in the early stages of rehearsal, I was slightly overwhelmed with the number of lines I was going to have to memorize. Frank McMullen was also disposed toward continuing to work. I should point out that at this point in time we had not yet received the news that the President was dead.

When that news finally came, we were in the middle of rehearsal, and everybody stopped whatever they were doing. I remember I was onstage in the middle of a scene, when one of the actors came in from the street and blurted out: "He's dead! The President is dead!" Nobody had to say that was the end of rehearsal, because we all knew it was. But before we dispersed, the actors all gathered. We cried together, we prayed together, and then we went our separate ways to begin the process of dealing with the incredible shock and the profound sadness and pain with our loved ones, our friends and our families.

It was one of the saddest days of my young life, as it was for all Americans. I know that even though it changed all of our lives, much like the events of September 11th, I am grateful for having been alive to witness the political magnetism of John F. Kennedy, the contributions he made to the world and how he enriched our lives, and to appreciate more deeply the fragility of the human experience.

Stacy

STACY KEACH's *acting career has spanned classic stage roles such as* Hamlet, Peer Gynt *and* Cyrano De Bergerac; *movies including* Fat City, The Long Riders *and* American History X, *and TV roles such as private eye Mike Hammer and the father from hell on "Titus." Keach also played the title character in the original production of* Mac Bird!

"In case of Removal of the President from Office, or of his Death, Resignation, or Inability to discharge the Powers and Duties of the said Office, the Same shall devolve on the Vice President...

Before he enter on the Execution of his Office, he shall take the following Oath or Affirmation— "I do solemnly swear (or affirm) that I will faithfully execute the Office of President of the United States, and will to the best of my Ability, preserve, protect and defend the Constitution of the United States."

(Article II, Section 1. of the Constitution of the United States)

November 22, 1963 - "Brave New World" author Aldous Huxley dies at 69

The Johnsons spent some time with Mrs. Kennedy and then came back to the State Room where the phone calls were going on. Mrs. Johnson sent for me and she said to me with a little notebook in her hand, "Liz, I have tried to start making some notes on the events as they have happened." The notes were mostly about Mrs. Kennedy, who, she said, looked like a "heap of helpless pink blossoms." And putting out her arms to her—then going on upstairs in the hospital to spend some time with Mrs. Connally.

I said to Mrs. Johnson, "As soon as we land in Washington the press is going to be all over the place and you will be asked to say something and perhaps you'd better think of something to say."

And she said, "I just feel like it's all been a dreadful nightmare but somehow we've got to find the strength to go on."

I said, "Nothing could be better than that," and I wrote it down on a piece of paper and in a few moments she showed it to Mr. Johnson and he approved it.

The plane landed, and as we stood there flattened against the walls of the plane, I suddenly was aware that pushing through us was Bobby Kennedy. He didn't look to the left or the right and his face looked streaked with tears and absolutely stricken. He said, "Where's Jackie? I want to be with Jackie." And he pushed through and we got him to her.

There was quite a delay at the door of the plane in getting a lift up that could take the casket of the dead president down. Mr. Johnson said, "Some of you men here help them." And so Sergeant Glynn and some of the others went to the back to help them lift the casket.

The lights of the television cameras at the field were on the door and we waited while the casket and the different members of the Kennedy staff got off.

The steps for the plane were pushed up and we walked down them—the new president, Lady Bird, myself, Marie Fehmer, Jack Valenti and then the Texas congressmen, as he had suggested. At the foot of the plane there was a very disorganized group of people waiting—congressmen, just looking expressionless, members of the cabinet, all of the members of diplomatic corps.

We landed on the White House lawn and got out of the helicopter. Again there was a battery of newspaper people. The Secret Service man motioned to Mrs. Johnson's car in front of the White House—and the president said to me, "Stay with Lady Bird and help her all you can."

I got into the car and we started driving through the night to The Elms—rolling up the window so we could talk.

Both of us were well aware of the difficult days ahead—made even more difficult because this had occurred in the home state of the vice president.

And I said to her, "It's a terrible thing to say but the salvation of Texas is that the governor was hit."

And she said, "Don't think I haven't thought of that. I only wish it could have been me."

LIZ CARPENTER *began as a White House reporter under Franklin Roosevelt and later became a speechwriter and media advisor to then-Vice President Lyndon Johnson, personal secretary to First Lady Lady Bird Johnson and Assistant Secretary of Education under Jimmy Carter.*

In the trauma room, a tense situation unfolded as Dr. Earl Rose and Dallas Judge Theron Ward insisted that the President's body could not be removed from Parkland Hospital until an autopsy was performed. Expediency and respect for Mrs. Kennedy were deemed paramount, however, and soon a bronze casket ordered from Dallas undertaker Vernon Oneal had arrived. Kennedy's people wished to spare Mrs. Kennedy the shock of seeing the casket, but she insisted on staying with her husband and witnessing everything that happened. The President's body was lifted into an ambulance and driven to Air Force One; by 2:00, the coffin was loaded onto the rear ramp of the Presidential airplane.

Four seats in the back of the plane had been removed to accommodate the casket; Mrs. Kennedy sat in one of the remaining chairs nearest the casket while O'Donnell, O'Brien, Dave Powers and General Godfrey McHugh stayed with her. O'Donnell was worried that Dallas officials would delay the plane and the Kennedy and Johnson camps waited uneasily for Judge Hughes to arrive and officially swear in Johnson as President of the United States. As the engines of Air Force One idled, 27 people—Johnson and his wife, Mrs. Kennedy, a few members of the press and various Kennedy and Johnson staffers—crammed into the central compartment of the plane as Johnson took the oath of office from Hughes at 2:38 p.m. Central Standard Time. White House photographer Cecil Stoughton took a historic record of this unbelievable moment in time and ten minutes later, the plane was in the air, headed for Andrews Air Force Base.

By the time the new President was deciding to return to Washington on Air Force One, Lee Harvey Oswald had left the Depository Building and returned to the rooming house on North Beckley Avenue, just a short distance away, where he had been living since October 14. At the rooming house, he grabbed

November 22, 1963 - General Douglas MacArthur comments on Kennedy assassination: "As a former comrade in arms, his death kills something within me"

a .38 caliber revolver, then quickly left. Dallas police officer J.D. Tippit responded to radio descriptions of Kennedy's suspected assassin and pulled up alongside Oswald, who was walking east on 10th Street, about a mile away from the rooming house. As Tippit got out of the car, Oswald pulled the revolver from his jacket, and shot and killed the 11-year police veteran. Oswald then went into the Texas Theater, where a double feature of *Cry of Battle* and *War Is Hell* was playing. A shoe store manager who had seen Oswald alerted the theater's cashier. Police were called in and after a brief struggle, Oswald was subdued, dragged out through the theater lobby and taken into custody.

WALTER HILL

November 22, 1963

Some things you remember exactly,

Even though it's been forty years.

I was a college student in Michigan.

On the morning of the 22nd, I drove to Chicago to see a girlfriend.

Outside of Evanston, I stopped at a short order joint to have lunch.

There were only about six or seven customers.

I was at the counter.

Some guy ran into the place and yelled, "Turn on the radio, they just

shot the President down in Texas."

The cook came out of the kitchen, hit the radio, and we waited.

About five minutes later, it was announced the President was dead.

My first thought was, "Oh, Christ, Johnson is President."

Walter Hill

WALTER HILL's *credits as a feature director include* Hard Times, Southern Comfort, 48HRS, Streets of Fire, Last Man Stanfing *and* Undisputed.

RON RUBIN

The morning I heard on the radio that President Kennedy had been shot, I was stretched out on my mother's couch, where I had spent the last few nights. I had been living in Paris for four years and was visiting her in Los Angeles, where she had moved from New York after my father died. I hadn't been sleeping well, my nights were tormented by nightmares featuring various villainous characters, who were dead set on preventing me from returning to Paris. But that previous night, the dream was different. I was back in Paris, wandering through a vast cemetery, past avenues of building-size marble monuments, etched with such names as Baudelaire, Proust, Chopin, Balzac, Sarah Bernhardt. Music was playing and children in provincial costumes were placing flowers at the foot of the monuments. When I awoke, my mother had already gone to work. I was still basking in the luxuriousness of my dream, when I reached out and snapped on the radio.

In trying to reconstruct that morning, the images, feelings, and sounds of the cemetery blend with that first radio report, and the

subsequent announcement that the President had died of his wounds. Where does one dream end, and another begin?

I had never been to Los Angeles before. It was a time of my life when the sun-drenched streets and the brown shoulders of the girls in their strapless dresses gave me the sensation that I was on vacation in a perpetual vacationland, where nothing, not even the tragic death of a young president, could be taken seriously.

The sense of profound loss, the emptiness, the awareness of promise interrupted, the bottomless dread that everything had irrevocably fallen apart, was left for another, less forgiving incarnation.

Ron Rubin

RONALD RUBIN *was born in the Bronx, New York in 1931. During the 1960s he lived in Paris and London, his jobs ranging from tour guide to actor. He returned to the United States in 1969, and toiled as a writer-producer for many television shows, such as "Room 222," "M*A*S*H" and "James at 15." He has published short stories and a novel,* The Annulment.

November 22, 1963 · UN Disarmament Committee cancels ratification session for disarmament resolution (will reconvene in Geneva on January 21, 1964)

PLAUTUS II PRODUCTIONS

ROBERT BUZZ BERGER

November 22, 1963

Janet and I were married at St. Patrick's Cathedral (the Lady Chapel), on November 16, 1963, in New York City. We then flew off for what was supposed to be a two-week honeymoon at the beautiful resort, The Dorado Beach Hilton, in Puerto Rico. It was to be warm ocean breezes, tennis and golf and the other things honeymooners do.

November 22nd was a stormy, no golf, no tennis day, complete with torrential rain, lightning and thunder. For us it was a good day for a late sleep-in, a room service brunch and a lazy day of reading and doing in-room stuff. We did finally dress and go to the main dining room for dancing and dinner. When we were seated at our table we found a type written slip of paper on our service plate stating, "Due to the death of the president, there will be no music this evening."

Janet and I read this and she said, "Puerto Rico is part of America... it doesn't have a president does it?" When we looked around the room and saw people in tears and felt the incredibly somber mood, the realization started to hit us. The president was John F. Kennedy. These were the days before CNN and USA Today... getting news in Puerto Rico was a non-starter unless you could speak Spanish. So we cut short our honeymoon and flew back to New York the next morning.

Every year when we celebrate our anniversary we can't help but remember the trauma of November 22, 1963.

ROBERT "BUZZ" BERGER*'s extensive list of producing credits include the TV movies and mini-series* Holocaust, Skokie, Sakharov, Murrow, Mandela, A Season in Purgatory *and* The Missiles of October.

November 22, 1963 - Japan's Liberal-Democratic Party wins 283 of the 467-seat lower house of the Diet

At the Pentagon, Robert McNamara and the Joint Chiefs of Staff instructed global U.S. command centers to be on alert. Onboard Air Force One, Lyndon Johnson prepared a statement to read upon returning to Washington and made phone calls to Rose Kennedy to express condolences; to Washington to set up meetings with Democratic and Republican leaders and White House staff; and to Andrews Air Force Base to arrange for the arrival of Air Force One. Mrs. Kennedy and her husband's friends requested that a Navy ambulance meet the plane and the U.S. Naval Hospital at Bethesda was called. The requests were initially rejected because of a law which forbade carrying the dead in an ambulance. The law was superseded.

TEMPTATIONS

I was living in Detroit when President Kennedy was assassinated. I was about 20, 21 and married at a very young age and, in all honesty, my wife and I were begatting—that's the Biblical term—at the time. You will always remember what you were doing at that moment in time and that's what my wife and I were doing. The TV was on and we stopped dead in our tracks and said, "Oh my God." It was a thing that shook us to our knees for the rest of the day. Everybody afterwards was just fixed to the television. Later on, I went to singing rehearsal with the other Temptations; we tried to rehearse but we couldn't really get into it because everywhere you would go, you would hear about what happened.

I lived on a street called Philadelphia between LaSalle Avenue and 14th, and LaSalle was a beautiful street. But, when I was coming home after rehearsal—it must have been around nine or ten o'clock that night—it was like the world was mourning, because I was walking down LaSalle and I was the only person on that street. It was eerie as all get out and the wind was howling like I had never heard the wind howl before and the trees just bent and bent like they were crying. It was very spooky and, asshole to elbows, I started running and I ran until I got home.

OTIS WILLIAMS *is the only living original member of The Temptations, one of the most popular male vocal groups in music history, with "My Girl," "Get Ready" and "Ain't Too Proud to Beg" among their dozens of career Top Ten hits.*

The day even *began* badly. An actor had insisted on an 8 a.m. meeting in my office at Universal Studios... no secondary player, but the sought-after star of our next production in the Chrysler Theatre anthology series for NBC.

Louis Jourdan would be making his television debut, but his then-agent, Alan Ladd Jr., made it clear to me in a phone call the previous night that his client's deal would not be closed unless I allowed Jourdan to personally present a list of "unofficial" requests having to do with script re-writes (an unending activity), potential co-stars (already set) and length of production schedule (7 days, engraved in stone) which was to begin the following Monday.

On the stroke of eight, Jourdan arrived, refused all offers of coffee, danish or pleasantries of any kind. After an acrimonious half-hour it became clear that I would soon be pursuing my second choice actor to play the symphony conductor role... when we were interrupted by my agitated assistant with news of the first alarms out of Dallas.

When I turned on the TV set, Mr. Jourdan was clearly unamused. But in the moments... and subsequently the hours... that ensued, the two of us followed the proceedings in silence. Riveted. He, even more than I.

And by mid-afternoon we had become fellow mourners. All tensions between us had vanished. We would be making the picture together. This scene occurred on November 22, 1963 and filming would commence the following week.

HOWEVER, it seems that fact can evolve into science-fiction. For when I dug the shooting script for "Clash of Cymbals" out of my files to refresh my recollection of these events, I was struck by something on the cover page which listed the dates of all drafts, each in a different color. To my astonishment, every one of those drafts were dated November of 1964!... meaning that we did not make the movie <u>until a full year later</u>.

Where did the year go? As the series producer, I never met with actors more than two weeks before a shooting date. Jourdan's appearance in the film is a matter of record, but could the various typists all have pre-dated their respective drafts in the wrong calendar year? Was the assassination so devastating as to be unreal? Am I still in denial? Or am I losing it? And did it ever really happen?

DICK BERG *wrote for live television during its Golden Era in the '50s and went on to produce* Bob Hope Presents the Chrysler Theatre. *In addition to producing theatrical features, his Stonehenge Productions has made such TV movies as* A Rumor of War *and the mini-series* Wallenberg *and* James Michener's Space.

BOB EDWARDS

American History Class

Our teacher had been beating up on President Kennedy since September. I wonder now whether he truly disliked Kennedy or whether he was trying to show us high school juniors that we should have some independent judgment. If so, he was wasting his time. We loved JFK. How could we not love him?

Kennedy was relatively young, and a charismatic contrast to the old general who presided over the buttoned-down 1950's. He was witty, smart and inspiring. Kennedy made us believe we could stand up to the Soviets, help the world's poor through the Peace Corps and land a man on the moon within a decade. He was also Catholic.

St. Xavier High School had been founded by a religious order brought to Louisville, Kentucky in the 1850's by a bishop who wanted Catholic children to be educated. The xenophobic Know-Nothings who ran the city at that time regarded Catholics as a dangerous immigrant influence and barred their children from public schools. A century later, there was still anti-Catholic bias in conservative Baptist Kentucky. We saw it in some campaign literature of 1960 which predicted that Kennedy, if elected, would answer to Rome and not the Constitution.

Kennedy had triumphed over that, succeeding where Al Smith, the only previous Catholic candidate, had failed. We Catholics knew Kennedy would serve as honorably as his 34 Protestant predecessors. His victory was the only favor we wanted. JFK was "our" President.

That was what irked our American history teacher. He wanted us to get past our parochial cheerleading and hold the prince of Camelot to the same tough standard we would have applied to Nixon had he won the 1960 election. He was asking a lot. By November of 1963, Kennedy had inspired Americans of all faiths.

A buzz began in fifth period and filtered through the hallways as we changed classes. Shots fired in Dallas. President Kennedy wounded and possibly dead. Impossible! There must be some mistake. We knew about Lincoln, Garfield and McKinley, but that was back in the wild and woolly long ago when we were still fighting Indians. Such things didn't happen in the New Frontier.

Now it was sixth period--American history class. The teacher was ashen, clearly shocked, though I took it to be guilt. Radio news coverage was piped through the public address system and it confirmed the worst. Someone said, "Oh my God, Lyndon Johnson is President." The rest of us thought this was grossly insensitive. The body wasn't cold and this guy had moved on. We weren't ready for that. We wanted to mourn our martyr. The hour was up and the school day over. Imagine 1,250 teenage boys leaving school in silence.

I boarded a bus with some fifteen to twenty other boys for the one-hour ride to the Abbey of Gethsemane near Bardstown, Kentucky. Weeks earlier we had signed up for a weekend religious retreat at this historic Trappist monastery, the home of the celebrated writer, Thomas Merton.

The assassination bulletin had moved just an hour or so earlier and Americans didn't know who had robbed us of our leader. The Soviets? Castro? A coup d'état? Rumors were plentiful and the public turned to broadcasters for answers. I was headed to a place where the news was forbidden.

The monks at Gethsemane devote their lives to prayer and work, deliberately shutting themselves off from the outside world. They take in members of the Catholic laity for short periods to give us a chance to experience their solitude. There are no newspapers available, no radios and no TV. In 1963, the monks didn't even speak to one another except in sign language necessary to carry out their work on the abbey's farm. When we arrived at Gethsemane on that Friday afternoon, the flag was at half-staff. For the next three days, it would be the only sign of what had happened. To be shut off from news at a time like that would be torture for the newshound I later became. The young devout Catholic of 1963 believed a weekend in prayer was entirely appropriate.

On Sunday, we boarded the bus for the trip back to Louisville. We heard for the first time that JFK had been killed by a fellow named Oswald, but no one knew why because Oswald too was dead, killed by a man named Ruby. We learned we would not be going to school on Monday. We would stay home and watch the funeral on TV.

After Dallas, it would be one shock after another and we high school history students of 1963 would be in the thick of it.

BOB EDWARDS has hosted National Public Radio's daily newsmagazine "Morning Edition" since its premiere in 1979, and has won numerous awards for his work. He is a national vice president of AFTRA and the author of Fridays with Red: A Radio Friendship, *about his friendship with sports broadcaster Red Barber.*

November 22, 1963 - Madison, Wisconsin, man taken into custody after wearing a swastika and cheering Kennedy assassination

Tensions on Air Force One were evident between the Kennedy and Johnson people, reflecting the tragedy that had occurred and the swiftness with which inevitable political realities had taken place. The Johnson and Kennedy camps remained apart, respectively in the front and rear sections of the plane. Mrs. Kennedy sat with her husband's casket, while O'Donnell, Powers, O'Brien and McHugh continued to stand beside her; Johnson and his aides tended to immediate business. O'Donnell wrote: "The impression that there was a wall of coldness between us and Johnson on the plane rose simply from the fact that we remained during the flight with Jackie beside the casket, separated by a narrow passageway from the President's office and lounge..."[3] Jack Valenti, then a Johnson aide, recalled:

"I can understand now what I could not really perceive then. To sit in the White House, inside the magic inner circle where only the anointed of the president could freely move, to be there amid power and celebration of power, to be the confidant and trusted emissary of the president, and now, by a freakish, ghoulish act of assassination to be isolated, alone, adrift, with the captain missing and a new helmsman in charge, this abrupt transition of power could not be managed by mere mortals."[4]

At the same time, the Boeing 707 with Dean Rusk and the other five Cabinet members—after briefly landing at Hickam Field in Honolulu to refuel—was also headed back to Washington. In a grim attempt to pass the time, several Kennedy staffers played poker. Pierre Salinger recalled, "It seems now, looking back, almost sacrilegious to have played poker at such a time. But if there had not been that game, it is hard to tell what would have happened on that plane, so high were the emotions."[5] Salinger won over $800.

November 22, 1963 - Many college football games, including Harvard and Yale's 80th scheduled match, canceled

Connie Stevens

I was a new bride and had been hired to go to Las Vegas where I worked quite often under contract to the Flamingo Hotel. I was going over some music that day. It was a happy time as I was spending time that afternoon with two of my favorite artists. One was Kelly Gordon, songwriter/singer who anyone would know from writing that fabulous song recorded by Frank Sinatra, "That's Life," and Shorty Rogers, a great jazz artist who was appearing locally.

We were around the piano singing songs, talking about life and what music meant to us when my husband, James Stacy, came running in from a room where he had been watching President Kennedy appearing in Dallas. It was a live broadcast and he shouted to us and came running from another room and had a very strange smile on his face that happens to a lot of people who think that this can't be happening and it's got to be some joke and he said, the President has been shot.

We all ran in there in time to see cars streaming every which way, people crying and screaming in the streets and running every which way. We all sat down and they stayed until about 11 PM, then they both went home to their families. It was an incredible shock. There was an occasional phone call from family and close friends saying, "do you know what happened". We didn't eat or sleep or even talk that much.

For the next 5 days we were in total mourning, connected with every face and voice coming from the television in our country. We never left the room. The same went on through the funeral, through the footage of everything he had done in his life as a young man bringing him even closer than I ever knew he could be to me. I was especially aware of this particular President as it was the first time I had ever voted and he meant more to me than I ever imagined and still does.

We lived in the Hollywood Hills and had a deck overlooking the city and it seemed like for days we heard total eerie silence in contrast with the faint ringing of church bells in all different directions.

CONNIE STEVENS' *career has included appearances on stage, TV and film, from the hit series "Hawaiian Eye" to* Rock-a-Bye Baby *and* Never Too Late. *She is currently the force behind the cosmetics empire Forever Spring.*

GARY STOCKDALE

I was just a kid when all this happened, a sixth-grader in Miss Bachtell's class at Balboa Elementary School. This was in Glendale, a sleepy suburb of Los Angeles, and a mostly middle-class, very safe, very Republican town. Some said that it also had the dubious distinction of being the largest all-white community in the United States. In fact, Glendale of the '60s was actually home to the California headquarters of the John Birch Society, the American Nazi Party and the Ku Klux Klan. But either in spite of, or maybe because of this fact, it was as middle-America as you could get on the West Coast. Balboa was a supremely typical elementary school in the now-defunct progression of elementary school, to junior high, to high school.

As an upperclassman in this small world, I'd been entrusted with the job of projection monitor, which included the not-insignificant power of being able to leave class whenever necessary—and if I had anything to do with it, whenever possible—to wheel the Bell & Howell 16mm projector into the 2nd–through–6th grade classrooms, showing scratchy prints of such cinematic masterpieces as *Hemo the Magnificent* and *Safety First!*

One particular Friday, after performing my projection-monitor duties, making my way as slowly as I could back to class through the quiet hallways, I was stopped in my tracks by an odd sight. Cindy Rogers was standing outside Miss Bachtell's classroom crying uncontrollably.

I wondered what this meant. Now, Cindy Rogers was a fine student, very mature for a sixth-grader; not at all a class clown like myself or Steve Selby. So she couldn't be in the hallway as a result of being disciplined. Not her.

I wanted to be sensitive, but I had to know. So I mustered up all the diplomacy and communication skills I'd picked up in my 11 years on the planet, and approached Cindy as she leaned against the locker between the two classroom doors.

"What's the matter with you?"

With great courage, Cindy lifted her reddened wet face to me and sobbed,

"Th-the...President...has been...shot!"

With that last word, she put her face in her hands and resumed her weeping. I stood there dumbfounded. Nothing like this had ever happened, not to us.

I was suddenly lightheaded, dizzy. As the fluorescent lights on the ceiling and the linoleum beneath my feet began to take flight and swirl around me, I fought to regain control of myself and finally blurted out the only response I could come up with: "Frank Pace was shot?!"

As it turned out, it wasn't the president of our sixth-grade class who had been shot, but the President of the United States. The first president we were aware of, the first president whose election we understood, whose initials alone identified him in our minds. JFK. And now, he was gone.

Suddenly, all of us in that very white, very sheltered town of Glendale shared our first communal experience of how unpredictable the world really could be, and how quickly it could come crashing in on us. Not even our monthly Civil Defense drills could prepare us for this.

So while we watched Caroline and John-John on our black-and-white TV sets, carrying on valiantly, walking in processions, riding in the funeral train, saluting—and never being seen crying in the hallway— we shared sadness with kids all over the country, many of whose parents wouldn't then be allowed to buy a house next to us in Glendale. After that day we were somehow different than we were before. And maybe that wasn't at all a bad thing.

Gary Stockdale

GARY STOCKDALE *is an Emmy-nominated film and television composer based in Los Angeles. For almost 15 years, he has composed music for The Bad Boys of Magic, Penn & Teller, including their current Showtime series "Penn & Teller: Bullshit!"*

From: Lee Cohen
Subject: JFK

People always talk about how "the world stopped" or "time froze," but the night of JFK's assassination, I was a freshman appearing in the Niles Township High School production of *Auntie Mame* in Skokie, Ill. It was a very elaborate staging with huge sets and lots of costumes and pasty-faced teenagers wearing big wigs and fake mustaches. The school had rented a lot of stuff at great expense and a decision was quickly made that "the show must go on." As I recall, a lot of us disagreed with that decision—but it was still an era of complacency and obedience. We would need the Johnson and Nixon years to realize that we could say no to school administrators. But we weren't there yet.

Considering it was a huge suburban high school and there was an enormous cast—all of whose parents, under normal circumstances, would have been there to support them—the audience was sparse (my mom came, but she left during the intermission, missing my part altogether).

Before the play went on, the school principal came out to talk about the terrible tragedy and how grief-stricken he was, thus setting the tone for what must have been (quite understandably) the least hilarious performance of *Auntie Mame* ever given. There were no laughs and little

November 22, 1963 - Fair Play for Cuba Committee denies connection to Lee Harvey Oswald, condemns Kennedy assassination

applause. We found ourselves going through the motions and by the second act, racing to the finish line.

 After the show, some of the cast went out to the local deli where I saw for the first time the morning *Chicago Sun-Times* and Bill Mauldin's now-famous cartoon of the weeping Lincoln Monument. Maybe I had been too angry about having to go on or had just been too busy before then— but for me, that was when it hit me...the first time I really felt it.

Lee Cohen

LEE COHEN *is a journalist, screenwriter and poet who lives in Los Angeles.*

Air Force One landed at Andrews Air Force Base just before 6:00 p.m.; a crowd of reporters and cameramen awaited them, along with members of Kennedy's staff. Robert Kennedy was the first person to board the plane. President Johnson tried to greet him, but he rushed by Johnson to comfort Jacqueline Kennedy. A forklift sat at the rear of the plane as the coffin was awkwardly lifted onto the ambulance. President Johnson stood in front of a bank of microphones and briefly addressed the gathered press, the nation, the world:

"This is a sad time for all people. We have suffered a loss that cannot be weighed. For me it is a deep personal tragedy. I know the world shares the sorrow that Mrs. Kennedy and her family bear. I will do my best. That is all I can do. I ask for your help—and God's."

November 22, 1963 - U.N. suspends all meetings as delegates from all nations stand for moment of silence

8
The World Mourns

Before dawn on Saturday, November 23, a line of cars followed the ambulance which brought John F. Kennedy's body to the White House. Jacqueline Kennedy, who had spent the night at Bethesda Naval Hospital, rode in the ambulance, still wearing the blood-spattered pink outfit from the day before. (When asked at one point if she would like to change, she responded, "Let them see what they've done.") During the night at Bethesda, Robert and Jacqueline Kennedy set plans in motion for President Kennedy's funeral, while lists were hurriedly drawn up in Washington to anticipate and accommodate the visiting dignitaries from home and abroad. At the White House, the casket was taken to the East Room and laid atop a black catafalque, similar to the one which bore the coffin of another slain President, Abraham Lincoln, almost a hundred years earlier. A silent mass was held at 10:00 a.m. for the Kennedy family; soon, friends and coworkers, leaders and government officials filed in to the East Room to pay their last respects. This would continue throughout the day, as citizens stood outside in the rain, watching the people arrive and enter the White House.

DR. OSCAR ARIAS

In 1963, President John F. Kennedy visited my country, Costa Rica. There he met with the presidents of Central America. The people of Costa Rica spontaneously flooded the streets of San José to welcome the President of the United States. It proved to be the greatest demonstration of affection toward a foreign visitor in our history.

Those were difficult times. Relations between the United States and Latin America were just beginning to recover from a period of confusion and distrust. Not long before, important U.S. leaders visiting Latin America had been met with hostile receptions provoked by decades of misunderstanding.

It was, therefore, extraordinary that this young man—the president of the most powerful nation in the world, a nation many people held responsible for much of the poverty and exploitation in developing nations—was received with so much enthusiasm and affection by a Latin American country.

At that time, I was a college student at the University of Costa Rica. I was one of the thousands of young Costa Ricans who were surprised by President Kennedy's decision to accept an invitation to visit our campus and give—outdoors and in the presence of thousands of students—a message to the young people of Latin America.

In those days, it was unthinkable that a President of the United States would dare speak on the campus of a Latin American university. But President Kennedy did.

Many of us who would later hold leadership positions in my country were able to see and hear that great man. We were inspired by the message of peace, democracy, freedom and justice expressed to us by the person in the world's highest political position.

In a world that seemed to be quickly forgetting the painful lessons left by two recent world wars, in a world that several times had been on the brink of nuclear destruction, in a world that appeared to be shifting inexorably toward totalitarianism, in a world burdened by hunger and despair, John F. Kennedy's voice was a voice of hope. The same voice of hope that I heard on my university campus was heard throughout the world.

President Kennedy taught me that to govern is to educate, to tell people what they need to know, not what they want to hear. These words have been my leitmotif in political life. It was my belief in this approach that led me to defy President Reagan when he was fighting the so-called Marxist-Leninist government in Nicaragua in the 1980s. Since he was popular in the region, antagonizing him meant antagonizing many people in Central America, but I did what I thought was right. I sat down face-to-face with the other Central American presidents and together we reached a peace agreement. The guns and bombs in our region fell silent and our people once again had reason to hope for the future.

President Kennedy was a great inspiration to me at that time and he continues to inspire me today. I will always remember the commitment to "the preservation of human dignity" that he made during his visit to Costa Rica in 1963, and I am deeply grateful to him for all of his contributions to peace and justice in our world.

Dr. Oscar Arias

DR. OSCAR ARIAS *was the president of Costa Rica from 1986 to 1990, and won the Nobel Peace Prize in 1987. He is active in numerous international organizations and established the Arias Foundation for Peace and Human Progress.*

FROM. ANNE JACKSON —

On Nov. 22nd 1963 — it was cocktail hour.
We were at the Connaught Hotel in London waiting
for our English friends to Join us... Eli had been
filming.

Our British representative phoned — "Annie
dear", he said, "your president has been shot" — I
Thought it was banter. — Our room door was
Ajar — I saw Anne Bancroft, the actress coming
toward me — her face was contorted in pain, her
Cheeks wet with tears. I said, "Robin dear,
I'll have Eli return your call" — and time
stood still.

I made arrangements to fly home, via
Paris the next day. I had left our 3 young
Children at home and I knew they'd seen
this tragedy on television. In Paris shops
windows had pictures of JFK — with bouquets
of flowers — a headline in a paris newspaper
read "Oswald Abattu" — the nightmare continued
The Parisians gave me pained and sympathetic
looks — the shock + loss was felt by everyone.

At home in NY.. my five year old
daughter, Katherine said "Mommy — I want
to go on Television and tell Caroline
how sorry I feel"

Anne Jackson

ELI WALLACH

After Anne hung up the phone at The Connaught
Hotel in London that fateful evening - I got a
call from the BBC. - "Mr Wallach - would you be
willing to appear on TV to give us an American's
reaction to the dreadful news. - and oh, yes - would
you tell us a little about Lyndon Johnson - your V-P.?"

On the way to the Studio my mouth went dry,
my heart pounded, my fingers went numb -
what is happening to America? Will our country
survive?

In the BBC waiting room I was introduced
to other Americans who were to go on the air with
me - None of their names Stuck - But one
Englishman began harassing me. "well its not
terribly Surprising - you Americans are a
destructive lot. I knew JFK very well - a
good man! - Then he added another choice slur -
"Now we're going to have a gun-slinging Texan
in the white House" and what in hell would an
actor know about politics? "Listen, I said, I'm not in
the mood to talk to you!" But he kept baiting
me - Finally I jumped at him - several of
the startled Americans restrained me ... "I
Just want to Shut him up", I shouted.

On The air I talked about Lyndon Johnson -
- I knew him as a Skillful politician in
Congress where he wielded great power - he'll
be able to handle the Job. Later I was informed
that the Englishman was Mr. Brown - the deputy head
of the Labour party ... which made me gulp.
The Reporters surrounded me back at the Hotel.
they had heard of the fracas at the BBC - "what happened
they asked - why did you attack him? Did you know
he loved to lift a glass? Did you really mean to
hit him?" I used a remark, - an answer I always
wanted to use - "No Comment" I said, "No Comment -

Eli Wallach

Acting legends ELI WALLACH *and* ANNE JACKSON *met in 1946 during an off-Broadway production of* This Property Is Condemned *and married two years later. They later performed together in plays such as* Rhinoceros, Luv, Waltz of the Toreadors *and* Cafe Crown. *Her film credits include* Lovers and Others Strangers *and* The Shining; *his include* Baby Doll; The Misfits; The Good, the Bad, and the Ugly; *and* The Godfather, Part III.

After Lyndon Johnson finished reading his statement to the nation at Andrews Air Force Base the night before, he went to his Vice Presidential suite in the Executive Office Building and set to work, speaking with members of Congress, White House staff, J. Edgar Hoover and his own aides on matters ranging from the mounting evidence against Lee Harvey Oswald to maintaining continuity in the policies of the United States. By the time Johnson awoke on Saturday morning, the White House had changed. Theodore White noted that, "Looking in as one passed, one could see that (the Oval Office) was being stripped—of John Kennedy's ship models and ship paintings, of his famous rocking chair, of his desk ornaments, then of his desk..."[1] Janet Travell, President Kennedy's White House physician, wrote years later that the only thing that remained was "the blood-red new rug that Jacqueline Kennedy had planned for her husband's return."[2] Johnson arrived at the White House just before 9:00 a.m. on the 23rd and began a series of meetings—with Robert Kennedy, CIA Director John McCone, McGeorge Bundy, Secretary of State Rusk, Secretary of Defense McNamara—before he and his wife spent some time with Mrs. Kennedy. After Johnson and former President Eisenhower visited the East Room, Johnson and his wife prayed in the nearby St. John's Church and then the new

President returned to work, discussing world problems with Eisenhower and leading his first Cabinet meeting. Shortly thereafter, he declared Monday to be a day of mourning:

"I earnestly recommend the people to assemble on that day in their respective places of divine worship, there to bow down in submission to the will of Almighty God, and to pay their homage of love and reverence to the memory of a great and good man. I invite the people of the world who share our grief to join us in this day of mourning and rededication."

GEORGE STEVENS, JR.

Recollections of November 23, 1963

I left my office at USIA—where I was working under Ed Murrow as director of the agency's Motion Picture Service—for lunch at the Chilean Embassy on Massachusetts Avenue. It was a warm day for fall, the sun was glistening on the Capitol dome and spirits were high on the New Frontier.

In the foyer of the embassy, I ran into Ralph Dungan, a White House political aide, and Senator Hubert Humphrey. Dungan was exclaiming how much President Kennedy was looking forward to the prospect of running against Barry Goldwater the next year. The Kennedy years were all about the future.

Lunch was served at a long table and during the main course I noticed Senator Humphrey leave the room, soon followed by Dungan. A few minutes later Humphrey returned and gestured for attention; "The President has been shot in Dallas in a motorcade," he said, his voice cracking. "We have no information on his condition." Humphrey hesitated, then left the room and everyone else remained seated. Across from me was John Brademas, the young congressman from Indiana, and at my right was Mrs. Johnny Walker, the elderly wife of the director of the National Gallery of Art. She took my hand and I noticed that all around the table people had silently joined hands. Mrs. Walker whispered, "He's a strong man, he may be alright." Ten minutes later Humphrey returned to the same spot at the side of the table. He started to speak, then sobbed: "He's gone."

I returned to my office where my colleagues were stunned and shaken. Amidst rituals of grief over the next 24 hours I tried to figure out what my responsibility was in the wake of this national tragedy.

Ed Murrow had had his lung removed in emergency surgery two months before. On Saturday morning, he came into the office for the first time since his operation. Ed was noted for his elegant striped suits, but on this day he was in slacks and a dark green cardigan sweater, considerably thinner than before. His appearance compounded the futility of that weekend.

I sat down to propose an idea, but before I could speak, Ed handed me a letter. At the top were the words, "The White House." It was signed, "John Kennedy." Some weeks before, President Kennedy had screened a documentary we made about his trip to Europe that summer.

Dear Ed:

I hope that things are going well and that you will be back with us very soon. The other night I saw one of your movies, "Five Cities in June." I think it is one of the finest documentaries the USIA has ever done.

Best Regards.
John Kennedy

I was enormously moved to be holding this letter less than 24 hours after its author had been assassinated. Ed and I sat silently for a moment, then I handed him the letter. Ed handed it back: "You made the film, you keep the letter."

The idea I proposed in that meeting was that USIA make its first feature-length film—a narrative of the Kennedy presidency to be framed by

footage of the world in mourning. We had already dispatched 35mm cam-
era crews with color film to cities across the world. I told Murrow that
within this film, we could express all the ideas that USIA was intent on
communicating abroad. I was 30 years old, Ed Murrow was 54. Ed
mulled the idea for a few moments then displayed the wisdom of his sen-
iority: "George," he said, "First make a ten-minute film about Lyndon
Johnson."

We made the ten-minute film called *The President* and Gregory Peck
narrated it. The new president was delighted and his film was shown
abroad in 134 countries. Then we made *John F. Kennedy: Years of
Lightning, Day of Drums* which was our eulogy to the fallen president. It
was shown overseas and, with permission gained by an Act of Congress,
it became the first USIA film to be distributed in the United States.

The Kennedy letter is framed in the library of our house in Georgetown.
It is a treasured reminder of a tragic day and two extraordinary men.

GEORGE STEVENS, JR. *is the founder of the American Film
Institute and creator of television's annual "Kennedy Center
Honors," which has aired for 25 years and won numerous Emmy
Awards. He executive-produced Terrence Malick's* **The Thin Red
Line** *and produced and directed the documentary* **George
Stevens: A Filmmaker's Journey,** *about his legendary father.*

ELKINS ENTERTAINMENT

On November 22nd, 1963, I had just spent two days in London working on some pre-production details with regard to Golden Boy, *the Sammy Davis, Jr. musical I was preparing to present (and did) on Broadway the following year.*

When the news was broadcast in London, like so many other people, I wept.

It was disorienting being in another country, but what was most extraordinary was that my associates, my partner, Lord Delfont, and so many of my British friends, shared the shock, emotion and the distinct feeling that we had lost an incredible leader, and neither our lives nor my country or theirs would ever be the same.

Like most of us, his death was akin to losing not only a President, but a family member. I imagine, like everyone else who was around at that time, I still miss seeing that face, hearing that voice and feeling that presence.

My best,

Hillard Elkins

HILLARD ELKINS' *illustrious theatrical productions in the U.S. and London include* The Rothschilds, Oh! Calcutta!, Candide, Sizwe Banzi Is Dead *and* The Island. *He also produced the films* Alice's Restaurant, A New Leaf *and* Richard Pryor—Live in Concert.

"The loss of the President is more than the loss of its most important office-holder and the symbol of its law and order, as stunning as that is in itself. It is also the loss of a man with a peculiarly apt set of talents and convictions for our time. What strikes us most about him is that he was a man of his age, and understood his age."

("Death of the President," *The Commonweal*, December 6, 1963)

Across the country people grieved, as cities planned to observe a day of mourning on Monday. Television networks and independent stations canceled regular programming and commercials in order to provide wall-to-wall coverage of the tragic events. The stock exchange announced it would be closed on Monday. Many sporting events were delayed, and one famous exception would be noted for years to come: the American Football League postponed its scheduled matches for Sunday, while the National Football League elected to continue as planned. NFL commissioner Pete Rozelle had spoken with Pierre Salinger at the White House, who insisted that Kennedy—a football fan—would have wanted the games to go on. Rozelle later called his decision the greatest mistake of his career. On Saturday, Philadelphia Eagles teammates Ben Scotti and John Mellekas argued the League's decision and got into a fistfight which landed them both in the hospital. In Dallas, emotions and self-recrimination fell particularly hard. UPI reporter H.D. Quigg wrote that, "Dallas never felt so alone. Joe M. Dealey, grandson of the community builder whose great bronze statue stands in the park where John F. Kennedy was shot through the brain, expressed the first-felt pang to a reporter: 'We are a tormented town.'"[3]

November 23, 1963 - Chicago Locals 705 and 142 in Gary, Indiana fight Jimmy Hoffa's negotiation of contract with 16, 000 trucking companies

From the desk of Bob Lilly

Georgetown, Texas

I was in my third year of playing professional football for the Dallas Cowboys, so I was at our practice field with the rest of the team. We were preparing to fly to Cleveland to play the Browns that Sunday.

During our workout session that Friday, November 22, 1963, Jack Eskridge, our equipment manager, came out onto the practice field and told the first group of players he encountered that he had just heard on the radio that President Kennedy had been shot. So Coach Landry then called us together and told us that he was sorry to hear about the shooting but that he was hopeful that the President would be all right and that we needed to keep practicing for our upcoming game.

A short time later, Jack Eskridge returned and told us that an anonymous caller on the radio had given the sad news that President John F. Kennedy had died. We were all totally deflated and especially sad that something like this had happened in our own city of Dallas, Texas.

Coach Landry told us that the Football Commissioner, Pete Rozelle, would make a ruling on whether the NFL games would continue as scheduled that weekend. Mr. Rozelle did rule in favor of playing all the professional football games, but he said in later years that his decision to do so during that weekend of national grief over the death of the President was the biggest mistake of his career.

So we flew to Cleveland, Ohio, but it was not a normal flight for any of us. Nobody was upbeat, and the former atmosphere of joke-telling and card-playing was replaced by gloom, sadness and grief. Our minds were definitely not on football.

Once we arrived in Cleveland, Ohio, the airline baggage personnel treated us with coldness and disdain, even refusing to help us unload the airplane. So we had to do the unloading ourselves. There were no open threats, but we could feel the undercurrent of seething hostility towards us.

The game between Cleveland and Dallas was played that Sunday, but our hearts were not in it. Even our opponents, the Cleveland Browns, were just as distracted and grief-stricken as we were. It's a wonder any of us were even able to play the game and that there weren't more injuries. The fans jeered us all during the game because we had come from Dallas, the city where President Kennedy had been assassinated. It was a tragic time for every American.

BOB LILLY *was the Dallas Cowboys' first-ever draft choice in 1961; he played with the team for 14 seasons as defensive end and later as defensive tackle, and became known as "Mr. Cowboy." He played in 11 All-Star Games and was the first Dallas Cowboy to be inducted into the Pro Football Hall of Fame. Sporting News named him 10th out of the 100 greatest players in football.*

Mickey Raphael

I remember being in the sixth grade on November 22, 1963, at John J. Pershing Grade School in Dallas, Texas. The day started like any other for a sixth grader, except for the fact that the President of the United States, John F. Kennedy, was visiting Dallas that day. One of my best friends, who was a nephew of Jack Ruby's, was as excited as I was. His family seemed to have a special place in their hearts for the President.

Midway through the school day, we sensed that something was not right. People were crying hysterically and there was talk of sending everyone home for the day. I quickly learned the President had been shot.

It was a very solemn scene. Everyone was watching the television for any good news, which did not come. My neighbor was a doctor at Parkland Hospital, where the President had been taken, and we all waited for any news from him.

My friend, Ruby's nephew, and his family seemed more devastated than most. It just seemed like the end of the world when I went to play at their house. The next few days in Dallas were filled with shame. The city of Houston changed a street named Dallas Street to some other name. It seemed the world blamed our whole city for the President's death.

I felt strange, connected to a small degree: a neighbor doctor at the hospital, a friend related to Ruby...Just living in Dallas that day made you feel some kind of responsibility for what happened. Even for someone in the sixth grade.

Mickey Raphael

Dallas, Texas native **MICKEY RAPHAEL** *has played harmonica with Willie Nelson's band for 30 years and has recorded with such artists as Elton John, U2, Emmylou Harris and Neil Young.*

Jerry Coleman

I was in my home in Ridgewood, New Jersey, and I was doing some work at my desk, as I recall, and all of the sudden the door opened and in came my then–16-year-old daughter, Diane. And she was crying. I thought she'd lost a tennis match. I said, "Diane, what's wrong?" She said, "President Kennedy just got shot," and immediately I turned on the television and listened to the dramatic story of what happened in Texas. Sadly, at that point, they didn't know. It was very early. They thought that he might survive. He was in the hospital in Dallas and then, a few moments later, it came out in the news that he had been shot and killed. And I still recall my daughter. She was actually terrified and crying. I didn't vote for Kennedy. I was a Republican. But he was my President. And I wanted to know who shot MY President. I was really ticked-off about this. And it finally came out that Lee Harvey Oswald was the man that they had apprehended a few moments later—a half a day later—and eventually he was killed on national television

by Jack Ruby, who later died. And so nobody really knows whether it was a conspiracy or not. But I still recall the day that my daughter came in and she was just crying her eyes out. And I was MAD that someone would shoot my President.

This was on a Friday, and the American Football League and the National Football League were in very heavy competition. Of course, the NFL had all the major markets. And Joe Floss, who was the commissioner of the AFL, who knew Kennedy in the South Pacific, canceled all the games immediately. And Pete Rozelle didn't do it. He was the commissioner of the NFL. They played. At that time, I said, "How can they possibly play? The whole country is in mourning." And later on, many years later, Pete Rozelle admitted that that was the worst mistake he had ever made—to play that day. He should've just canceled all games. He didn't do it. But...he made a mistake.

JERRY COLEMAN *played second base for the New York Yankees from 1949 to 1957, then became a broadcaster for his former team as well as for the San Diego Padres.*

The world reaction was equally swift and heartfelt, with messages and tributes pouring in from leaders and citizens alike. Sir Winston Churchill said, "The loss to the United States and to the world is incalculable." In a statement, French President Charles de Gaulle said, "President Kennedy died like a soldier, under fire, for his duty and in the service of his country." Cuban President Fidel Castro was in the middle of an interview with French journalist Jean Daniel when he received news of the assassination on the phone. "He came back, sat down, and repeated three times the words: 'Es una mala noticia.' ('This is bad news.')"[4] Daniel wrote that when Kennedy's death was confirmed, Castro "stood up and said to me: 'Everything is changed. Everything is going to change...The Cold War, relations with Russia, Latin America, Cuba, the Negro question...all will have to be rethought.'"[5]

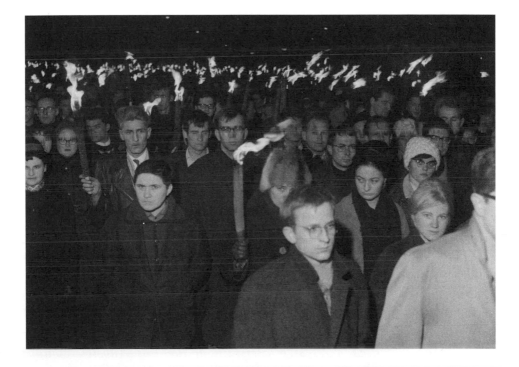

November 23, 1963 - British Columbia Lions beat Saskatchewan Roughriders (36 to 1) in the Western Finals of the Canadian Football League playoffs

ROZ LEADER

We (mother, father, and two teenage children) were living in London in 1963. On that Friday, November 22, my husband and I were just leaving our flat to go to dinner at the home of friends—the kids were already out with their chums—when we had a phone call telling us that Kennedy had been shot in Dallas. Hardly believing it, we raced over to our friends' house to find that they had already moved the dinner into the den in front of the TV set where we watched the whole thing unfold. It was particularly upsetting to be in another country so far away from it all. One had a sense of wanting to flip channels in the hope that this was just another Orson Welles hoax. I don't remember where our kids were going that evening but they both had a phone number of where we would be. The first call was from our 14-year-old daughter who was with two other classmates from the American School. They had decided to go to the American Embassy in Grosvenor Square and we promised to meet them there. When we got to the embassy there were about 50–100 people (mostly Americans) on the broad stairs and on the glass-fronted doors were bulletins being posted from the inside. The press was also there in considerable numbers. (A *Life* photographer snapped our daughter and her friends reading the notices and the picture appeared in the magazine the following week.) It was now 10 p.m. London time and the crowd was growing. Our son joined us and we Americans stood on the steps as cars began pulling up to the building with people, in twos and threes, coming to offer condolences. We were stunned and touched by this spontaneous parade that did not end until well after midnight. It was an amazing experience.

Roz Leader

ROZ LEADER, *a political and social activitist, started and later sold a publishing company for museum and gallery posters and has been a research assistant at the Los Angeles County Museum of Art for the last 15 years.*

GREG GUMBEL

My memory of the day John F. Kennedy died remains one of the most vivid I have ever had. I was a freshman at Loras College in Dubuque, Iowa, in the fall of 1963. On the 22nd of November, I'd had classes at 8 and 9 a.m. and didn't have another scheduled until 4 p.m. On campus at that time, there were two gymnasiums. The main gym was "upper campus," on a part of the campus that, literally, was up higher than the "lower campus" by several hundred feet, and it was called the upper gym. The smaller gymnasium was, therefore, called the lower gym and it was in that building that I was all alone, shooting baskets to while away the afternoon that day.

One of my many newfound friends on campus that year was Tim Lind from Waterloo, Iowa, and he came into the gym, came walking up to me. He said, "Hey, did you hear? They shot Kennedy." I said, "Who? Where?" Tim said, "I don't know who, but it happened in Dallas." I left the basketball on the floor and, together, we walked to the nearest dorm's TV room to catch the details.

To this day, I have never felt more strongly about voting for a President of the United States than I did for John F. Kennedy back in the early '60s. And to this day, other than the passing of my father, no death has ever affected me more than that of John F. Kennedy.

Greg Gumbel

GREG GUMBEL is a 30-year veteran of sports broadcasting and currently part of CBS' lead announce team for the National Football League. He has provided play-by-play coverage of the NBA, NCAA and Major League Football and hosted CBS' Emmy-winning "The NFL Today."

GARY COLLINS

For some reason, and I'm not sure why, national calamities seem to overshadow some of most wonderful or disastrous events in our personal lives.

John Kennedy's assassination was a watershed in the sense that it signaled the end of something special and the beginning of a new and extremely volatile activism. We, as a nation, saw the lights go out on romance and innocence in the Camelot of politics and reality set in.

I was having dinner at a small bistro in Paris that evening in November (We were eight or nine hours later) and a man rushed into the restaurant and shouted "President Kennedy has been shot!" The room went silent. The proprietor turned the radio on and we all sat dumbfounded as the news of the tragedy unfolded. The more we heard the more we came to realize that there was no hope and people began to sob and comfort each other. These were Frenchmen not tourists. Kennedy touched everyone everywhere. You might hear many things about the French with regard to visitors, but on that night and for many to come they remained extremely sensitive and kind to all of us.

September 10, 2001 found me in France once again, having just arrived and my wife, Mary Ann, and I were joining a party to sail around the Med for a week or so. We were returning to the ship late in the afternoon on the eleventh when we heard shouts from people all around us there at the mooring in St. Tropez that the Trade center had been hit by terrorists. We all huddled around the one television set on board and watched CNN. When we did venture out for supplies or to shop we were met with a compassion I had never experienced in all my visits to France. Truly, this was an event that affected everyone.

I was not the same person after November 22 nor was I after September 11. I hope I'm a better one.

Sincerely,

Gary Collins

GARY COLLINS *is a veteran of numerous TV series as well as the Emmy-winning host of the syndicated talk show "Hour Magazine." He has hosted the Miss America Pageant nine times and is married to former Miss America winner Mary Ann Mobley.*

Russian Chairman Nikita Khrushchev wrote a telegram to President Johnson which said, in part: "I shall remember my personal meetings with President J. F. Kennedy as a person of broad outlook who realistically assessed the situation and tried to find ways for negotiated settlements of the international problems which now divide the world." Khrushchev's son, Sergei, recalled Foreign Minister Gromyko calling his father at home with the unconfirmed news of Kennedy's death. "Father hung up and walked to the middle of the room, as if undecided whether to sit down at the table or wait where he was. He shifted from one foot to the other. A bitter expression was fixed on his face."[6] Khrushchev ordered a high-level delegation sent to the funeral and, in addition to the telegram to Johnson, a personal letter sent by his wife to Jacqueline Kennedy.

"This was unprecedented. Mama accompanied Father on trips and people had gradually grown used to the idea, but that was the extent of her role in state affairs. By this gesture, Father wanted to emphasize as far as possible the sincerity and personal nature of his sympathy."[7]

One of the few countries that did not join in the outpouring of tributes was China; its trade union paper ran a cartoon of Kennedy lying face down with the caption: "Kennedy Biting the Dust."

November 23, 1963 - Hoover informs Johnson that tapes of Oswald contacting Russian Embassy In Mexico City don't match Oswald's voice.

"The question-and-answer period opened, I suppose inevitably, with someone asking me, 'What do you think about President Kennedy's assassination? What is your opinion?'

Without a second thought, I said what I honestly felt—that it was, as I saw it, a case of 'the chickens coming home to roost.' I said that the hate in white men had not stopped with the killing of defenseless black people, but that hate, allowed to spread unchecked, finally had struck down this country's Chief of State."

(Malcolm X, *The Autobiography of Malcolm X*,
Ballantine Books, 1964)

Throughout the tragedy and its national and world repercussions, the wife of President Kennedy became the focal point of all people and their thoughts. Theodore Sorensen wrote, "No one will forget how his widow, eyewitness to the lowest level of human brutality, maintained the highest level of human nobility."[8] A restrained woman who mostly avoided the glare of the public eye, Jacqueline Kennedy was now at the center of a living nightmare and, somehow, she ennobled it. "The power of the government had passed on to Lyndon B. Johnson," wrote William Manchester, "but Mrs. John F. Kennedy possessed a far greater power, over men's hearts, and like Johnson she could not shirk it."[9]

November 23, 1963 · American civilian, captured by Communists in June, is released 350 miles north of Saigon near Tam-ky

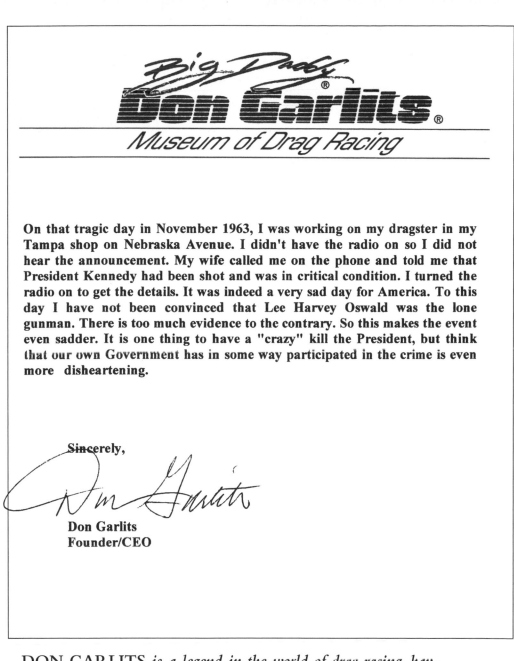

Museum of Drag Racing

On that tragic day in November 1963, I was working on my dragster in my Tampa shop on Nebraska Avenue. I didn't have the radio on so I did not hear the announcement. My wife called me on the phone and told me that President Kennedy had been shot and was in critical condition. I turned the radio on to get the details. It was indeed a very sad day for America. To this day I have not been convinced that Lee Harvey Oswald was the lone gunman. There is too much evidence to the contrary. So this makes the event even sadder. It is one thing to have a "crazy" kill the President, but think that our own Government has in some way participated in the crime is even more disheartening.

Sincerely,

Don Garlits
Founder/CEO

DON GARLITS *is a legend in the world of drag racing, having won the National Hot Rod Association U.S. National eight times, among numerous national and world titles. His Museum of Drag Racing and Museum of Classic Automobiles are part of a tourist complex in Ocala, Florida.*

November 23, 1963 • The Horatio Alger Society forms

From: Barbara Bottner
Subject: JFK

Paris, France, November 22nd, 1963 I was at the Ecole Des Beaux Arts, studying painting for my junior year abroad.

It was Matthew Robbins' birthday. Susan Dalsimer, Walter Murch and I were going to celebrate him turning 20. We were in Paris, driving around on motorcycles, so we didn't need a lot to make us happy. A movie, Truffaut's *Quatre Cinq Coups*, then a cheap dinner somewhere on the Left Bank.

As we went into the cinema, we heard a rumor to the effect that President Kennedy had been wounded. We were worried, but the reports were unreliable, mostly rumor. The French love gossip. The information that was floating around wasn't clear. What was not told in the United States for hours was still pretty vague in our time zone, five hours later. Whatever worries we had abated as the movie began. (Matthew and Walter were both to become screenwriters and directors; Walter would subsequently win three Academy Awards. Susan was to become a VP at Warners and publisher of Miramax Books. Movies, well, they were movies, and we were hearing them in a second language. That took up most of our concentration.)

There was a sort of pandemonium in the streets when we

November 23, 1963 · Family Life Bureau of National Catholic Welfare Conference lashes out at states that ban interracial marriages

emerged. Kennedy was beloved in France. Now it was ten o'clock in France, 5 p.m. in the United States. The story was becoming clearer. We began to understand that he was shot and mortally wounded. But, then, we heard 'non, non' he was not dead, merely in the hospital. He was going to recover. Then, 'non, non,' he was, in fact, dead. Definitely dead.

The more we tried to understand that he might be dead, the more stupefied we became.

We were hungry and in shock. We went to the famous Les Deaux Maggots. Normally, we would not have paid the price for dinner there, but that night, budgets mattered not.

Over French bread, we attempted to grapple with the events. We tried to overhear what the French were saying, but as soon as they overheard us speaking English they bombarded us with questions, assuming that by being American, we must have had more information than they did. The French are conspiratorialists. They wanted us to give them theories. Then the history of the politics of Texas, explain the motives, the possible enemies; they wanted a history lesson in American politics. We wanted to know what the radio was saying. We could hardly eat.

Finally, we began to walk down the crowded streets. Everyone was out that night and talking or arguing with each other.

Matthew and I walked ahead of Susan and Walter. We

November 23, 1963 • British Labor Party opposes renewing act that curtails immigration from Pakistan, India and West Indies

were not at our most vigilant. Some Algerians asked me to look at their map. We felt a brotherhood that night, as people do during catastrophes. I stopped to help them.

Matthew is wiry and hardly intimidating. An Algerian and his friend surround me and begin to pull me towards a car as if they were going to kidnap me. There was a fair amount of white slave trade then, and I was young.

Perhaps I would not be living in a lovely street called Rainbow Drive now, if Walter, who is well over six feet, hadn't gleaned what was going on. He strode up behind us and bellowed, "What the hell do you think you are doing?"

The Algerians ran off into the crowded Parisian streets, merging into the stunned population. It was as if evil itself was there in the streets of Paris, too.

Barbara Bottner

BARBARA BOTTNER *worked as a set designer, an actress and a substitute teacher before becoming an award-winning children's author of such books as* Bootsie Barker Bites, Two Messy Friends, Scaredy Cats *and* Marsha Makes Me Sick. *She has also written for television.*

November 23, 1963 · Langston Hughes' gospel musical, *Tambourines to Glory,* closes in New York after 24 performances

There was speculation that Kennedy would be buried in or near his hometown of Brookline, Massachusetts, but on the strength of Robert McNamara's and Jacqueline Kennedy's belief that he should be buried on federal soil, it was decided that Arlington National Cemetery would be a more fitting resting place. After visits by McNamara, Robert and Jacqueline Kennedy, an area was chosen on the slope below the Custis-Lee Mansion, the 19th-century estate originally owned by an adopted son of George Washington. As Robert McNamara and Robert Kennedy examined the site, a park service employee remembered John Kennedy and his journalist friend Charles Bartlett visiting the area earlier in the year. Kennedy had been particularly taken with the view of Washington, D.C. and commented that he could stay there forever.

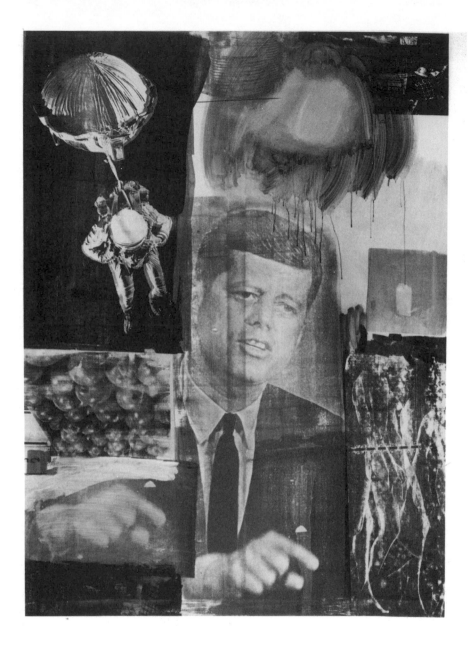

9
Pain and Retribution

Some citizens had already begun to gather outside the White House late Saturday night, preparing to watch the procession that would take John F. Kennedy's coffin to lie in state in the Capitol Rotunda. By the morning of Sunday, November 24, crowds had lined the streets and filled Lafayette Square. The rains that had fallen on Saturday now stopped, and as Theodore White noted, "the skies cleared so that the nation could witness the pageantry of death."[1] By noon on Sunday, Jacqueline Kennedy had already attended mass in the East Room with family and friends. She and Robert Kennedy would return to the East Room a little while later to place letters and mementos in the coffin with her husband.

John F. Kennedy passed his torch to a whole generation of Americans who were too young to have any but the dimmest memories of him—people born in the second half of the century, tempered not by World War II but by Vietnam. I was born in 1957, the very peak of the baby boom. My earliest memory in life is of my parents leaving Chicago for the 1960 Democratic Convention in Los Angeles. They were Adlai Stevenson Democrats—"Madly for Adlai"— who became big JFK supporters. One of the first songs I ever knew, the year I turned three, was "Whistle while you work, Nixon is a jerk...." At age six, I was playing with blocks and toy soldiers at home after kindergarten when the first bulletins from Dallas were broadcast. I watched the news coverage of the assassination and the funeral with great interest. I remember my mother crying and my father telling me that I should always remember the date—November 22, 1963.

These early childhood memories helped shape not just my lifelong interest in politics and history, but my expectations for myself. Whatever that Kennedy "thing" was, I wanted a part of it. I developed an inchoate (no, not his boarding school) sense of longing to be connected to something larger and more historic. This made me more than one of those kids who knew everything about Kennedy, down to his high school nickname ("Rat") and brief foray into journalism (he covered the founding conference of the United Nations in San

Francisco for a Boston newspaper). It made me determined to find a career that could take me closer to the world he inhabited, where world history could play out before my eyes.

As I grew older, I responded to Kennedy's idealism, but also to his irony and sense of detachment. Those qualities, which might have led him into journalism had his brother, Joe, not been killed, attracted me to the news business. (Not that Kennedy bears blame for that!) The skepticism also kept me from feeling too worshipful of JFK. When revelations of his indiscretions and risk-taking emerged, I reacted as a realist rather than a sanitizer. Writing in *Newsweek*, I criticized some of the JFK hagiography—praise that Kennedy himself would have found saccharine. When I became friendly with members of the Kennedy family, I responded to their irony and sometimes brutal honesty. I found that, generally speaking, the Kennedy women inherited more of that irony and more of his good qualities.

In college, I wrote my thesis on Kennedy and Vietnam, and I interviewed several members of his administration. Much later, at *Newsweek*, I conducted the first interview with Robert McNamara about the war. I resisted efforts to rationalize their failed policymaking or to predict with any certainty what Kennedy would have done in Vietnam had he lived. Doing so ignores the vagaries of history.

But when it comes to the Cuban Missile Crisis, I have no doubts about Kennedy's greatness. No matter what one thinks of the rest of his career, he saved the world in October of 1962. It would have been so easy for him to accept the advice not just of the military but of older senators with much more experience in foreign policy—men like William Fulbright and Richard Russell—and order air strikes against Soviet positions in Cuba. The result, we now know from the Russians and Cubans, would quite likely have been nuclear war. Avoiding that war and defusing a nuclear crisis is not just a tremendous legacy for Kennedy. It is the greatest legacy any president can leave.

Whatever the fate of young Kennedys in politics, the glamour of the name has a few more decades in it. The magic will last as long as my generation is alive, then slowly disappear. But Kennedy's role in averting nuclear war will be remembered by historians forever.

Jonathan Alter

JONATHAN ALTER *is a senior editor and award-winning columnist of "Between the Lines" for* Newsweek. *He is also a contributing editor to* The Washington Monthly *and a contributing correspondent to* NBC News.

November 24, 1963 • Additional troopers ordered to guard Governor Connally as he recuperates in Dallas Hospital

 UNITED FARM WORKERS of AMERICA, AFL-CIO

We in the farm workers movement still cherish the memory of John F. Kennedy because he was the first national political figure to capture the hearts of Latinos when he ran for president in 1960 and because of the Kennedy family's close identification with Cesar Chavez and the United Farm Workers over the years.

President Kennedy's brother, Robert, was closely tied to the UFW beginning in the mid-1960s, when the late New York Senator traveled to Delano, California to support La Causa, Cesar Chavez's farm labor cause. But few people realize that Cesar met John and Robert Kennedy in 1960, two years before he founded the first successful farm workers union in American history.

Then, Cesar was living in Los Angeles and serving as staff director for the Community Service Organization (CSO), the most militant and effective Latino civic action, civil rights group of its day in California. Cesar met with the Kennedy brothers that year to review the CSO's impressive voter registration and get-out-the-vote efforts he was organizing in East Los Angeles and other Latino barrios in the state.

JFK would go on to rack up near-unanimous numbers in Latino precincts during the 1960 presidential election, a feat only surpassed by his brother, Robert, eight years later in that ill-fated California Democratic presidential primary. Robert Kennedy became the first politician of any significance to publicly embrace the farm workers' cause, which further endeared the Kennedy family among farm workers and Latinos. But the association between Cesar and the Kennedys really began with JFK's campaign.

John Kennedy and Cesar Chavez could not have hailed from more disparate backgrounds. One was a son of wealth and privilege. The other was a product of poverty and privation. Yet the two men shared common values of faith and justice.

For me and entire generations of Latinos and other Americans, they inspired us to get involved socially and politically. And they endure as two of the most powerful icons in Latino America.

Arturo Rodriguez

ARTURO S. RODRIGUEZ *is the second president of the United Farm Workers of America, AFL-CIO, taking over after Cesar Chavez's death in May, 1993. He was elected to the AFL-CIO's governing executive council in 1995.*

ROBERT GOULET
President

VERA GOULET
Vice President

ROBERT GOULET

I was in Los Angeles working in my first film when we heard of the assassination. The company curtailed filming for tears and gloom were then the order of the day.

I drove to the rented house my wife Carol and I were living in and we had a collective cry.

She then said "I'm sorry to do this to you at this time, (my birthday was four days away), but you have to open this gift I have for you, now"! I told her I appreciated the thought and the gift but I didn't really want to be concerned with gifts at that moment.

She insisted and showed me a large box in the corner of the living room. It looked to be battered and I could not imagine what it might contain. Reluctantly I opened it and to my surprise my five year old daughter, Nicolette popped out.

Well, the tears were mixed with joy and they cemented for me a most poignant memory.

Robert Goulet

ROBERT GOULET *has been a star of stage and screen for decades and made an unforgettable Broadway debut as Lancelot in the original production of* Camelot. *He has numerous best-selling albums and TV appearances to his credit, and won a Tony Award for the musical* The Happy Time.

A law was made a distant moon ago here
July and August cannot be too hot
And there's a legal limit to the snow here
In Camelot

The winter is forbidden 'till December
And exits March the second on the dot
By order summer lingers through September
In Camelot

Camelot, Camelot
I know it sounds a bit bizarre
But in Camelot, Camelot
That's how conditions are

The rain may never fall 'till after sundown
By eight the morning fog must disappear
In short there's simply not a more congenial spot
For happily-ever-aftering
Than here in Camelot

Camelot, Camelot
I know it gives a person pause
But in Camelot, Camelot
Those are the legal laws

The snow may never slush upon the hillside
By nine p.m. the moonlight must appear
In short, there's simply not a more congenial spot
For happily-ever-aftering
Than here in Camelot

("Camelot," from the musical *Camelot*, 1960; music and
lyrics by Frederick Loewe and Alan Jay Lerner)

While Jacqueline Kennedy prepared the letters and mementos, a very different scenario was unfolding in Dallas. Lee Harvey Oswald—whose arrest, arraignment and interrogation had become a local media circus—was being moved from the Dallas City Jail to the Dallas County Jail. At 11:20 a.m., Central Standard Time, detectives took Oswald into the city jail's basement and led him to a waiting armored vehicle. He was passing by reporters and observers when 52-year-old Jack Ruby leaped toward Oswald and fired one shot into his ribs from a .38 caliber, snub-nosed revolver. NBC alone had decided to broadcast Oswald's prison transfer and was the only network to carry the astonishing murder live—a historic and heinous first for television. Detectives disarmed Ruby, while Oswald was rushed by ambulance to Parkland Hospital and brought to Trauma Room Two, where Governor Connally had been treated just two days before. Several doctors who had attempted to save President Kennedy's life now treated Oswald, but his internal bleeding was too heavy and he was pronounced dead at 1:07 p.m. Ruby, who owned a strip club and a dance hall in Dallas, had a police record and was known by officers in the city; his easy access to the Dallas City Jail and his motives for killing Oswald—other than a self-admitted admiration for President Kennedy—became yet another part of the disturbing legend surrounding the President's death.

November 24, 1963 - Aga Khan IV reads convocation address at Kamil Islam College

From: Geoff Pietsch
Subject: JFK

I cast my first presidential vote for John Kennedy in 1960. It was not an easy decision. I came from a Republican family, but I never liked Nixon's inexcusable Red-baiting. Still, Kennedy seemed undeserving. His senate record was undistinguished and his campaign seemed to consist largely of empty rhetoric: "We've got to get this country moving again." (Oh? Where to?) "We can do better." (For example?) So, while I was glad he won, I listened very closely to his inaugural address—and was carried away with the idealism of it. The torch had been passed to our new generation of Americans who were unwilling to tolerate poverty and injustice.

I know now—I knew then too—that Kennedy had many faults and failings, that he was capable of cynical political deals and compromises. His presidency has been summed up as more promise than fulfillment. His days were too few. Still, I believe those years were the catalyst for the best of the '60s generation—for civil rights and opposition to war, for feminism and all the other social justice causes that sprouted then. Thus, as I write, I still get choked up, 39 years later, as I recall driving from my mom's home in New York down to Miami for my second year of prep school teaching, speeding through the North Carolina night and listening to Bobby Kennedy address the 1964 Democratic Convention. Bobby spoke for a generation of us when, to eulogize his brother, he closed with Shakespeare's lines from *Romeo and Juliet*: "When he

November 24, 1963 • Ottawa Rough Riders beat Hamilton Tiger-Cats (35 to 18) in the Eastern Finals Canadian Football playoffs

shall die, take him and cut him out in little stars, and he shall make the face of heaven so fine, that all the world will be in love with night, and pay no worship to the garish sun" (LBJ insisted that Bobby's speech come after the convention finished nominating him for President; he feared that the emotion of the speech might somehow catapult Bobby into the nomination.)

I'm a bit embarrassed by the seeming naïveté of those lines. I know full well that JFK was not a wondrous hero. But the emotions are what I felt then—not so much for JFK himself but for what we as a country had dreamed because of him—and had lost. Now, in the 21st century, I still feel the same.

Geoff Pietsch

GEOFF PIETSCH *is a former American history teacher and he also coached cross-country track for 36 years at Ransom Everglades School in Coconut Grove, Florida.*

I was walking in Los Angeles near the high school from which I graduated, when the most shocking news was announced. "Jack Kennedy has been shot and killed." I thought, "What have we come to?"

At first I blamed myself. "What could I have done to prevent such a happening?" Then I started to cry. I mean out and loudly.

I had known President Kennedy well through his future brother-in-law, Peter Lawford. We had met in Winter Haven, Florida during the filming of a picture.

Mr. Kennedy was a most outgoing, charming person and it became an instant friendship. I don't mean to attempt painting a one-sided picture here, but those who knew him well attest to what I say.

I didn't think to extend condolences to Peter or any of the family because I wanted to be alone with my own sadness.

You asked, "How did his death affect me?" Well, if such a thing can happen to such a man, what is in store for the rest of us? Of course, this is not the only time a thing like this has occurred, but why do they happen? Is there a schedule or time set? The impact is nonetheless devastating. Could it happen to one of us?

God bless this world and God be thanked for giving humanity such a man as a gift even for such a short time. Amen.

Sincerely,

Richard Simmons

RICHARD "DICK" SIMMONS *was an MGM contract player and later gained fame as the title character on TV's "Sergeant Preston of the Yukon." Simmons served as a pilot in the Air Transport Command during World War II.*

November 24, 1963 ▪ sixty three die in Texas rest home fire

Adam Turteltaub

The 20th Anniversary of the Kennedy Assassination

I was two years old when President Kennedy was shot. Throughout my life I have heard tales of where people were and how they learned he had been killed. They were powerful, to be sure, but they were tales of a distant event and hard to appreciate.

Then came the 20th anniversary of the assassination.

I was working on Capitol Hill on the staff of Senator Daniel Patrick Moynihan. There was a memorial mass scheduled, and the Senator, who was out of town at the time, had decided to return to Washington to attend the memorial. He had been an assistant to the secretary of labor in the Kennedy Administration so his returning to town for the mass was no surprise.

I went to the airport to pick up the Senator and his wonderful wife, Liz. As they entered the terminal, I could see the Senator in an animated conversation with an older, balding gentleman.

"Hello, Lad," the Senator said, and then he went back to his conversation. Liz and I talked as we headed out to my car, a Plymouth Sapporo with two doors, and a minimal back seat.

As we got closer, the Senator said, "Say, Adam, do we have room for one more in there?"

"It'll be tight," I said, "but sure."

"Great," he said to me. Then to the other gentleman, "Come along."

When we got to the car, I unlocked the doors and the Senator opened the door

for Liz to crawl in back. Then he said to me, "Lad, you know Mac Bundy."

"No," I said, "We've never met."

With that, McGeorge Bundy and I shook hands, I slid my seat forward and the former national security advisor to President John F. Kennedy crawled into my back seat on the 20th anniversary of the day the President died.

Twenty years after the assassination, a knight of Camelot had his knees in his chin in the seat behind me.

Over the next 25 or so minutes, the two men talked, first about current affairs, especially the Reagan defense buildup. Bundy asked the Senator what Barry Goldwater thought about the Star Wars missile defense program. Moynihan and Goldwater spent a great deal of time together since they were vice chair and chair, respectively, of the Senate Intelligence Committee.

The Senator replied, "Funny you should mention that. Just the other day I mentioned to Barry that Mac Wallop thought it was a good idea, and Barry said to me, 'Pat, Mac Wallop doesn't know a laser from his own piss.'"

All of us broke up laughing, and the conversation proceeded backwards slowly and cautiously to November 22, 1963. The day had great power to both of them, I knew.

They both discussed where they were when they heard the news and how they—unlike most Americans who had nowhere to go — returned to the White House, not sure what needed to be done, but knowing that the White House was where they should be. The Senator recalled that someone, whose name I can't remember, was the only one who knew what needed to be done from a constitutional perspective. He set to work those who needed to respond. The rest just wandered around, I learned, as stunned as the rest of the world.

Then we were in Georgetown. I double-parked about half a block away, the closest I could get with all the security. I let the three of them out and watched them go in.

Then, I waited for the service to conclude so I could bring the Senator, his wife and who knows who else, back to the office.

There was a building under construction right next to where I was standing. Two bricklayers were joking about all that was going on. One propped a brick up against another and smashed it.

"Thought it would sound enough like a gunshot to give them all a surprise," he said, laughing to his friend.

No one but me even looked up.

An hour or so later the Senator and Liz emerged from the mass, no longer so chatty. I went back to the office and wrote down everything I could remember of that day, and since then have never forgotten where I was on the 20th anniversary of the Kennedy assassination.

After leaving Senator Moynihan's office, ADAM TURTELTAUB pursued a career in advertising and marketing. He currently serves as the marketing director for a company which provides training in the law and ethics for Fortune 1000 companies. He happily spends his nonworking hours with his wife and two sons.

"What we need is a period of dignified mourning for a graceful human being who passed through our midst with style and energy, a mourning more intense in virtue of the treachery of his end; but less intense than that which degenerates into abject pity for ourselves, or that asks that we place our personal grief above the best interests of our country as we understand them...Kennedy wouldn't want a caterwauling public besotted by its own tears for its own sake. He asked us to keep the torch lit. And that means work, each one of us according to his own lights, to keep this country at least as strong and as free, stronger, we can hope, and freer, than it was when John F. Kennedy last knew it."

("The Morning After," *National Review*, December 17, 1963)

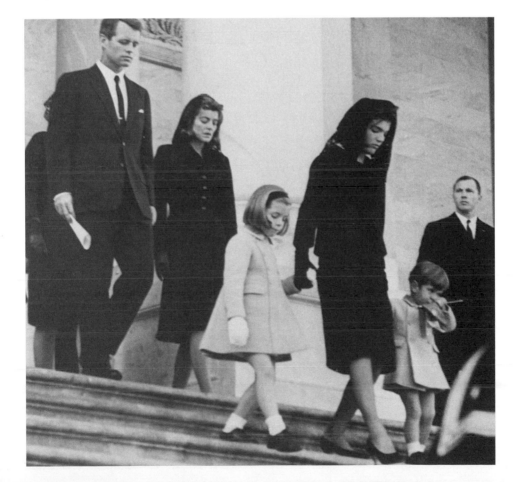

The news of Oswald's shooting reached Washington before the procession to the Capitol Rotunda began. President Johnson and his wife arrived at the north portico of the White House, soon followed by gray horses pulling an empty caisson and Black Jack, a black riderless horse that symbolized the nation's slain leader. (In the confusion of events, it was initially reported that the horse was Sandar, a gift given to Mrs. Kennedy in 1962 by President Ayub Khan of Pakistan; Black Jack was a 16-year-old gelding with years of experience in official funeral duties.) John F. Kennedy's coffin was brought down the steps of the portico and placed on the caisson; as it was taken away, it was followed by the riderless horse. Just after 1:00 p.m., Mrs. Kennedy appeared with her children, Caroline and John, Jr., and they were joined by Robert Kennedy in the limousine that took them to the Capitol.

November 24, 1963 • Pope Paul VI declares "capacity for hatred and evil still remains in the world"

TUFTS UNIVERSITY

PRESIDENT JOHN DIBIAGGIO

Like so many others, the day and time of President Kennedy's assassination is forever etched in my memory. I was in Michigan at the time, and upon returning from lunch I was informed by my staff that the President had been shot. We listened to the radio reports and we all wept openly when Walter Cronkite's distinctive voice announced that the wounds had proven fatal. The next few days are a blur in my memory, as we sat glued to our television screens and found ourselves sobbing at each new heart-rending image. Our nation lost its innocence during that horrendous time, and, in many ways, struggles to this day to regain it.

John DiBiaggio
President
Tufts University

JOHN DIBIAGGIO *has been president of Tufts University since 1992. He has also been chairman of the American Council on Education and on the boards of AFI, the NCAA Foundation and the blue ribbon Knight Foundation Commission on Intercollegiate Athletics.*

CATES/DOTY PRODUCTIONS, INC.

November 22, 1963

On that day I was working for ABC as a PA on "The Hollywood Palace" show which was telecast from the Palace Theater in Hollywood. Late that morning I was in the control room answering the phones and watching Chubby Checker and a group of dancers rehearsing a "twist" number on stage. Suddenly the Script Supervisor, Lilly LaCava came running from the offices upstairs, down the aisle toward the stage shouting "they shot the President..." For a moment everyone in the house thought she's gone nuts until she explained that the news was coming over the TV in the offices. Several more people came down confirming the bulletins. Everyone seemed to go into shock wondering how bad it really was. To me, President Kennedy was invincible and all this didn't seem possible.

Nick Vanoff, the Executive Producer came down and called a halt to the rehearsals, which in fact had come to a stop on their own. The whole place went into a "suspended animation" as the news out of Dallas got worse. Then the word came down that the show for that week had been cancelled. The TD had brought up both the ABC and CBS feeds in the control room and a group was quietly watching when around noon Walter Cronkite broke the final news that the President was dead.

DENNIS E. DOTY *has produced dozens of TV movies and such recent works as* Collected Stories *and James Agee's* A Death in the Family *with Gilbert Cates through their Cates/Doty Productions.*

November 24, 1963 - Oswald linked to mail-order rifle

JACK SHEA

When John Kennedy was elected President of the United States of
America, I was very proud. As a then-<u>young</u> Irish American Catholic, I
identified with him as the first leader from my background to assume such
an exalted position. More importantly, I saw his youth and energy in deal-
ing with the political issues taking the same path with which I agreed.

I am a television director and I was at an idea meeting in Hollywood plan-
ning a future TV program when I first heard the news that Kennedy was
injured. The meeting finished and I rushed off to my car to get to a
rehearsal in Burbank. My thoughts were not on the TV problems, but on
Kennedy's condition. I was entering the Cahuenga Pass, the radio was
on, and suddenly a voice announced that frightful message that the
President was dead. It was like a body blow hit me. Somehow I pulled
my car over and got off the freeway; I was crying. I don't remember
reacting like this to anything before in my life. I sat there and cried and
prayed for him, then I dried my tears and proceeded to the studio. An
actress was already there and stood in shock in the empty studio. We
tried to comfort each other. We were scheduled to rehearse a comedy. I
said, "Well, there's nothing we can do now but pray for our country and

our President." She agreed and we started to leave when an exec appeared who said, "Where are you going?" He thought we should go right ahead and rehearse. The actress started to cry again. By then several more people had amassed, and we all argued that no more rehearsals should occur. We prevailed and left. Before we could get out of the building, the networks had decided to shut down completely; only news programs remained and shortly the city, the state and, of course, the whole country went into mourning.

I remember the rest of the weekend: sitting at home with my family, watching the TV reports, going to church and praying, watching video of the next president being sworn in and marveling in the miracle that is America.

Jack Shea

JACK SHEA *has produced and directed television series and specials ranging from "Death Valley Days" and "Sanford and Son" to "The Waltons" and "Designing Women." He is a past president of the National Board of the Directors Guild of America.*

UNIVERSITY OF CALIFORNIA, LOS ANGELES

UCLA

BERKELEY • DAVIS • IRVINE • LOS ANGELES • RIVERSIDE • SAN DIEGO • SAN FRANCISCO

SANTA BARBARA • SANTA CRUZ

OFFICE OF THE DEAN
SCHOOL OF THEATER, FILM & TELEVISION

On November 22, 1963, I was 23 years old, two years out of college, living in New York City, married, and helping to put my husband through graduate school with my first full-time job. I worked at the Professional Placement Center of the New York State Employment Service on Madison Avenue and I was assigned at that time to the medical professions, specifically what was called the "Nurse's Registry" which sent out nurses to hospitals and homes on a daily basis. On that late afternoon, I was on the phone with a client who suddenly paused, said, "Oh, my god," and then apparently dropped the phone. After a moment she came back on and told me the President had been shot. Other people in my office must have heard too for shortly we were all standing around in disbelief; everything stopped and someone turned on a radio. Eventually, we had to answer the phone and send nurses out for the little bit of work day that remained. We didn't know yet that Kennedy was dead—that news came later in the evening. I called my husband and he came in our car to pick me up (a rarity) and we drove home silently in the dark streets that seemed somehow deserted.

Best, Vivian

VIVIAN SOBCHACK *is the associate dean at UCLA's School of Theater, Film and Television. She has published an extensive list of critical essays and articles and is the author of the upcoming* **Carnal Thoughts: Bodies, Texts, Scenes and Screens.**

November 24, 1963 • Premier Georges Pompidou insists that de Gaulle will remain as president for at least nine more years

Eight men lifted the coffin up the Capitol steps, as a military band
played the Navy hymn, "Eternal Father, Strong to Save." Inside
the Rotunda—the huge circular room connecting House and
Senate sides which architect Benjamin Henry Latrobe called "the
hall of the people"—the President, Jacqueline, Robert, John, Jr.
and Caroline were joined by Rose and the Kennedy family, along
with members of the Cabinet, the House and Senate. Short, elo-
quent eulogies were given by Senate Majority Leader Mike
Mansfield, Speaker of the House John W. McCormack and Chief
Justice Earl Warren, but the most indelible moment immediately
followed: Mrs. Kennedy and Caroline knelt before the casket, the
former kissing the flag on top of the coffin, the latter reaching
underneath the flag to touch the casket. Joseph L. Myler wrote,
"All the time the eyes of television had been watching. They were
still watching as a beautiful and brave woman and her little
daughter walked out into the world again."[2]

*"Our nation is bereaved. The whole world is poorer because of
his loss. But we can all be better Americans because John Fitzgerald has
passed our way, because he has been our chosen leader at a time in histo-
ry when his character his vision and his quiet courage have enabled him
to chart for us a safe course through the shoals of treacherous seas that
encompass the world. And now that he is relieved of the almost superhu-
man burdens we imposed on him, may he rest in peace."*

(Chief Justice Warren, from his eulogy in the
Capitol Rotunda, November 24, 1963)

November 24, 1963 - First diesel truck-tractor produced

Best Western
Marty's Valley Inn
& Conference Center

November 22, 1963 is a day that I will never forget. I was a 17-year-old freshman college student at San Diego State College in San Diego, California. I was crossing the street to the college from a parking lot to get to a class at 11 a.m. when someone yelled from their car, I was walking in front of it, that President John F. Kennedy, The President of the United States had just been shot. I can still see that instant frozen in my mind. Time stood still.

I think I froze in my steps for a second not wanting to believe what this stranger had just told me. I hurried to the class that I was to attend. Confusion was beginning to run rampant everywhere as the news spread and the disbelief of what had just transpired in Dallas, Texas. We did not have the access we have today with the many radios, television, and Internet. I found someone with a car radio near the classroom and we all listened to the information that was coming over the radio, stunned in disbelief.

All classes were dismissed that day and I decided to head home about an hour away by car. Our parents owned several restaurants in a town called Oceanside, California and I stopped at one of them, Marty's Valley Inn, to find many customers, employees, people off the street glued to the television set that was located in the cocktail lounge of the restaurant. There was no joking, no laughter that usually filled the lounge. A serious quiet hush had fallen across the lounge and restaurant as everyone was glued to this television set.

Our family had been a very strong Republican Family for as long as I could remember. Yet I remember both my parents very distraught and emotionally drained from what had happened that morning in Dallas, Texas. Politics meant nothing at a moment like this. Camelot had been silenced.

The day was also our Mothers 53rd birthday. A large party had been planned with many friends coming to help celebrate that evening with her. All was postponed immediately in honor of what had happened. A birthday cake lay in the main kitchen of the restaurant half decorated.

Everyone that I ran into the next several days appeared to be in shock The next real shock came when Lee Harvey Oswald, the accused assassin of John F. Kennedy, was shot and killed in front of all the world television cameras, to see, by Jack Ruby in a Dallas, Texas jail hallway several days later.

We all lived in a world that believed that nothing like this could happen in the United States. The strongest nation in the world, the most respected and honored of all the nations in the world and a country that so many wanted to come to live to fulfill their dreams. How could this happen to us? All dreams were shattered at this moment in time.

JIM SCHRODER *is general manager of Best Western Marty's Valley Inn in Oceanside, California. He has been involved in many charitable causes here and abroad and is active in such organizations as the Oceanside Economic Development Commission, the San Luis Rey Shrine Club and the Oceanside Sister Cities Foundation.*

November 24, 1963 - Cars return to Baghdad streets for first time since Baathist regime toppled a week ago

ANDREW J. FENADY

Mid-morning November 22, 1963, my pal, Nick Adams, and I were in a screening room at 20th Century Fox where I had a deal for features and television. Richard Zanuck was in charge of the studio and Bill Self was head of the television department. Nick and I had done a television series together, "The Rebel." Nick wanted to take another look at a movie called *Ride the High Country* starring Joel McCrea and Randolph Scott, so I set it up. We were smoking cigars and watching the scene where James Drury is marrying Mariette Hartley when the projectionist buzzed and said, "Phone call for you, Mr. Fenady."

"A.J." my secretary, Erika Theuke, said, "You better get up here..."

"Erika, you know we're right in the middle of..."

"JFK's been shot."

"Where?"

"In Dallas."

"No, I mean where? The arm? The leg..."

"They said in the head."

I slammed down the phone, clicked on the projectionist. "That's all."

"What the hell's the matter?" Nick hollered as I headed toward the door.

I told him while we ran through the hall.

Erika had the office radio turned on and the reporter was saying that President Kennedy had been taken to Parkland Memorial Hospital and had suffered a severe head wound that appeared to be fatal.

I just looked at Nick and took a puff on the cigar.

Almost four years before that, while we were shooting "The Rebel," Nick and I had made a $100 bet on who would be elected president — John F. Kennedy or Richard Nixon.

On the morning of November 22, 1963, the hundred-dollar bill I had won from Nick was still in my wallet.

And nearly 40 years later—it still is.

ANDREW J. FENADY *has written and produced such films as* Chisum, Ride Beyond Vengeance *and* The Man With Bogart's Face *(based on his own novel), in addition to numerous series and TV movies such as* "Confidential File," "Hondo," "The Rebel" *and* "The Love She Sought."

BARBARA EDEN

I recall that on that day my husband at the time, Michael Ansara, and I walked into Dupar's Restaurant in Studio City to have breakfast with friends and the first thing they said was "Something terrible has happened!" We said, "What?" And I'll never forget their answer: "The President has been shot, it happened in Dallas! JFK is gone." I had to sit down. I felt like I couldn't stand.

When Mike and I got home, we watched the terrible news on TV all that day and the next. I remember feeling an immediate sense of insecurity. A kind of fear about what might happen next. But I did also feel comforted that our system here in America allows for almost anything to happen and we still are viable. Presidential succession takes place, the government continues to operate and the country goes on, seriously wounded, yes, but almost without losing a beat.

However, I do remember being stunned for a long time. There was a sense of great loss. Probably, the most vivid memory of my feelings on that tragic day was that I felt incredibly sad.

BARBARA EDEN is best known for her work on the sitcom favorite "I Dream of Jeannie." She has starred in films and TV movies and frequently appears on stage and in concert.

Morton's Restaurant Group, Inc.

Allen J. Bernstein
Chairman of the Board
Chief Executive Officer

Along with tens of millions of other Americans, the incredibly sad and disturbing memories of November 22, 1963, will be etched in my mind for the rest of my life.

But, for me, that date has additional and very personal significance. Every year, I am reminded of the assassination of John F. Kennedy on the anniversary of his death because November 22 is also my birthday.

I was born on a Thanksgiving Day and I turned 18 on November 22, 1963, a date that will always invoke memories of national tragedy and sorrow.

I was a freshman at the University of Miami. The United States was getting more heavily involved in the war in Vietnam—and turning 18 meant you had to register for the draft.

I got to the Selective Service office early that morning, about half an hour before the doors opened.

I remember having mixed feelings after registering. I had no desire to be drafted, especially with the war in Southeast Asia heating up, but my parents had instilled their love of this country in me, and I was prepared to do what might be asked of me.

I was nursing a bad cold and my sore throat was getting worse as the day wore on, so instead of having lunch, I made my way to the campus infirmary.

As the doctor was beginning his examination, a nurse came running out of the admitting office, screaming, "The President's been shot in Dallas!! They've shot President Kennedy!"

Suddenly, time stood still. We are all in a state of shock. A minute passed; it seemed like an hour, and then someone turned on a radio, and we found out that it was true.

I'll never forget the reaction in that infirmary to the shattering news. Some people sobbed. Others were too stunned to say anything. One person cursed Castro. Another said something about the Russians and the beginning of World War Three.

We forgot what minor ailments had brought us there.

A few minutes later, all eyes were riveted on a small black-and-white television set. And then Walter Cronkite, his eyes teary, and his voice choking, reported the devastating news that President Kennedy had been pronounced dead at Parkland Memorial Hospital.

I walked back to my dormitory in a daze.

There was a long flat parcel waiting for me. I went through the motions and opened it. It was an enormous chocolate-fudge sheet cake. A birthday cake from my mother, large enough to feed every one in the dorm.

But there was to be no celebration that day. Classes were suspended and the entire campus went into communal mourning. We were in a state of stupor. Like most of America, we were unable to fully process what had taken place.

I was watching TV on Sunday—and I saw Jack Ruby kill Lee Harvey Oswald. It was all too surreal.

The images of the funeral on Monday are still incredibly vivid. None more so than little "John-John" saluting his fallen father.

The assassination forever changed the way I look at life. There was a loss of innocence, a sense that all was not well with the world I lived in. The security and certainty I had taken for granted no longer existed.

It couldn't happen here.

But it did.

It was my 18th birthday. And my coming of age was marked by a tragic event that shook the world.

ALLEN J. BERNSTEIN *is one of the country's most prominent restaurant executives and is CEO of Morton's Restaurant Group.*

November 24, 1963 - Marina Oswald spends night at Inn of Six Flags in Dallas Fort Worth

Throughout the rest of Sunday, into the night and next morning, an estimated 250,000 people arrived and waited to go into the Rotunda and pay their respects. Plans to close the Rotunda doors on Sunday night were abandoned and people who knew they had no chance of getting inside still waited for hours in the cold in lines that stretched for miles. Jacqueline and Robert Kennedy appeared again that night, entering the Rotunda and walking past the mourners who were there. Again, she knelt by the coffin and then she and Robert left the Capitol Building, past the thousands who waited. The Associated Press reported: "Before leaving, she looked for a long time into the faces of the silent mourners, as if trying to rivet their sorrowing expressions forever in her mind. For a brief moment, a thin, grateful smile parted her lips."[3]

November 24, 1963 • Symon Gould, American Vegetarian Party Founder (and presidential candidate in 1960), dies at 70

10
Farewell

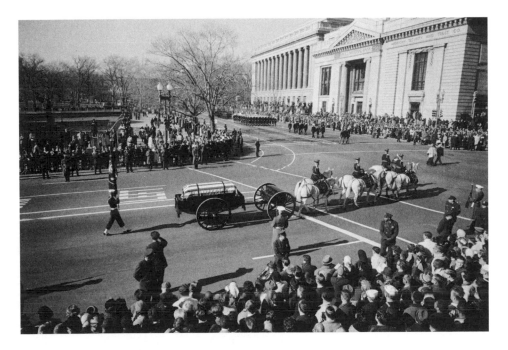

President Kennedy's casket was brought down the steps of the Capitol on Monday morning, November 25, and placed once more on the caisson. And once more, Black Jack followed the caisson. This was to be John F. Kennedy's final journey. The first destination was St. Matthew's Cathedral, a personal choice by Mrs. Kennedy. The funeral cortege stopped at the White House, where President Johnson and the Kennedy family walked eight

blocks to the cathedral, leading an imposing, somber gathering of dignitaries from across the world: President Charles de Gaulle from France, First Deputy Premier Anastas Mikoyan of the Soviet Union, Foreign Minister Golda Meir from Israel, Emperor Haile Selassie I from Ethiopia, Prince Philip from Great Britain and President Eamon de Valera of Ireland were just a few of the hundreds of representatives who traveled to witness President Kennedy being laid to rest. Richard Cardinal Cushing, Archbishop of Boston—the priest who had married John and Jacqueline Kennedy and had spoken the invocation at Kennedy's 1961 inaugural address—received the body and blessed the casket. Inside St. Matthew's, friends, family and world leaders listened to Cushing say the Requiem Mass. Only John, Jr. grew restless during the service. When the services were over, he left the church with his mother and sister and waited, as his father's casket was brought down the steps. Mrs. Kennedy whispered into John, Jr.'s ear and he saluted as it passed. "And in that moment," Robert M. Andrews wrote, "he suddenly became the brave soldier his father would have wanted him to be on this day, of all days."[1]

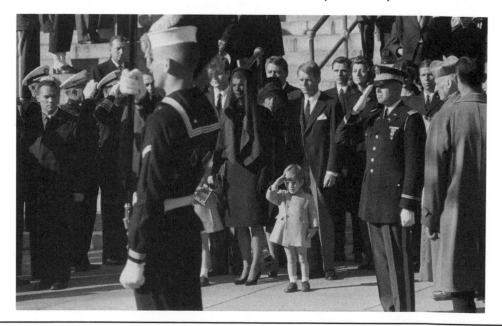

November 25, 1963- Soviet Newspaper, Izvestia, vows to continue President Kennedy's peace efforts

lm

l e o n a r d m a l t i n

It's always seemed to me that John F. Kennedy's assassination marked a watershed in the history of America—and the world. Perhaps I think of it this way because I was twelve years old, and full of youthful idealism, when it occurred.

I was in the eighth grade, and when someone ran into class and blurted out the news that President Kennedy had been shot, we all laughed, thinking it was a joke. When our principal made the official announcement a short time later over the public-address system, I remember thinking to myself, "This is impossible." Today, I would use the work "unthinkable," but the idea is the same. Looking back, it occurs to me that what seemed unthinkable to me in 1963, at age twelve, never seemed that way again.

Kennedy was the first President I was really aware of, and responded to. I saw him in person twice, once on the campaign trail in my home town of Teaneck, New Jersey, and another time in a motorcade in Manhattan. He was, of course, a very dashing figure, but what I remember even more was his press conferences, where I was dazzled by his intelligence and wit.

I've often wondered what the world would be like if those shots had not rung out in November of 1963. I tell myself that much of the chaos we've experienced during the last forty years might not have happened, but of course, we'll never know. And somehow, I don't think twelve-year-olds will ever be as idealistic again.

Sincerely,

Leonard Maltin

LEONARD MALTIN *is one of the country's most respected film historians and critics, whose books include* The Great American Broadcast: A Celebration of Radio's Golden Age, Of Mice and Magic: A History of American Animated Cartoons, Leonard Maltin's Movie Encyclopedia *and his yearly* Movie & Video Guide. *He also appears on "Entertainment Tonight" and co-hosts the movie review show "Hot Ticket."*

FRANCESCO SCAVULLO, INC.

It was a beautiful hot November day. I took advantage of the weather and took my *Seventeen* magazine models to Atlantic Beach, Long Island to photograph bathing suits, as the day was so warm.

While we were photographing and changing bathing suits in the van the news came on the radio that President Kennedy had been shot. We all freaked. We all were shocked. We all started crying. The girls said "Is he dead or alive? Is he dead or alive?" We kept changing the dial for different stations and then we heard the news that President Kennedy was dead.

We finished taking our pictures, but we were all in shock and we were all crying. We drove home in silence, all teary-eyed. It was the worst day of my life. The next worst day was the day Bobby Kennedy was shot. I thought I must leave this country and go live in Italy. They are killing all the good men.

Francesco Scavullo

FRANCESCO SCAVULLO *is one of the world's most well-known photographers whose work has appeared in practically every major fashion and style magazine. He has published six books, including* Scavullo Nudes *and directed several TV commercials.*

November 25, 1963 - Republican leaders call for halt to campaigning during national mourning for President

[The following letter was written in 1963 by college student Roger Enrico to his parents, who sent it to their local newspaper where it was printed on December 5, 1963]

Dear Folks,

Just a note to communicate some of the sights and sounds of Washington, D.C. on Monday, November 25, 1963.

We left Wellesley at 6:30 on Sunday, and drove over a near-empty Route 9 to the interchange for the Massachusetts Turnpike. This is no ordinary four-lane highway; it is flanked on both sides by shopping centers, bowling alleys, nightclubs, restaurants, by everything, in fact, from a Ford Motor Co. assembly plant to Carling's Brewery. Tonight the strip was dead. As we traveled through Brookline Hills, I could not help but feel the extreme grief the people of this area were captivated by. But then out of the dead city and on to the famed Massachusetts turnpike for a 500-mile trip south to our nation's capital.

The vast interchanges and freeways leading into the city were void of traffic save buses and trucks; crossing the George Washington Bridge, which has two levels and 12 lanes to carry its normal burden of traffic, we again, were accompanied by only a few trucks and buses.

The traffic situation was much the same until we arrived in Maryland, where the traffic became abnormally heavy. After 70 miles of heavy traffic, we finally edged our way into Washington, and headed immediately for the Capitol building. It was an extremely cold Monday morning, yet there were people everywhere. We were now walking up the myriad of steps to the Capitol building; there were about a thousand people mulling around in absolute silence. Our first thoughts were that we could get into

the Rotunda after only a short wait, but as we rounded the corner of the building we began to get some idea of the popularity of John Kennedy.

We joined those walking to the end of the line, which we envisioned must be about four or five blocks long—especially at this late hour. After passing the 10th block, we were stopped by a policeman who discouraged us from lining up. He told us that the line was now 17 blocks long, and, since the blocks contained over a thousand people each, it was impossible for us to reach the Rotunda before the closing time of 9 a.m. We then turned around and walked back to the Capitol. On the way back, I attempted to listen to the comments of some of the people who were turned away as we were. One woman was telling a friend in a subdued voice that she had been in line for seven hours and still was 10 blocks from her goal; she gave up and said, "I hope my standing here for seven hours was sufficient to pay my respects to this great man."

We then walked to the steps of the Senate, and, standing on the balcony facing the endless line of mourners, took time to collect our thoughts. There were over 20,000 people out there, but all that could be heard was a continuous and methodical shuffling of feet. My friends then interrupted my gazing train of thought to tell me that we had to leave so that we could park the car and get in line to watch the funeral procession. As we came around to the other side of the Capitol, there was a little boy crying because he had been unable to see the President. His mother comforted him by saying, "Isn't it better to remember him the way you saw him on television?" The little boy agreed...and so did I.

After parking the car, we made our way down 17th Street (the route to be taken by the procession to the cathedral) to the White House. Along the way (it was now 6:30) there were people huddled in blankets sleeping on the curb. Arriving at Lafayette Park across the street from the White House, we took our places on the curb on a corner almost directly

across from the gate where the procession would leave the White House grounds. We waited until 12:30 when the procession, coming from the Capitol, came into view. There were thousands of people lining the street, but again hardly a sound came from the vast crowd. Only the muffled drums and the sound of the marching feet broke the silence. First came the service bands and marching contingents, and then the honor guard of bagpipers from Scotland...and then the President. I remembered the last time I had seen him. About a month ago in Boston when he was coming in a motorcade riding in his Presidential Lincoln convertible to attend a $100-plate banquet put on by the Democrats for his birthday...then my thoughts drifted to the time in 1960 when he came to Hibbing, and I was able to shake his hand and meet him close up for a split second...now I was seeing him pass by again—in his funeral procession.

Behind the coffin walked his widow and two brothers, Bobby and Ted, and behind them walked the new President, Lyndon Johnson, flanked by Secret Servicemen. And following them came the greatest array of world leaders ever assembled in one place for one reason—to pay respects to THEIR former leader. My eyes moved fast to pick them out...Charles de Gaulle, Haile Selassie, Queen Frederika, Prince Philip...and then they were past. After the world leaders came the Joint Chiefs of Staff with a serviceman walking alongside of them listening intently to a walkie-talkie which was connected to the defense command. The national leaders came next...and then it was over, and we began to walk back to the car.

It took us four hours to get out of the city and we continued on our way home.

ROGER A. ENRICO *is the former chairman of the board and chief executive officer of PepsiCo.*

"...I cannot help feeling that literary accounts of the Kennedy funeral have seemed so pitifully inadequate largely because the image of a riderless black horse possesses a visual power far beyond any literary meaning. On the one great state occasion of our time a group of anonymous television photographers transcended all the poets, novelists, and assorted wordmongers of Western Civilization. At long last the Image had made the Word superfluous."

(Andrew Sarris, "The Cardinal," *The Village Voice*, December 12, 1963)

The line of cars, soldiers and mourners—miles long—made its way across the Arlington Memorial Bridge and into the National Cemetery. President Kennedy's coffin was brought up the slope that faced the Capitol and the Lincoln Memorial, and "The Star-Spangled Banner" was played by the Marine Corps Band. Fifty jet planes—one for each state—tore through the sky overhead, followed by Air Force One, which dipped its wings. A prayer was spoken by Cardinal Cushing and a 21-gun salute was fired. The flag from the coffin was presented to Mrs. Kennedy and then she, Robert and Edward lit an eternal flame, burning from the center of a circular granite stone; the flame was built in accordance with Mrs. Kennedy's wish to mark her husband's grave in a manner similar to Paris' unknown soldier.

November 25, 1963 - British leaders in both houses of Parliament pay tribute to Kennedy

JOAN VAN ARK

November 22, 1963. I was the resident ingénue in the acting company at the Arena Stage in Washington, D.C. (only my second paying job after the famous Guthrie Theater at the tender age of 18).

This November day started with a pre-rehearsal trip to a hair salon...for hair color?...a manicure?...I don't remember which.

What I do remember was sitting under the hair dryer and watching this weird emotion and confusion soon after I arrived. Murmurs...then shock...even some tears. The President had been shot while riding in a motorcade in Dallas, Texas.

My first instinct—and reaction—was to get to a church—any church—and pray. Which I did.

What followed in the next numbing 24 hours isn't exact...the cancellation of all rehearsals—the empty-lost lonely feeling...the comfort of all the younger unmarried company members staying together that first night in the wardrobe designer's Georgetown townhouse (her actor husband was working in New York).

But the most lasting image from that moment in history came a day or so later. Standing along the street, when the caisson procession with his coffin proceeded down Pennsylvania Avenue to the steps of the Capitol, there stood the unforgettable figure of this grief-stricken widow—thin—elegant—and totally immersed in "black" from head to toe, holding her children's hands on either side of her.

To this young actress, she embodied the essence of woman...of wife, now widow...and, most of all, mother. And she has, to this day—out of that terrible moment in history—illustrated the seamless and lasting beauty of grace under pressure.

Tony nominee JOAN VAN ARK *is a veteran of stage and television, and is probably best known for playing Valene Ewing on the long-running drama series "Knots Landing."*

SHAME AND GRIEF

1963 was not a great year. I was 16 years old. My father, who was loved by everyone who met him, died of cancer in May at the far-too-young age of 40. I was devastated. Everyone was. But no one told me how to handle my grief, so after crying for the last time, I shut down all my emotions and feelings for the next 20-some years. The only feelings that I could reach were those of life's undeniable unfairness. On the afternoon of November 22nd, I was sitting in my 12th grade class when the public-address system interrupted whatever it was that I wasn't listening to in class. Over the intercom came the voice of a news reporter informing us that President John Kennedy had been shot. While the rest of the class seemed stunned, to my eternal chagrin, with a sad attempt at humor, I leaned over to a classmate and said, "He'll never die, he's too rich."

Some minutes later, the reporter announced that the President had died. I felt ashamed. Here I was, a young fool, trying to be funny, attempting a joke at the expense of a fatally wounded husband, father and leader.

When I arrived home that November afternoon, my mother, who was far from completing her sullen trek through grief, said to me, "Now I know that Daddy has good company." It almost seemed to lift her spirit a bit. Looking back with years of therapy and 12-step programs under my belt, honing my ever-maturing psyche, I realize much of what I was actually doing.

I was learning to use what was, at that time, my under-developed sense of humor as a defense against feeling anything. There was also a tremendous sense of injustice I felt from losing my father. Here was a wealthy president, one my father had worked closely with author James Michener in Bucks County, Pennsylvania, to help elect, for whom I was supposed to be concerned. I couldn't be concerned about anyone other than myself.

I wasn't a fool. I was a kid. I was heavy of heart with no idea or knowledge of how to deal with my deep, repressed sorrow. I still sense the pangs of the shame I felt back then, but it is different now. Today I understand and have learned from it. I've learned how to deal with grief by making it okay to feel the feelings. I can teach my own children how they can deal with their own grief. I've learned not to judge what I don't understand. Most importantly, I've learned that when I judge anyone negatively, including myself, I'm judging God and his handiwork negatively, and saying I know better than God. And I don't.

Steve Young

STEVE YOUNG *is a writer and motivational speaker who has written for television and whose stories and articles have appeared in magazines and national newspapers. He is the author of* Great Failures of the Extremely Successful.

The Sherwood Schwartz Company

Friday, November 22, 1963 was the final day of shooting the pilot film of a new series called "Gilligan's Island." It was afternoon and we were filming on location on a beach called Moloaa Bay on the island of Kauai in Hawaii.

I was producing the pilot and Rod Amateau was directing, and we, as well as the cast and crew, were anxious to finish. It had been a difficult week because there was a storm someplace under the sea nearby and the waves underneath had pulled moorings loose from some pilings we had sunk offshore for some special effects. We were all exhausted and looking forward to the weekend.

We would have Saturday and Sunday to relax at a hotel in Honolulu. On Monday, the only thing left would be to film the S.S. Minnow leaving the harbor in Honolulu with the crew (Gilligan and the Skipper) and the five passengers (Mr. and Mrs. Howell, Ginger, the Professor and Mary Ann). That would become the opening of every episode in the series.

Suddenly, one of the assistants came rushing down to the beach yelling that President Kennedy had been shot. Nobody took him seriously and I told him this was no time for practical jokes. We were trying to finish this last scene for the pilot film. He insisted it was the truth, and a few moments later somebody else arrived on the beach with the same news.

Gradually reality set in. We were so far from the mainland that this news seemed unreal. When it finally sunk in, we were so shocked it was difficult to keep working; to finish that last sequence. Whoever said, "The show must go on," must have been right because your mind and body work on automatic under conditions like this. We were numb with grief and bewilderment. But somehow we managed to get the final angles on that last scene we were filming, thousands of miles away from the drama that was unfolding back in Dallas. It was an afternoon that none of us would ever forget.

The next day we were in our hotel in Honolulu when one crazy event after another appeared on television: someone named Lee Harvey Oswald in the

book depository, theories about a conspiracy, then Oswald being shot and killed by Jack Ruby. News was constantly updated and filling the airwaves.

In spite of these tragic events, we had to finish work on the pilot of "Gilligan's Island." On Monday, we had to film the opening sequence with the crew and passengers on board the S.S. Minnow setting out on their "three-hour tour."

Then there was an announcement from the government that all navy installations were being closed down on Monday out of respect for President Kennedy. That meant all of us would have to stay over an extra day in Honolulu, assuming Honolulu Harbor would be available on Tuesday.

That's exactly what happened. On Tuesday, the director, Rod Amateau, and the cast, Bob Denver, Alan Hale, Jim Backus, Natalie Schafer, Kit Smythe, John Gabriel, and Nancy McCarthy, filmed the scene aboard the S.S. Minnow leaving Honolulu Harbor to start their three-hour tour. Shortly thereafter, Kit Smythe was replaced by Tina Louise; John Gabriel was replaced by Russell Johnson, and Nancy McCarthy was replaced by Dawn Wells.

But it all started that fateful day. I usually have a poor memory for dates and events, but I'll never forget that Friday afternoon, November 22nd, when our beloved President Kennedy was assassinated.

Yours sincerely,

Sherwood Schwartz

SHERWOOD SCHWARTZ *began writing in radio for "The Bob Hope Show" and "The Adventures of Ozzie and Harriet" before moving to television, where he produced and wrote for innumerable series and, most famously, created the classic sitcoms "Gilligan's Island" and "The Brady Bunch."*

Writers, newscasters and commentators offered their observations and reflections on the funeral, describing the rituals, the pomp, the dignity of Jacqueline Kennedy, the array of foreign leaders who came to pay tribute to the slain President. Washington *Star* columnist Mary McGrory offered:

"Of John Fitzgerald's funeral it can be said that he would have liked it. It had that decorum and dash that were his special style. It was both splendid and spontaneous. It was full of children and princes, of gardeners and governors."[2]

Perhaps most memorably, writer Jimmy Breslin—in a column for the *New York Herald Tribune*—interviewed Clifton Pollard, the gentleman who was called on Sunday to dig John F. Kennedy's grave. Pollard's pride in his assigned task conveyed the true permanence of the events from November 22, 1963, in a simple and unusually direct way.

November 25, 1963 · Austrian divers find Nazi counterfeiting equipment in lake

Rose Marie

I was doing the Dick Van Dyke Show. It was the first day of
rehearsal for the show that we were going to film that week.
It was about 10:00 A.M. The entire cast was sitting around
having coffee, donuts, Danish, etc. having the usual gab
session of "How are you?" "What did you do last night?" etc.
We were reading the script, making comments, etc. when our
prop man, Glenn Ross came running out of the prop room saying,
"The President's been shot!" We looked at one another for
about a minute and couldn't believe what he said. He then
explained it happened in Dallas and the President was in the
hospital there. It was a hectic time in Dallas, but our
little group couldn't say a word -- we just looked at one
another and said, "Oh my God. No! It can't happen." Dick
Van Dyke, Carl Reiner, Morey Amsterdam, Mary Tyler Moore,
Richard Deacon, and myself were stunned and couldn't talk.
We just sat in the prop room and listened to the radio. When
Walter Cronkite finally said "The President died at 1:00 P.M.
Dallas time," Mary and I burst into tears and everybody hung
on to one another. Carl said, "Let's go home. We can't work
today."

So very quietly we started to leave -- nobody spoke -- we
just left for our respective homes. I got into my car and
couldn't stop crying. I called my husband, who had been
asleep, and told him what happened. He couldn't believe it
either. I said, "I'm on my way home." When I got home the
T.V. was on and we both just looked at each other in disbelief.
For those three horrible days following the shooting the T.V.
was never off. My husband and I walked around the house like
lost souls.

During the funeral, when the bugler played Taps and didn't
quite hit the high note, my husband said, "I knew he'd blow
it," and slammed his hand on the table. My husband was a

trumpet player who did the Bing Crosby Show, Tennessee Ernie Ford Show, Dinah Shore and George Gobel Shows (among many others). He was one of the top men in the music business, so missing the big high note on Taps meant a lot to him and he was quite upset.

We didn't film the Van Dyke Show that week - in fact, the following week we filmed the show without an audience. It was quite a while before the entire Van Dyke group was able to get back to normal.

As for my personal feelings -- I felt lost -- I had admired JFK from the moment he was elected. He gave our country such dignity and a sense of pride. I was so very proud to be an American with him as my President and Jackie as his beautiful wife. To me it was the way America should always be looked upon and I think we've lost that since he's gone!

ROSEMARIE GUY is best remembered as Sally Rogers on "The Dick Van Dyke Show" and is a veteran of numerous films, sitcoms and variety shows, not to mention 14 years as a regular guest on "The Hollywood Squares."

November 25, 1963 - Capital Records Canada releases "Beatlemania! With the Beatles"

monty hall

It was early morning when I was driving to the NBC studios at Sunset and Vine. In between emceeing a show called "Video Village" on CBS television, I was producing another show titled "Your First Impression" on NBC TV. While driving, the program I was listening to was interrupted with the news that the President had been shot. The commentator did not know the extent of the damage. I arrived at my office in a state of shock. The only one there was my secretary. We turned on the television and watched in stunned horror.

One by one my staff arrived. None of them said a word, but sat down on one of the chairs in my office. As others arrived, production people, writers, etc., they brought chairs in from outer offices, sat down and joined in that somber gathering. The morning moved on, the news not getting any better. No one moved. The only sounds were the voices from the TV set and the sobbing of the girls, and yes, some of the men. And so it went all day. Not one bit of work was done. The network pre-empted all programming.

Even though at one point I told the staff they could go home, none of them did. It was a time in our lives that bonded us in our grief. Our President was dead. His youth and our youth ended that day. We would never be the same.

MONTY HALL *was the co-creator of the classic game show "Let's Make a Deal" and its host from 1963 to 1986. His philanthropic work over the years has earned him hundreds of awards, including the Order of Canada from his native country.*

November 25, 1963 • 2000 attend funeral services for slain Dallas policeman J.D. Tippit

Gerald Kruglik, MD.

"No Way"

I was in the chemistry lab at Columbia College on Friday, November 22, 1963. While tediously pipetting a solution of hydrochloric acid, I was thinking about the Columbia Lion Marching Band program for the following day. We had achieved quite a bit of notoriety for the program we'd put on at Harvard the prior week. It was a humorous take on presidential politics in which we'd marched off the field backwards, in honor of the likely Republican candidate Barry Goldwater. Our excitement was all the greater when it had been announced that President John F. Kennedy was in the crowd and rather enjoyed the show.

My reverie was broken by the announcement from somewhere in the lab that President Kennedy had been shot. I ran out into the hallway and tried to confirm this startling news.

"No, way," some student was saying, "Where'd you hear that?" "Who's got a radio?"At first, I didn't believe it. If it were true, there'd be proof. A professor would confirm it. Or something. I went back to finish my experiment.

It was hard to concentrate. The longer the delay in corroboration, the better I felt. Then a graduate student provided the details. He'd been shot during a motorcade in Dallas, Texas, and taken to Parkland Hospital as a precaution. No particulars on his condition.

The experiment went poorly, I kept waiting for the "all clear," that our President, our hero (that word was not a sarcastic barb those days) would be pronounced in "stable and satisfactory condition," having suffered only a minor wound.

They closed the lab early that dreary afternoon. I stepped around groups of shocked and strangely silent students and made my way back to the dorm, where I called my girlfriend so we could cry together.

That entire weekend instead of football, I watched television. I saw the riderless horse, and JFK, Jr. salute and waited until I could wake up from the nightmare.

Gerald Kruglik

GERALD KRUGLIK, M.D. *is a practicing radiologist who runs an outpatient center in Tamarac, Florida. He graduated from Columbia University in New York City and holds an M.D. degree from the University of Illinois in Chicago. He is currently writing books for children with the noted author Barbara Bottner, his wife of 15 years.*

In December of 1963, Patrick Bouvier Kennedy and an unnamed stillborn daughter were reburied in Arlington. Jacqueline Bouvier Kennedy Onassis died on May 19, 1994, and was also buried in Arlington, next to her husband.

Dan Quayle: It is not just age; it's accomplishments, it's experience. I have far more experience than many others that sought the office of Vice President of this country. I have as much experience in the Congress as Jack Kennedy did when he sought the Presidency. I will be prepared to deal with the people in the Bush Administration, if that unfortunate event would ever occur.

Judy Woodruff: Senator Bentsen.

Lloyd Bentsen: Senator, I served with Jack Kennedy. I knew Jack Kennedy. Jack Kennedy was a friend of mine. Senator, you are no Jack Kennedy. What has to be done in a situation like that is to call in the—

Woodruff: Please, please—once again, you are only taking time away from your own candidate.

Quayle: That was really uncalled for, Senator.

Bentsen: You are the one that was making the comparison, Senator. And I'm the one who knew him well. And frankly, I think you are so far apart in the objectives you choose for your country that I did not think the comparison was well taken.

(from the 1988 Vice Presidential debate, Omaha, Nebraska, October 5, 1988)

November 25, 1963 - Sixteen-mile northern end of the Taconic State Parkway completed in New York state

On the night of November 25, 1963, after the funeral was fin-
ished, there were buffets held for the visiting foreign dignitaries.
President Johnson greeted the various leaders, but Jacqueline
Kennedy was the center of attention, becoming an ad hoc diplo-
mat and meeting privately with Selassie, de Gaulle, de Valera and
Prince Philip. After the dignitaries had left, there was a party for
young John, Jr. It was his third birthday. Kenneth O'Donnell
remembered his friend Dave Powers leading family and friends
in singing "Happy Birthday" and then "The Gang That Sang
'Heart of My Heart,'" a favorite of John Kennedy's.

"Singing 'Heart of My Heart' was too much for Bobby. It
brought back to him the night of the last rally of the 1958
Senatorial campaign in Massachusetts when Jack, Bobby and Ted
had climbed up on a table at the G and G Delicatessen on Blue
Hill Avenue in the Dorchester section of Boston to harmonize
on that song before a crowd of admirers."[3]

November 25, 1963 • Communist forces destroy two strategic hamlets in North Vietnam

ED FRIENDLY

I was sitting in the English Grill at 30 Rockefeller Plaza, having a quick lunch with some NBC executives, when my secretary rushed up to the table to tell us JFK had been shot. All of us paled—the crowded restaurant came to a hush, the bartender turned the TV on and table by table people left to return to their offices, without even remembering to call for a check or to pay their bill.

On arriving at the fourth floor at 30 Rockefeller Plaza, all of us NBC program vice presidents were called to the President's office to implement immediate program changes—cancellations, as NBC News took over the network. The horrible events of that Friday afternoon sunk in as the tragic news of his death stunned the nation. We in the program department were superfluous and sent home.

My wife, Natalie, and I had devised a monthly plan whereby each took one of our two children—our daughter, Brooke, aged eight and our son, Trip, aged six—somewhere alone so that we could give them the special attention they needed and establish a one-on-one relationship without sibling rivalry or parental pressures. It was my turn to be alone with our son that weekend.

Once home, I was glued to the TV set and radio but quickly realized that it would be difficult for a six-year-old to comprehend a father breaking a promise to go away on a weekend because our President had died. So, off we went in the car for our two-hour drive to Quogue, Long Island, our weekend/summer home. Here was a 41-year-old man and a six-year-old boy talking about practically nothing other than JFK, the office of the President, the history of the U.S. and our historic tragedies of assassinations. Amazingly, he comprehended the gravity of the moment and I truly believe became as involved as I. Two days later we drove back to New York to join his mother and his sister. God knows it hadn't been a typical father-son weekend, but I do believe a bond had formed between his memory of JFK and his country.

JFK left an indelible mark on both of us, all USA citizens and indeed the world, regardless of age.

For those who have lived a long time, December 7, 1941, November 22, 1963 and September 11, 2001 are moments none of us can ever forget...days that we have replayed in our minds over and over.

ED FRIENDLY *started in advertising before moving to California and co-creating and co-producing "Rowan & Martin's Laugh-In" and "Little House on the Prairie." As a full-time horseman, Friendly and wife Natalie have owned and raced thoroughbreds since 1970. He founded and established Thoroughbred Owners of California.*

U C L A°

SCHOOL OF THEATER
FILM AND TELEVISION

School of Theater,
Film and Television

I was walking across the campus of Queens College. Classes were on hiatus for the Thanksgiving break. A fellow student, an actress in the theater department strode across the quadrangle toward me. Her face was filled with pain, but this was not unusual for her, as she was a bit on the melodramatic side. She said, "He's dead. The president is dead." I thought she was rehearsing lines for a play. "President Kennedy has been shot in Texas," she said.

I turned around and walked back to the apartment I shared with three other roommates. None of them were home and I watched the TV alone. I had been sitting in this same apartment a year before when the call came in that my father had died. He was forty-eight. I was of the generation of young men who were taught that it was unmanly to express emotion. Like John Wayne, you kept it inside. I had not cried when I heard of my father's death. I did not cry when I drove home and found my living room filled with friends and relatives. I did not cry at his funeral. When I sat in front of the TV and saw the man I had believed in was dead, and I wondered what would happen to our country without him, the tears came. I cried for Kennedy and I cried for my father.

HAL ACKERMAN *is a playwright, screenwriter and novelist and has taught screenwriting at the University of California in Los Angeles for 18 years.*

CITY OF BEVERLY HILLS

MARK EGERMAN
MAYOR

On November 22, 1963, the day of the assassination, I was a first year law student at UCLA School of Law. The law school is located at the northeasterly area of the campus. My wife (then my finacé) Lynn Fenberg Egerman was a graduate student and a teaching assistant in science. She was completing her science requirements prior to entering UCLA School of Medicine. She was in the life science building located near the southerly end of UCLA's campus.

We both heard the report of the shooting at about the same time in the morning. Needless to say, we were dazed and could not believe that such a horrific event had happened. I started walking from the law school south through campus to find her. Her feelings were the same, and she had started walking north towards the law school to find me. Amazingly, amid thousands of students, we found each other mid-way between the law school and the life science building. Our first words to each other were, "did you hear what happened?" "Is it true?" "Will President Kennedy survive?"

We then walked back to the law school together where I knew there was a radio. Both of us were in a state of utter disbelief, shock and sadness. We returned to the law school and went to the law review office where I had a desk. There was a radio on at the time, and we sat listening to the news report. The room was filled, but it was utterly silent except for the radio broadcaster's voice. Everyone was shell shocked and disbelieving that this could have happened.

I remember that initially while being told that the President had been shot, the seriousness of his wounds were not immediately relayed. Then the news trickled in, all of it bad. We learned that he had been shot in the head and that his condition was extremely serious. Even as the news got worse, Lynn and I kept saying to each other that it would be alright, that he would live. Finally, when it was reported that he had died, we just hugged each other and cried.

Much can be written about the feelings of young adults who had the good fortune to see and hear a young idealistic President who was a model and inspiration for public service. President Kennedy had initiated the Peace Corps. Young Americans were asked to give of themselves so that others in foreign lands could progress. That message of giving to others and to your own country had a profound impact on all of those in my generation. My wife went into medicine to help others. I went Into law. The Kennedy White House was "Camelot."

Lynn and I, like so many others of our age, felt that we could make a difference in the world. That belief remained after the assassination, but with an overlay of great sadness.

Always,

[signature: Mark Egerman]

MARK EGERMAN

MARK EGERMAN *was mayor of Beverly Hills and is a member of the Beverly Hills City Council. He has practiced law for more than 30 years.*

"Once a leader becomes a martyr, myth naturally follows," wrote William Manchester. "The hero must be clothed in raiments which he would have found strange, but which please the public eye."[4] The danger in reflection is creating myths, in glorifying a past that never really was. But myths serve a purpose, too, providing heroes for people who need something to believe. On the 20th anniversary of Kennedy's death in 1983, Arthur Schlesinger wrote, "It is impossible to predict what Presidents who died might have done had they lived; it is hard enough, heaven knows, to predict what living Presidents will do."[5] Schlesinger remembered John F. Kennedy as someone who "made politics seem in truth (in the phrase he cherished from John Buchan's *Pilgrim's Way*) 'the greatest and most honorable adventure.'"[6] Theodore Sorensen speculated that, "The forces he released in this world will be felt for generations to come."[7] And they have. If John F. Kennedy's record was incomplete, the attempts he made and the bond he formed with the country as he made them are what we remember.

November 25, 1963 - At 3:08 p.m. following 21-gun salute and three artillery volleys, "Taps" plays at John Fitzgerald Kennedy funeral

"Of all the Presidents, this was the first to be a Prince Charming. To watch the President at press conferences or at a private press briefing was to be delighted by his wit, his intelligence, his capacity and his youth. These made the terrible flash from Dallas incredible and painful. But perhaps the truth is that in some ways John Fitzgerald Kennedy died just in time. He died in time to be remembered as he would like to be remembered, as ever-young, still victorious, struck down undefeated, with almost all the potentates and rulers of mankind, friend and foe, come to mourn at his bier."

(I.F. Stone, "We All Had a Finger on That Trigger,"
I.F. Stone's Weekly, December 9, 1963)

Footnotes

Chapter 1

1 "Whither Texas?" *The New Republic*, 2 November 1963, p. 6.

2 Benjamin C. Bradlee, *Conversations with Kennedy* (New York: W.W. Norton & Company, 1975), p. 237.

3 William Raymond Manchester, *The Death of a President: 1963* (New York: HarperCollins Publishers, Inc., 1967), p. 46.

4 Pierre Salinger, *With Kennedy* (New York: Doubleday & Company, 1966), p. 1.

5 "Second-Term Time." *Newsweek*, 25 November 1963, p. 30.

6 Richard Reeves, *President Kennedy: Profile of Power* (New York: Simon & Schuster, 1993), p. 657.

7 "Second-Term Time." *Newsweek*, 25 November 1963, p. 30.

8 Arthur Krock, "Hurdles for G.O.P." the *New York Times*, 17 November 1963.

9 "Republicans: Something on the Move?" *Time*, 22 November 1963, p. 17.

10 Kenneth O'Donnell, David F. Powers, with Joe McCarthy, *Johnny, We Hardly Knew Ye: Memories of John Fitzgerald Kennedy.* (New York: Little, Brown, Pocket Books, 1973), p. 12.

11 Bo Byers, "Chronicle Poll Sees Goldwater Over Kennedy." *Houston Chronicle*, 22 November 1963.

12 Theodore C. Sorensen, *Kennedy* (New York: HarperCollins Publishers, Inc., 1965), p. 750.

13 Pierre Salinger, *With Kennedy* (New York: Doubleday & Company, 1966), p. 1.

CHAPTER TWO

1 Saul Friedman, "Yarborough Choosy About His Partner." *Houston Chronicle*, 22 November 1963.

2 Hugh Sidey, *John F. Kennedy: President* (New York: Atheneum, 1964), p. 19.

3 Ibid., p. 19.

4 David Halberstam, *The Powers That Be* (New York: Alfred A. Knopf, 1979), p. 389.

5 David Brinkley, *David Brinkley: A Memoir* (New York: Alfred A. Knopf, 1995), p. 138.

6 Laurence Leamer, *The Kennedy Men: 1901–1963* (New York: HarperCollins Publishers, Inc., 2001), p. 575.

7 Ibid., p. 414.

8 Theodore C. Sorensen, *Kennedy* (New York: HarperCollins Publishers, Inc., 1965), p. 13.

9 Hugh Sidey, *John F. Kennedy: President* (New York: Atheneum, 1964), p. 69.

CHAPTER THREE

1 William Raymond Manchester, *The Death of a President: 1963* (New York: HarperCollins Publishers, Inc., 1967), p. 121.

2 Hugh Sidey, *John F. Kennedy: President* (New York: Atheneum, 1964), pp. 360–61.

3 Kenneth O'Donnell, David F. Powers, with Joe McCarthy, *Johnny, We Hardly Knew Ye: Memories of John Fitzgerald Kennedy* (New York: Little, Brown, Pocket Books, 1973), p. 2.

CHAPTER FOUR

1 Jim Bishop, *The Day Kennedy Was Shot* (New York: HarperCollins Publishers, Inc., 1992), p. 125.

2 Laurence Leamer, *The Kennedy Men: 1901–1963* (New York: HarperCollins Publishers, Inc., 2001), p. 736.

3 Thomas C. Reeves, *A Question of Character: A Life of John F. Kennedy* (New York: The Free Press, 1991), pp. 38-39.

4 Laurence Leamer, *The Kennedy Men: 1901–1963* (New York: HarperCollins Publishers, Inc., 2001), p. 736.

CHAPTER FIVE

1 Kenneth O'Donnell, David F. Powers, with Joe McCarthy, *Johnny, We Hardly Knew Ye: Memories of John Fitzgerald Kennedy* (New York: Little, Brown, Pocket Books, 1973), p. 31.

2 Tom Wicker, "Gov. Connally Shot; Mrs. Kennedy Safe," the *New York Times*, 23 November 1963.

3 Mike Wallace and Gary Paul Gates, *Close Encounters* (New York: HarperCollins Publishers, Inc., 1984), p. 201.

CHAPTER SIX

1 Pierre Salinger, *With Kennedy* (New York: Doubleday & Company, 1966), p. 5.

2 David Brinkley, *David Brinkley: A Memoir* (New York: Alfred A. Knopf, 1995), p. 155.

3 Dan Rather with Mickey Herskowitz, *The Camera Never Blinks: Adventures of a TV Journalist* (New York: HarperCollins Publishers, Inc., 1977), pp. 116–117.

4 Theodore Harold White, *The Making of the President, 1964* (New York: The New American Library, 1965), p. 25.

5 David Brinkley, *David Brinkley: A Memoir* (New York: Alfred A. Knopf, 1995), p. 158.

CHAPTER SEVEN

1 Kenneth O'Donnell, David F. Powers, with Joe McCarthy, *Johnny, We Hardly Knew Ye: Memories of John Fitzgerald Kennedy* (New York: Little, Brown, Pocket Books, 1973), p. 38.

2 Jim Bishop, *The Day Kennedy Was Shot* (New York: HarperCollins Publishers, Inc., 1992), p. 249.

3 Kenneth O'Donnell, David F. Powers, with Joe McCarthy, *Johnny, We Hardly Knew Ye: Memories of John Fitzgerald Kennedy* (New York: Little, Brown, Pocket Books, 1973), p. 41.

4 Jack Valenti, *A Very Human President* (New York: W.W. Norton & Company, Inc, 1975), p. 52.

5 Pierre Salinger, *With Kennedy* (New York: Doubleday & Company, 1966), p. 9.

CHAPTER EIGHT

1 Theodore Harold White, *The Making of the President, 1964* (New York: The New American Library, 1965), pp. 26–27.

2 Janet Travell, M.D., *Office Hours: Day and Night: The Autobiography of Janet Travell, M.D* (New York: The World Publishing Company, 1968), p. 428.

3 H.D. Quigg, *Four Days: The Historical Record of the Death of President Kennedy* (American Heritage Publishing Co., Inc., and United Press International, 1964), p. 60.

4 Jean Daniel, "When Castro Heard the News." *The New Republic*, 7 December 1963, p. 7.

5 Ibid., p. 7.

6 Sergei N. Khrushchev, *Nikita Khrushchev and the Creation of a Superpower* (University Park, Pennsylvania: The Pennsylvania State University, 2000), p. 698.

7 Ibid., p. 699.

8 Theodore C. Sorensen, *Kennedy* (New York: HarperCollins Publishers, Inc., 1965), p. 751.

9 William Raymond Manchester, *The Death of a President: 1963* (New York: HarperCollins Publishers, Inc., 1967), p. 351.

CHAPTER NINE

1 Theodore Harold White, *The Making of the President, 1964* (New York: The New American Library, 1965), p. 27.

2 Joseph L. Myler, *Four Days—The Historical Record of the Death of President Kennedy* (American Heritage Publishing Co., Inc., and United Press International, 1964), p. 84.

3 Associated Press, *The Torch Is Passed: The Associated Press Story of the Death of a President* (New York: Associated Press, 1967), p. 179.

CHAPTER TEN

1 Robert M. Andrews, *Four Days—The Historical Record of the Death of President Kennedy* (American Heritage Publishing Co., Inc., and United Press International, 1964), p. 114.

2 Mary McGrory, "The Funeral Had That Special Kennedy Touch." *The Evening Star*, 26 November 1963, p. A1.

3 Kenneth O'Donnell, David F. Powers, with Joe McCarthy, *Johnny, We Hardly Knew Ye: Memories of John Fitzgerald Kennedy* (New York: Little, Brown, Pocket Books, 1973), p. 46.

4 William Raymond Manchester, *The Death of a President: 1963* (New York: HarperCollins Publishers, Inc., 1967), p. 624.

5 Arthur Schlesinger, "What the Thousand Days Wrought." *The New Republic*, 21 November 1983, p. 30.

6 Ibid., p. 30.

7 Theodore C. Sorensen, *Kennedy* (New York: HarperCollins Publishers, Inc., 1965), p. 757.

Bibliography

Associated Press. *The Torch Is Passed: The Associated Press Story of the Death of a President*. New York: Associated Press, 1967.

Baldrige, Letitia and Verdon, Rene. *In the Kennedy Style: Magical Evenings in the Kennedy White House*. New York: Doubleday, 1998.

Bishop, Jim. *The Day Kennedy Was Shot*. New York: HarperCollins Publishers, Inc., 1992.

Bradlee, Benjamin C. *Conversations with Kennedy*. New York: W. W. Norton & Company, Inc., 1975.

Brinkley, David. *David Brinkley: A Memoir*. New York: Alfred A. Knopf, 1995.

Byers, Bo. "Chronicle Poll Sees Goldwater Over Kennedy." *Houston Chronicle*, 22 November 1963.

Collier, Peter, and Horowitz, David. *The Kennedys: An American Drama*. New York: Summit Books, 1984.

Cronkite, Walter. *A Reporter's Life*. New York: Alfred A. Knopf, 1996.

Daniel, Jean. "When Castro Heard the News." *The New Republic*, 7 December 1963.

"Death of the President." *The Commonweal*, 6 December 1963.

De Kooning, Elaine. *The Spirit of Abstract Expressionism: Selected Writings*. New York: George Braziller, 1994.

Friedman, Saul. "Yarborough Choosy About His Partner," *Houston Chronicle*, 22 November 1963.

Garson, Barbara. *Mac Bird!* New York: Grove Press, Inc., 1966.

Goldwater, Barry M. *With No Apologies: The Personal and Political Memoirs of United States Senator Barry M. Goldwater.* New York: Berkley Books, 1980.

Halberstam, David. *The Powers That Be.* New York: Alfred A. Knopf, 1979.

"JFK and Congress: Counterattack." *Newsweek,* 25 November 1963.

Kennedy, John F. *Profiles in Courage.* New York: Harper & Row Publishers, 1964.

Khrushchev, Sergei N. *Nikita Khrushchev and the Creation of a Superpower.* University Park, Pennsylvania: The Pennsylvania State University, 2000.

Leamer, Laurence. *The Kennedy Men: 1901–1963.* New York: HarperCollins Publishers, Inc., 2001.

Lincoln, Evelyn. *My Twelve Years with John F. Kennedy.* New York: David McKay Company, Inc., 1965.

Manchester, William Raymond. *The Death of a President: 1963.* New York: HarperCollins Publishers, Inc., 1967.

Manchester, William Raymond. *One Brief Shining Moment: Remembering Kennedy.* New York: Little, Brown & Company, 1983.

Martin, Ralph G. *A Hero for Our Time: An Intimate Story of the Kennedy Years.* New York: Fawcett Books, 1984.

Middleton, Neil, ed. *The Best of I.F. Stone's Weekly.* Middlesex, England: Pelican Books, 1973.

"The Morning After." *The National Review,* 17 December 1963.

The *New York Times,* November 16–26, 1963.

O'Donnell, Kenneth, Powers, David F., with McCarthy, Joe.

Johnny, We Hardly Knew Ye: Memories of John Fitzgerald Kennedy. New York: Little, Brown, Pocket Books, 1973.

President's Commission on the Assassination. *Warren Commission Report: Report of President's Commission on the Assassination of President John F. Kennedy.* New York: Bantam Books, 1964.

Rather, Dan with Herskowitz, Mickey. *The Camera Never Blinks: Adventures of a TV Journalist.* New York: HarperCollins Publishers, Inc., 1977.

Redding, Stan and Mansell, Walter. "President Praises Rep. Thomas as Space Leader, U.S. Patriot." *Houston Chronicle*, 22 November 1963.

Reeves, Richard. *President Kennedy: Profile of Power.* New York: Simon & Schuster, 1993.

Reeves, Thomas C. *A Question of Character: A Life of John F. Kennedy.* New York: The Free Press, 1991.

"Republicans—Something on the Move?" *Time*, 22 November 1963.

Salinger, Pierre. *With Kennedy.* New York: Doubleday & Company, 1966.

Schlesinger, Arthur. "What the Thousand Days Wrought." *The New Republic*, 21 November 1983.

"Second-Term Time." *Newsweek*, 25 November 1963.

Sidey, Hugh. *John F. Kennedy: President.* New York: Atheneum, 1964.

Sorensen, Theodore C. *Kennedy.* New York: HarperCollins Publishers, Inc., 1965.

Sorensen, Theodore C., ed. *Let the Word Go Forth: The Speeches, Statements, and Writings of John F. Kennedy, 1947 to 1963.* New York: Delacorte Press, 1988.

Travell, Janet, M.D. *Office Hours: Day and Night: The Autobiography of Janet Travell, M.D.* New York: The World Publishing Company, 1968.

United Press International. *Four Days—The Historical Record of the Death of President Kennedy.* American Heritage Publishing Co., Inc., 1964.

Valenti, Jack. *A Very Human President.* New York: W.W. Norton & Company, Inc, 1975.

Wallace, Mike and Gates, Gary Paul. *Close Encounters.* New York: HarperCollins Publishers, Inc., 1984.

White, Theodore Harold. *The Making of the President, 1964.* New York: The New American Library, 1965.

"Whither Texas?" *The New Republic,* 2 November 1963.

Permissions / Acknowledgments

Excerpt by Associated Press from *The Torch Is Passed, The Associated Press Story of the Death of a President*, Associated Press, 1967. Reprinted with permission of The Associated Press.

Excerpt by Alphonzo Bell, Jr., from *The Bel Air Kid*, Trafford Publishing, Copyright © 2002 by Alphonzo Bell, Jr.

Excerpt by Dave Barry from *Dave Barry Slept Here—A Sort of History of the United States*, reprinted with permission of Random House, Inc.

Excerpts by Jim Bishop from *The Day Kennedy Was Shot*, HarperCollins Publishers, Inc., 1992. Copyright © 1968 by Jim Bishop.

Excerpt by David Brinkley from *David Brinkley: A Memoir*, reprinted with permission of Random House, Inc.

Excerpt by Bo Byers from "Chronicle Poll Sees Goldwater Over Kennedy," Copyright 1963 *Houston Chronicle* Publishing Company. Reprinted with permission. All rights reserved.

CAMELOT, by Alan Jay Lerner and Frederick Loewe © 1960 Alan Jay Lerner and Frederick Loewe © Renewed, Publication and Allied Rights assigned to Chappell & Co. All Rights Reserved. Used by Permission WARNER BROS. PUBLICATIONS U.S. INC., Miami, Fl. 33014.

Excerpts by Liz Carpenter from *Lyndon: An Oral History* by Merle Miller, Penguin Group (USA) Inc, 1980. Reprinted with permission of Ms. Carpenter.

Material by Gary Cartwright from *Turn Out the Lights: Chronicles of Texas in the 80s and 90s*, Copyright © 2000. By permission of the University of Texas Press.

Excerpt by Walter Cronkite from *A Reporter's Life*, reprinted with permission of Random House, Inc.

Excerpts by Jean Daniel from "When Castro Heard the News," reprinted by permission of *The New Republic*, © 1963, The New Republic, LLC.

Excerpt by Editors from "Death of a President," *The Commonweal*, December 6, 1963, p. 300 © 1963 Commonweal Foundation, reprinted with permission.

Excerpts from *Four Days—The Historical Record of the Death of President Kennedy*, American Heritage Publishing Co., Inc., and United Press International, 1964, reprinted with permission of UPI.

Excerpt by Saul Friedman from "Yarborough Choosy About His Partner," Copyright 1963 *Houston Chronicle* Publishing Company. Reprinted with permission. All rights reserved.

Excerpt by David Halberstam from *The Powers That Be*, reprinted with permission of Random House, Inc.

Excerpt from "JFK and Congress: Counterattack," reprinted with permission of *Newsweek*.

Excerpt by Arthur Krock from "Hurdles for GOP," reprinted with permission of the *New York Times*.

Photography and Art